ISBN 978-1-330-05050-7
PIBN 10013362

1 MONTH OF
FREE
READING

at

www.ForgottenBooks.com

By purchasing this book you are eligible for one month membership to ForgottenBooks.com, giving you unlimited access to our entire collection of over 1,000,000 titles via our web site and mobile apps.

To claim your free month visit:

www.forgottenbooks.com/free13362

English
Français
Deutsche
Italiano
Español
Português

www.forgottenbooks.com

Mythology Photography **Fiction**
Fishing Christianity **Art** Cooking
Essays Buddhism Freemasonry
Medicine **Biology** Music **Ancient
Egypt** Evolution Carpentry Physics
Dance Geology **Mathematics** Fitness
Shakespeare **Folklore** Yoga Marketing
Confidence Immortality Biographies
Poetry **Psychology** Witchcraft
Electronics Chemistry History **Law**
Accounting **Philosophy** Anthropology
Alchemy Drama Quantum Mechanics
Atheism Sexual Health **Ancient History**
Entrepreneurship Languages Sport
Paleontology Needlework Islam
Metaphysics Investment Archaeology
Parenting Statistics Criminology
Motivational

·HERALDRY AS ART·

AN ACCOVNT OF ITS DEVELOPMENT AND PRACTICE CHIEFLY IN ENGLAND

BY

G.W. EVE

B.T.BATSFORD, 94 HIGH HOLBORN
LONDON 1907

SE

BUTLER & TANNER,
THE SELWOOD PRINTING WORKS,
FROME, AND LONDON.

Preface

THE intention of this book is to assist the workers in the many arts that are concerned with heraldry, in varying degrees, by putting before them as simply as possible the essential principles of heraldic art.

In this way it is hoped to contribute to the improvement in the treatment of heraldry that is already evident, as a result of the renewed recognition of its ornamental and historic importance, but which still leaves so much to be desired.

It is hoped that not only artists but also those who are, or may become, interested in this attractive subject in other ways, will find herein some helpful information and direction. So that the work of the artist and the judgment and appreciation of the public may alike be furthered by a knowledge of the factors that go to make up heraldic design and of the technique of various methods of carrying it into execution.

To this end the illustrations have been selected from a wide range of subjects and concise descriptions of the various processes have been included. And although the scope of the book cannot include all the methods of applying heraldry, in Bookbinding, Pottery and Tiles for example, the principles that are set forth will serve

all designers who properly consider the capabilities and limitations of their materials.

For many facilities in the preparation of the work I here beg to tender my very sincere thanks. To the Countess of Derby for the gracious loan of her bookplate; to the Earl of Mar and Kellie for permission to reproduce the shields at Alloa House; to Mr. W. H. Weldon, Norroy King of Arms, for the enamel plaque of his crest; to Mr. W. Brindley for a cast of the Warren shield; to Mr. N. H. J. Westlake for the Arms of Queen Jane Seymour, from his *History of Stained Glass*; to Messrs. Hardman of Birmingham for the loan of the Pugin drawings; to Messrs. E. C. and T. C. Jack for a reproduction of an embroidered shield.

My best thanks are also due to Monsieur Emil Levy for leave to use illustrations from the Catalogue of the Spitzer Collection; to the Society of Antiquaries for the Black Prince's shield; to the Society of Arts for the loan of sundry blocks; and to the officials of the Victoria and Albert Museum and the National Art Library for their usual and invariable helpfulness. Finally I am especially indebted to my publishers, Messrs. Batsford, who have spared neither time nor trouble on my behalf.

<div align="right">G. W. E.</div>

23, SHEEN GATE MANSIONS,
 EAST SHEEN, S.W.

October, 1907.

Contents

CONTENTS

CONTENTS

CONTENTS

HERALDRY AS ART

CHAPTER I

Introductory

In dealing with heraldry from the artist's point of view, as a decorative subject which offers interesting scope for technical effort, it will not be necessary to go overmuch into the question of its origin, nor to elaborate its history beyond what is needed to give such knowledge of its methods as may help the doing of present work or the intelligent appreciation of the old. Nevertheless, the archaeological aspect of the subject, the conditions and rules of its existence, must also be carefully studied in order to ensure the correctness of the statement that heraldry makes and of which heraldic art is the expression.

As for its origin, we may safely say that heraldry, in its essence, began when man first used natural forms to symbolize, and ascribe to himself, those qualities—strength, courage, cunning—which he had full cause to recognize in the beasts with whom he struggled for existence; when he reproduced, as well as he could, their ferocious aspect, to strike terror into his human enemies while satisfying his own warlike vanity, and so adopted them as badges or even as totems.

In Europe heraldry began to be systematized (as we know it) somewhere about the eleventh century, and it flourished exceedingly until about the middle of the sixteenth century, the period thus indicated being that of its greatest strength and beauty.

The development of defensive armour dictated the placing on it of the badges that had for long been used in other ways, so that, being depicted on the shield, they became the arms, and became the crest when displayed on the head-piece. The device worked on the garment which covered the body-armour made it a veritable *coat of arms*, and this term, as well as that of coat armour, came in time to be also applied to the similar armorials of the shield.

The Crusades, in their aggregation of troops of various nationalities, helped to extend, in showing the necessity for, a regular system of heraldry as a means of distinguishing one party from another, and the feudal system itself with its numerous groups, each under its knightly or noble head in ever-extending subordination, conduced to the same end.

The Tournaments which played so brilliant a part in the splendours of the Middle Ages also afforded fresh and greatest scope for heraldic magnificence. Being restricted for the most part to competitors of noble birth, many of whom were attracted from distant places, they afforded opportunity for observation and comparison of the various bearings. They naturally suggested the inclusion of foreign as well as native armorials in the heraldic MS. of the times, as we find them depicted in the Rolls of Arms. The necessity for well-ordered arrangement

soon made itself felt, and thence was evolved systematic heraldry as it now exists. The rules thus originated, being based on the ever-present difficulties which arose in the actual use of coat armour, were admirable for their purpose, for they were devised with a common-sense regard for the conditions under which they were to be applied, were at first simple and therefore easily understood.

The manner in which the arms were displayed was the most conspicuous that was possible, every suitable space that offered itself being employed to bear them in one form or another. Thus in time they appeared on the shield, helmet and surcoat, and also on the ailettes, those flat pieces of steel which were used to still further deflect a blow which had slid from the helmet and might otherwise have injured the shoulder.

The use of heraldry in battle or tournament by no means exhausted its possibilities, however, for even in the warlike Middle Ages armorials were used by priests and women, and by statesmen whose services were those of the council chamber rather than of the field. In every case their strong personal and allusive quality was felt to the full, and intensified the human interest in ordinary things. So that the enamelled brooch of Queen Eleanor, with its arms of her warrior husband Edward I linked with her own, becomes something more than a mere fastening ; and the armorial robes of the noble wife who wears her husband's armorials on her mantle, covering and protecting her own arms embroidered on her gown, are made beautiful expressions of a chivalrous idea.

Heraldry was made especially interesting by the symbolic meanings which it embodied, thus expressing in its own way a very universal desire for significance in decorative forms. In the Middle Ages, especially full as they were of militant fervour and chivalric mysticism, symbolism entered into everything. Not the heraldry alone but every part of a knight's armour had a mystic meaning, the knowledge of which was an important part of a knightly education. Many of these meanings are quaintly set forth in one of the books that Caxton printed, *The Order of Chivalry*. Therein the shield is considered as the especial emblem of its bearer and of his knightly duty, for " like as the stroke falleth down upon the shield and saveth the knight right so the knight ought to apparel him and present his body tofore his lord when he is in peril hurt or taken." Even the manner of doing things was underlaid by beautiful ideas. So he who bore the sword of Justice in a ceremony was enjoined to bear it truly upright, for Justice should lean neither to one side nor the other, but be impartial between the two.

Besides the creatures (lions and so forth) which were taken to signify strength, courage, fidelity and other virtues, there were also those which symbolized the great mystery of the perpetuation of life, which has appealed to the imagination of man throughout historic times. The Peacock, in the periodical renewing of his splendour of plumage ; the Swan, emerging in spotless beauty from the dusky obscurity of its cygnet state, both expressed this universal idea. To Christian chivalry the Peacock typified the Resurrection and therefore Immortality, and

the Swan became the emblem of that cult of womanhood which was so beautiful and characteristic of knightly regard. The symbolism of the Cross and the emblems of saints and martyrs form a large part of heraldry, as is natural. Plants and flowers were naturally taken to express beautiful qualities—constancy, purity, love— as with similar intention they may still be acceptably employed in the wreaths and garlands which are, on occasion, associated with armorials.

Symbolism of this kind has been lost to heraldry, not, however, leaving it without significance; for arms have also allusive meanings that are no less interesting as records of incidents that are thought worthy of remembrance.

Many mediaeval bearings originated in this way, the belt and buckles of Pelham, which commemorate the capture of the French king at Poitiers, for instance. The more modern kind of heraldic symbolism occurs in the arms of the great Admiral Sir Cloudesley Shovel, who commemorated his victory over the fleets of Turkey and France at the end of the seventeenth century by adding two crescents in chief, and a fleur-de-lis in base to his existing coat, gules a chevron ermine. In our own time successful generals embody in their armorials the badges of regiments with which they have been connected, or bear allusions to places where their successes have been won. In a more peaceful field the skill and assiduity of a distinguished physician may be rewarded by the addition to his arms of some part of the Royal insignia, to mark for all time the services he has rendered to the State. Such arms are conferred by special

grant, and are called Arms of Augmentation or Augmentations of Honour. In this way the inherent qualities of heraldry are seen to be very stable and to remain constant through the ages in spite of changes of manners and of general environment.

Our heraldry, which quickly reached a high degree of decorative excellence, developed as a system, in a natural way, on the line of its own necessities; as did its artistic expression in a great measure, though the latter owed much to transmitted designs and (mainly through the influence of the textiles and other importations) helped to perpetuate in Western art the beasts and birds and strange composite conceptions of the East. These ancient prototypes of familiar heraldic forms are singularly interesting, as sometimes possessing in a very marked degree qualities, such as vigorous expression and characteristic generalization of form, which teach valuable lessons in their application to modern use.

Although at first the mediaeval draughtsman followed the drawing of his imported or traditional motives very closely (as in the lions of some of the thirteenth-century MSS. and seals), he soon began to treat them in his own way, the way that came to be considered peculiarly heraldic. In thus handling his motives he was entirely himself, and the outcome was the natural result of the splendid sense of design which characterized him. The style is rightly considered purely heraldic because it arose from its own heraldic conditions, and was the result of the very sane intention that the thing done should be suited to the use to which it was to be put, viz. to serve as a distinctive badge which could be seen, and easily

read at a distance or when in motion. Such conditions dictated simple directness of treatment and resulted in that bold clear definition which combined with good distribution and the fine balance of colour that results from it, to produce a very decorative whole. Thus, as so frequently happens in other ways, the treatment at first suggested by reasons of practical convenience resulted in an effect of great decorative value. The method of depicting the pattern-like figures varied, as was natural, with the materials employed and with other varying circumstances, and, where opportunity served, a high degree of elaboration was reached; but whether the treatment was simple or elaborate, breadth of effect and decorative quality are nearly always conspicuous. The various methods of working, each satisfactory in its own way, are extremely interesting, as giving historic sanction to the choice of treatment in heraldic expression, and in opposition to the narrow view that as a certain kind of work admirably suits its purpose in its own place that same treatment should be obligatory in all other cases. The old work confirms the broader view, so that when a flat treatment, for example, in harmony or in contrast with surrounding decoration, seems desirable, the armorials may be done flatly; and when, on the other hand, a more elaborate treatment seems fit, modelling in relief or any other means of decorative expression may be properly employed. Nevertheless, the broad-minded advice to " do as you like " has been sometimes taken too literally. Order as well as freedom is necessary to the doing of good work, and that can only be secured by study of the subject from the sys-

tematic or archaeological, as well as from the artistic
side.

Heraldic art reached its greatest strength in the four-
teenth century, as appears in what was perhaps the most
beautiful example of the work of the period, the shield
of arms in Canterbury Cathedral, said to be that of
Edward the Black Prince (Fig. 1). It is probably
one of the shields that were used for his funeral. Here
the lions of the English coat are admirably distributed
and are full of power and spirit. The fleurs-de-lis of
France are beautifully free and graceful, and are
equally well designed to occupy their spaces and as well
proportioned to them. The whole work, which is so valu-
able a lesson in the best qualities of heraldic design, has
suffered from the wear of the centuries; but sufficient
remains to show that when uninjured it must have been
superb.

Heraldic art continued finely decorative and expressive
for a very considerable time until the forms which had
shown so much spontaneity became more patternlike,
reverting in a measure to the character of such of the
earlier figures as more nearly reproduced those of the
textiles; for the fourteenth-century examples, such as
that to which we have just referred, show a conscious
effort to express the attributes of strength and vitality
which were associated with and were symbolized by the
animals that were depicted. In the late mediaeval work
this vivifying force became weakened under the numbing
influence that is inseparable from the reiterated use of
forms that have become stereotyped. In respect to the
appeal which visible expression makes to the ordinary

mind as opposed to mere diagrammatic indication, the best work of the fourteenth century in its effort to depict

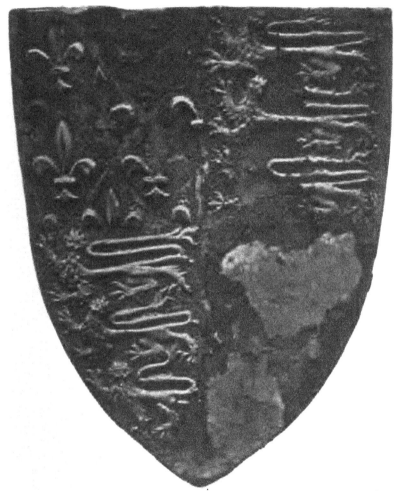

FIG. I.—Shield of the Black Prince in Canterbury Cathedral.
Fourteenth Century.

recognized attributes links itself in intention with the work of the Renaissance, although the methods that were employed differed so greatly.

At the end of the fifteenth century the personal bearing of heraldry in war had almost ceased, but it remained an important feature of the tournaments during the whole period of their existence.

Besides satisfying the martial sense which ever delights in brilliance and colour, it also gratified the desire for the expression of meaning in decoration, a mental attitude which heraldry exactly fitted. And heraldry thenceforward became mainly decorative, while retaining the allusive and symbolic qualities that are hardly separable from it.

In Tudor times the number of armorials increased in a very marked degree, no doubt sharing in the impetus given to the arts in England by the much-needed peace which followed the dynastic wars of York and Lancaster. As though to link it with that welcome event, beautiful and simple flowers added their charm to heraldry in notable quantity, and gillyflowers, columbine, marygold, and many more, appear on shields of arms and in crests, as well as in the garlands which were so admirably used as decorative accessories to the armorials.

The Gothic heraldry, in common with the other decorative arts, having become formalized into a style from which the human interest had to a great extent gone, a change took place in harmony with the new feeling; but in the revolt from the formalism of late Gothic art heraldry frequently went to the opposite extreme, and employed naturalistic forms in an unsuitable way.

Much of the Renaissance work, however, retained some of the best qualities of the Gothic, in the pose of the

figures and in the general composition, while in addition it attempted a more detailed characterization than before.

In many respects it was very admirable and seems, in its suggestion of individual thought working on the traditions of an older style, to suggest the lines on which modern heraldic design might develop. German heraldry has followed these lines to a large extent, and though it has perhaps become over-florid, is still full of proofs of the advantage which results from continued touch with the Gothic.

In this country there had been a constant succession of foreign masons and sculptors, from the time when, in the twelfth century, the Frenchman William of Sens came to restore Canterbury Cathedral, and the Renaissance style probably received its most effective impetus in England from Torregiano and his fellow Florentine artists when they superseded the native workers in the designing and carrying out of the tombs of Henry VII and others in the beginning of the sixteenth century. The king's tomb was begun in 1503, and is a useful landmark in the history of the evolution of heraldic style. From this and similar works the English sculptors and designers learnt the methods of that revival of art on classic lines which had become developed in Italy for nearly a century before it made so definite an impression here.

The work that was produced under these influences was marked by great vitality, variety and grace, until it, in its turn, became weak and uninteresting, so that by the seventeenth century it had degenerated into sheer

stiff ugliness that it is almost impossible to connect with the graceful strength of its prototypes.

Holbein, who worked here (except for a short interval) from 1526 until his death, executed, besides his paintings, many designs for goldsmith's work and so forth, and has left some few heraldic drawings, probably designs for the decoration of books, such as dedicatory plates, or for stained glass; but the Italian influence was over-powering, and he left little permanent impression on heraldic style. An example of his heraldry may be referred to in Fig. 221, p. 243.

As time went on, and the practical use of heraldry in the field became more remote, the sense of proportion became weakened, the decorative distribution of the early work was no longer sought after, and the general loss of grip is everywhere perceptible in the design ; while in the execution, especially in later times, minute finish of detail took the place of the earlier breadth of treatment. The marked inferiority of the heraldry to the other decorative work of its time (a fault that is frequently visible in the work of the present day) points to a general loss of interest in the expression of heraldry, although its use was tenaciously adhered to, and it is abundantly evident that in the period which extended from the early seventeenth century until recent times regard for heraldry (when such regard existed at all except as a mere desire of display) was mainly directed to its systematic side and to the ever-increasing detail of its rules and precedents.

However, the Gothic revival in the early part of last century again directed attention to heraldry, and the

work of Williment, Pugin, Powell, Burges and others, showed once more how decoratively and expressively it could be handled when it was seriously studied and applied.

With reference to the old examples, a study of which is absolutely necessary in order to understand the principles which underlie all heraldic design, it will be well to sound a note of warning against making a fetish of the work of any period, however good ; against mere copying of old examples however excellent, except, of course, for purposes of study. To merely copy and piece together bits of precedent is not the way to make an artistic thing at all. A copy can have no vitality of its own, and cannot even reproduce that of its original. Even Pugin and Powell cannot be said, in spite of all their sympathy and power of draughtsmanship, to have altogether succeeded in suggesting the intense vigour which characterized the work of the originals that were followed. A broad view must be taken if new work is to harmonize with new conditions or be anything more than a mere shadow of a preceding style.

Heraldry in order to be expressive and interesting ought to be original, or perhaps one should rather say individual, in treatment ; an effort to express itself by means of the artistic qualities that the old work possesses and teaches us to admire, rather than a copy of its forms. By original is meant something that the artist thinks out for himself, his individual expression of what he wishes to convey, with all the help that he can obtain from his knowledge of previous work, but without feeling himself bound to imitate it. Points of resemblance are inevit-

able. It is hardly possible to avoid showing the influ-
ence of the examples from which the artist has learnt his
craft, nor does it matter ; but when the copy is intentional
and the intention stops at that, the work ceases to interest
as individual design. All styles should be studied for the
sake of the lessons they may teach in the application of the
ordinary principles of design to correct heraldic motives,
for, after all, that and fitness are what constitute good
heraldry. Composition, the balance of mass and arrange-
ment of line, with all their various possibilities, may be
learned from all forms and styles of art, pictorial as well
as ornamental, that is itself based on sound principles.
The appreciation of such points and their satisfactory
application constitute what we know as the sense and
power of design, and they must be understood before one
can pretend to practise or discuss it.

Heraldry in its setting forth may be regarded in two
ways. As the depicting of an actual shield, crest, helm
and so forth, as they would be shown in a picture of a
tournament, for instance ; or, as a presentation of the
heraldic facts in the way that is thought most expressive
without having too much regard to preceding renderings.
The former way seems more suitable to the execution
of ancient and historic arms or of such as are to accom-
pany Gothic surroundings, and the latter to be more likely
to harmonize with modern decorative conditions, as
well as to possess more vitality and variety in itself.
This harmony with surrounding decoration, whether
on a wall or in a book or in any other way, is one of the
essentials of good design and must be continually kept
in mind. Another, equally important, is that work should

be designed with direct regard to the materials and methods by which it is to be done. These very obvious points cannot be too often insisted upon, however wearisome the reiteration, for neglect of them is at the bottom of most bad work.

Careless treatment of the heraldry, with which it is, nevertheless, obliged to deal more or less, sooner or later, seems to pervade applied art and to spoil what is otherwise meritorious work. Doubtless much of the mischief arises from fear lest improving the drawing or composition may violate heraldic rules ; and this brings us to the necessity of acquiring so much knowledge of the systematic side of heraldry as will suffice to show what points are really essential (and therefore to be carefully preserved and if need be accented), and what, on the other hand, may be modified or ignored. This may best be done by study of the system of heraldic description known as blazon, which is described further on. But before proceeding to do so it will be necessary to deal first with an heraldic composition as a whole.

CHAPTER II

Evolution of Shield Forms

THE armorial group, called an " Achievement " of Arms, principally consists of the shield and the crest, the latter . supported on its helm, and accompanied by the mantling or lambrequins, and in addition, mottoes, coronets, supporters and other accessories proper to the occasion may form part of its composition. The term " achievement " (sometimes corrupted into hatchment) may be applied to any heraldic group whether it be a complete presentation of full armorials or only a selected part of them. In the simple arrangement of shield, helmet and crest, the proportion of the parts to each other remained fairly constant from the end of the thirteenth century down to the Renaissance, that is to say throughout the whole mediaeval period, and may be taken roughly to be rather more than two-fifths of the whole height for the shield and rather less than three-fifths for the helmet and crest.

This, it need hardly be said, must not be taken for actual measurement, but only as suggesting the relative weight in the design of its component parts. The result

of these proportions is to bring the helm a little above the actual middle of the composition, and its place is then found to be a very satisfactory one, in which it serves as a central point on which the other objects group themselves. There is also seen to be due scope for the clear definition of the details of both arms and crest, while there is an appropriate suggestion of dignity in the whole effect. The principal artists of the Renaissance, Dürer above all, appear to have fully appreciated this, similar proportions appearing in the best type of Renaissance work as in that of the Gothic period.

Such proportions were no doubt suggested by those of the actual things themselves, but not wholly so; for in other cases the object of the artist was rather to display the armorials to the best effect than to copy their appearance when they were being used in another way.

Fig. 2, the reverse of the Great Seal of Henry IV, a splendid example of the seal engraver's art, is an interesting illustration of how armorials were borne by man and horse, as well as of their approximate proportion. An example of the influence of local considerations in modifying proportion is the group which occupies the middle of the canopy of the tomb, in Westminster Abbey, of Louis Robsart, Lord Bourchier, who was standard-bearer to Henry V. The shield is minimised as much as possible because its bearings appear large and bold on the carved banners at the sides; the crest, however, not occurring elsewhere on the monument, is comparatively enormous. In this case the shield

that is associated with the crest is destitute of charges, which may, however, have been modelled in gesso on the stone and have disappeared.

In a similar way the arms in the group over the point

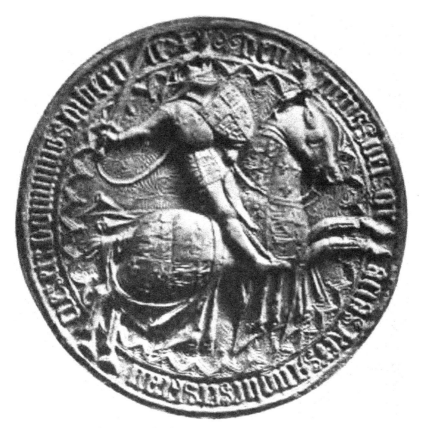

FIG. 2.—Seal of Henry IV. Reverse.

of the arch of the chantry of Henry V near by are extremely small, a part of the mantling is even allowed to fall over them, because they are fully displayed

on the shields supported by angels in the spandrils below.

The shape of the space that is available for displaying the achievement and the character of the bearings also influenced proportion, so that a crest may be exagger·· ated, or a shield may be comparatively enlarged, in the latter case in order to accommodate quarterings perhaps, and the sense of proportion may still be satisfied because of the evident reason for the treatment

The object of an achievement being to display the armorials in the most distinctive way, it follows that the subordinate parts of it, especially the helmet and mantling, should all be designed to that end, that their lines should compose in such a way as to concentrate the attention on the more important subjects, and that their details, however intricate, should not detract from a broad effect. In short, they should be so arranged as to support the central motive and not to compete with it. Whatever the style of the design it should first of all express the subject in the most explicit way, and carefully avoid letting scrolls outshine the crest or mantling distract attention from the shield which is encompassed by it.

Choice of method should naturally be based on the desire to represent things in the most direct way and by the simplest means that are suitable to the purpose in hand, using exactly the right amount of elaboration, from the perfect simplicity demanded by a figure in perforated iron, through the varying detail of different forms of applied art, stained glass, enamel, modelling, carving, painting and engraving. There is always

great charm about simple treatment that is at the same time expressive, but the right simplicity can only be reached through knowledge, and is a very different thing from the emptiness which ignorance hopes to have mistaken for it. Clearness of statement expressed by vigour of drawing, beauty of line, balance of mass and harmonious coherence of composition, are obviously essential qualities; and when to these are added suitability to environment and material, the result will be that expression of rightness which constitutes style, whatever the style may be.

Heraldic accuracy is assumed as a matter of course, for heraldry that is not accurate stultifies itself.

The usual grouping of an achievement was suggested, no doubt, by the method of displaying armorials in processions and other ceremonials, when the crested and mantled helmet was placed on a lance-staff or some similar support, and the shield was hung below by its guige. That the grouping was also a natural one is visible in the seal of Henry IV (p. 18), especially if we imagine the figure to be seen from the opposite side.

There is nothing heraldically essential in arranging the armorials in this order, for the crest may be placed in any other relation to the shield that circumstances may render preferable. When, for instance, it is undesirable to pile up the design in height the crest is placed at the side of the shield. The earliest instance of which I am aware is that of Lord Basset of Drayton, whose arms thus appeared on his stall-plate as a Knight of the Garter. In such cases it is usually most convenient

to pose the crest on the true right of the shield because the swing back of the mantling serves admirably to tie up the whole design, but there is no reason why the positions should not be reversed if the lines can be made to compose satisfactorily; that is to say, it is only a matter of ornamental design and not in any way of heraldic right or wrong.

THE SHIELD.—In the application of badges to the distinctive decoration of armour, whence arose the term armory for the science of heraldry, the shield naturally singled itself out to be made of especial importance as the most suitable space on which to display the device; for not only was it most conspicuous from its position with regard to the rest of the armour, but its detachability, and the facility with which it could be hung by its guige from some suitable support, rendered it a ready means of representing its master in ceremonials and pageants. As such a representative it became the principal vehicle of honourable distinctions, and conversely was also made a means of punishing misconduct.

The decorative value of shields had been recognized from the earliest times; on the Greek pottery, for example, they appear bearing the symbolic representations of birds, lions and other animals, which are there drawn with all the vigorous beauty and sense of design that we should naturally expect from such a source.

In the Roman sculptures also shields frequently occur, of whose shapes some were to reappear at the Renaissance.

The Norman shields, as they are represented in the Bayeux tapestry, in early carvings and in seals, were long and narrow, and the leather guige by which they could be suspended from the neck was already in use, as well as the other thongs which served as arm and hand holds (Figs. 3 and 6), and were so arranged as to permit the grasp to be applied in a variety of ways as the positions of the shield might demand. The

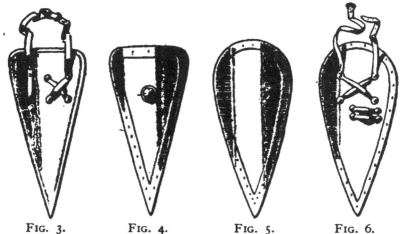

FIG. 3. FIG. 4. FIG. 5. FIG. 6.
Back of Fig. 4. Norman Shield. Eleventh Century. Back of Fig. 5.

two sets of grips, called enarmes, that are here shown will serve to make clear the general arrangement, but their placing varied considerably, and was naturally adapted to individual requirements and peculiarities. The shields were strongly curved in a horizontal direction, partially encircling the body and, in many instances, had in the centre a projecting boss or umbo. They were rounded at the top, as in Fig. 5, or the top was straight with rounded corners, as in Fig. 4.

Being pointed at the base they were capable of being thrust into the ground, so as to be easily held in position by men fighting on foot, to whom they formed a very efficient defence, being about 4 feet high, in combination with the hedge of lances that accompanied them. Their width was about 2 feet or perhaps a little more.

They usually consisted of a foundation of wood covered with strong thicknesses of leather, additionally strengthened with bands and bosses of metal, and were often richly painted, and even, it is said, sometimes adorned with gems.

The round-topped pointed shield appears on the seals for a considerable length of time, and in Italy has never gone out of decorative use.

Throughout the eleventh and twelfth centuries the Norman shield remained with very little modification, and was therefore the first shape to which regular heraldry was applied.

The subjects, besides the armorials which were gradually increasing in number and in regularity of arrangement, were at first little more than fanciful decoration, the signs of the zodiac and similar devices, as well as the badges, which long continued to be used from time to time in a more ephemeral way than the regular armorials, though nearly approaching them in character.

Very early in the thirteenth century the height of the shield began to decrease, and continued to do so until by the middle of the century an almost equilateral form was arrived at (Figs. 7, 8, 9). This was probably

the effect of the progress in the making of defensive
armour, whose improvement ultimately resulted in the
disuse of the shield altogether. By the end of the thir-
teenth century heraldry had become general, and the
triangular shields bore coats of arms which showed in
their composition the influence of the shape that contained
them. The fact that a single lion was depicted as ram-
pant rather than in another pose, was probably due
at first to the greater ease with which it could thus be
adapted to the space and so satisfy the decorative sense
of distribution. And the attitude was already in exist-

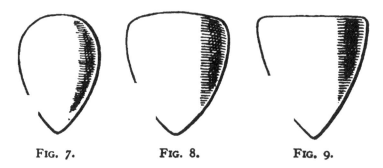

FIG. 7. FIG. 8. FIG. 9.

ence in the designs of the textiles and in other works
of Eastern origin.

Until the beginning of the fourteenth century the
curves which describe the sides of the shield commenced
quite at the top, but soon afterwards (the shape becoming
rather narrower in proportion to the height) the side lines
began straightly at right angles with the top and, at about
one-fourth of the height, began to develop into the curve
which formed the point (Fig. 11). This is known as the
heater shape from its resemblance to the heater of a
smoothing iron. Soon afterwards the straight part

of the sides extended downwards and the shield, thus becoming wider at the base, more nearly approached the square form, as in Fig. 12.

The shapes here given are designed to explain the varying forms from time to time, and not the relative size of actual shields.

The pointed shield was one of the most satisfactory shapes for the display of a single coat of arms, but it became inconvenient, in most cases, when two coats were impaled together or when quarterings were involved, the restricted base rendering it extremely difficult to

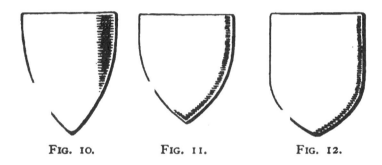

FIG. 10. FIG. 11. FIG. 12.

deal with objects in that part of the shield. The seals and monuments naturally represent shields as very flat, but they were not actually so, but were almost always curved in section to a greater or less extent, and in one or more directions; for armour was designed to deflect a blow rather than to directly resist it, this being one of the ordinary principles on which most kinds of defence are based. As we have seen in the Norman shields, the curve was at first simply from side to side, afterwards, in order to prevent a blow from glancing downwards, the lower part of the shield was made to

project, and finally the top was brought forward so that
the shield had a double curvature, convex from side
to side and concave perpendicularly (Fig. 13).

A large shield called a pavoise was used for fighting

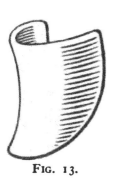

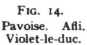

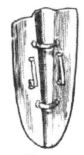

FIG. 13. FIG. 14. FIG. 15.
 Pavoise. Afli. Back of Fig. 14.
 Violet-le-duc.

on foot, a partial reversion, for definite practical reasons,
to the long shield of the Normans. Like the Norman
shields, it in some cases had a pointed or rounded base,
while in others it was roughly rectangular, its most
marked characteristic being the large and projecting
rib whose hollow served on occasion to accommodate
a supporting stake (Figs. 14 and 15). It was provided
with handgrips and, in most cases, with a guige by
which it could be slung on the shoulders or carried on
the back when not in use. Besides those which were
painted with subjects which extended over the whole
surface in the usual way, others were decorated with
small painted shields drawn on the larger one.

The term pavoise is sometimes given to the large
decorative shields (of various shapes) which were made

in considerable numbers in the sixteenth and seventeenth centuries, especially in Italy; but there is no doubt that the term, in strictness, should be confined to this special defence of the foot-soldier.

A shield with a sharp arris or ridge and a round base is said to have been the last form to be used in actual war (Fig. 16), and is interesting as the prototype of the ridged Renaissance shield, which became of such decorative value, especially when modelled in relief, because of the play of light and shade which it afforded (Fig. 16A. See also Figs. 20 and 21).

FIG. 16.—Fifteenth Century.

·It will, of course, be understood that the various shapes of shields, as they were gradually evolved one from the other, did not in representation supersede their predecessors altogether, however more or less completely they may have done so as actual defence, and a considerable amount of overlapping took place in this as in other heraldic fashions.

The armorials themselves having been influenced in their composition by the shield shape that was in vogue when they were devised, the choice of a form that is equally convenient for all the arms of a series presents considerable difficulty, and therefore should not be decided upon until the nature of their whole contents has been properly considered.

Shields were used in the tournament in a variety of ceremonial ways. Froissart describes, in his account of the meeting that was held near Calais in 1390, how

they were hung outside the pavilions of the defenders, so that by touching them the challengers could signify their intention as to the kind of encounter that was to ensue. For this purpose two shields were displayed, one " for peace " and another " for war," and according as one or the other was touched the encounter took

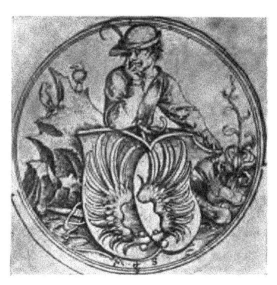

place with blunt or pointed wea- pons. Similar shields are re- ferred to by Ed- ward the Black Prince in his will, dated 1376: "l'un pur la guerre, de nos armes entiers quartelles " (those represented in Fig. 1 at p. 9), " et l'autre pur la paix, de nos bages des plumes d'ostruce "

Fig. 16a.—Ridged Shield. Fifteenth Century.
Martin Schongauer.

(Fig. 17), both of which decorate his tomb.

Together with the banners and pennons of the chief personages, shields were hung from the windows of the knights' lodgings in the neighbouring town to where the lists were set. They also adorned the walls of the banquet hall, and in every way the actual shields contributed to the pageantry of the time, and naturally suggested their representation in tapestries and in other permanently decorative ways.

The treatment of the bearings on the actual shield was, no doubt, by means of painting in flat colours, the charges being drawn in the simplest and most direct way; for although there are examples in the illuminated manuscripts of knights armed with shields whose charges are in relief, such treatment was probably exceptional owing to its cost and to the difficulty of repairing damage, or may even have been due to the elaboration of the illuminator. So that although relief was em-ployed in cases of unusual mag-nificence the ordinary treatment was probably flat.

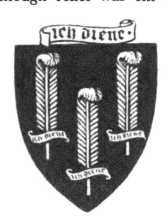

Shields for great ceremonial purposes being more purely de-corative were naturally more elaborate, and of these the shield at Canterbury must be again in-stanced. Such a shield after serving in the funeral procession was suspended over the tomb, together with the sword and crested helmet, as was done for

FIG. 17. — Shield " for Peace " of The Black Prince. After Stothard.

Edward III and Henry V in Westminster Abbey and for Humphrey, Duke of Gloucester, " the Good Duke Humphrey," in old St. Paul's; but of these only the insignia of Henry V remain, and they are by no means in such interesting preservation as those at Canterbury. A similar trophy adorned the tomb of Edward IV at Windsor, and is said to have been embroidered with pearls and gold.

The shields that were intended for ceremonial or

decorative purposes were very carefully made of layers of various materials, such as canvas and leather, which were stretched over and glued down to the wooden understructure in order to afford a key to the material that formed a surface for the subsequent work, in much the same way that panels were prepared for other kinds of painting at that time. The charges were then modelled in gesso, afterwards gilt and painted,

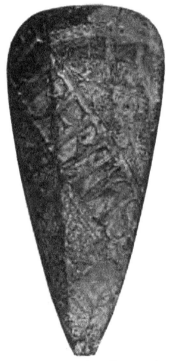

or else were fashioned in modelled leather and pinned down to the surface. The spaces were often diversified with diapered patterns in raised lines of gesso or by means of punches, and when the gold and colour were added the whole effect was extremely rich and beautiful. Of such pageant shields excellent specimens were in the great Bardini collection, now dispersed.

Fig. 18, a kite-shaped shield of the fourteenth century, bears bendwise the word Libertas, the motto of the republic of the town of Luroques, in beauti-

FIG. 18.—Italian Decoration Shield. Fourteenth Century.

ful letters, whose treatment is perfectly appropriate to the gesso in which they are executed. The shape of the shield follows closely one of the early Norman forms, and is somewhat of the same proportion, being 44 inches

high by 21 inches broad. The square pavoise (Fig. 19) of wood covered with vellum is painted with the arms of the Buonamici, and over them as crest is the portrait of the head of that family, Bienheureux Buonamici.

At the time that the use of shields in actual combat was becoming less and less frequent, the invention of engraving on metal plates, the im- provement in wood-en- graving, and finally the production of printed books, opened a fresh field for heraldic art in the making of the plates of arms which marked the patronage of a literary work, or in the more familiar bookplate which signified the ownership of the book. Then began that long series of beauti- ful little works by Martin Schongauer, Israel van Meckenen, and by Dürer

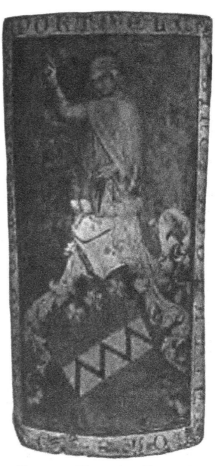

Fig. 19.—Florentine Decoration Shield. Fourteenth Century.

and their successors. In the large number of designs thus produced the shields, in many instances, became much less simple, ceasing to be a representation of the real defence,

though some of them were developments from it. The
cusped forms such as Figs. 20 and 21, which came into use
in the latter half of the fifteenth century, and became still
more frequent in the Tudor period, perhaps have some
affinity with the elaborate fluted armour of the time,
but others were frank adaptations of the contemporary
decorative scrolls and were really cartouches more or
less in place of a shield.

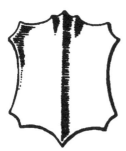 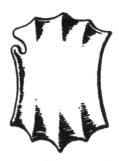

FIG. 20.—Fifteenth Century. FIG. 21.—Sixteenth Century.

The special tournament shield, the shield à bouche,
had a marked influence on subsequent forms. In order
that the shield might, during the joust, fit closely to
the shaft of the lance a semi-circular opening was made,
sometimes at the top but more usually at the side, as
in the example (Fig. 22), and from this simple expedient
a very great variety of shape resulted, of which the
manner of evolution is interesting.

In the ornamental forms that were based on the actual
ones this embouchure was sometimes plainly indicated,
as in the shield from the group of Dürer's coat of arms
(Fig. 23) and in the French wood-carving (Fig. 24); in
others the lower point of the opening was merged into

one swinging line, as in the shield of the well-known Death's Head coat of arms. The next step was to duplicate the curve suggested by the bouche, and from the

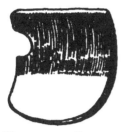
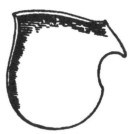
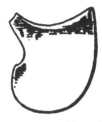

FIG. 22. — Tournament Shield. Fifteenth Century.

FIG. 23. — Dürer's Arms. Early Sixteenth Century.

FIG. 24. — French Wood-carving. Fifteenth Century.

resulting form proceeded an endless variety of similar shapes, the addition of foliated or scroll ornament completing the transition from the practical shield to the ornamental one. An interesting instance of this duplication of form occurs in the shield from a fifteenth-century monument in St. Gatien Cathedral (Fig. 25). With the re-

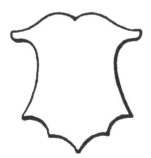
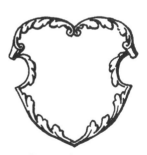

FIG. 25.—Fifteenth Century.

FIG. 26. 1530.

cognition of the purely ornamental character of the shield-form the placing of the spear opening on the naturally correct side, the dexter, ceased to be thought important,

D

and it was placed indifferently on one side or the other, and when such shields occur in pairs, as in those on the Pirckheimer bookplate by Dürer, the bouche-derived curves are placed symmetrically on opposite sides.

Foliated decoration applied to the duplicated tournament form is well exemplified in the shield from the plate of the arms of Herr Kress, who was the friend of Dürer, though the plate is not Dürer's work (Fig. 26).

Among the work of Dürer's school the beautiful plates of his pupil Hans Sebald Beham will well repay study for

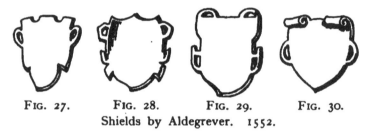

FIG. 27. FIG. 28. FIG. 29. FIG. 30.

Shields by Aldegrever. 1552.

their excellent composition and for their extreme beauty of draughtsmanship and engraving. Beham's shields were often scrolled at the edge, but not extravagantly so, and he frequently employed plain shields, which, like most others at the time, however plain in outline, were shown more or less concave in some or all directions : a well-known device to obtain relief for the light side of the charges by means of the adjacent shadow that is formed by the concavity of the shield.

The shields that accompany the figures of the Virtues and Vices, engraved by Aldegrever in 1552, are most unusual in their curiously shaped edges, and show very emphatically the complete departure from the character of the defence shield (Figs. 27–30).

The Italian form derived from the tournament shield took a longer shape, still retaining the bouche, and often had the base divided into three parts, and many examples of this shape occur on the walls of the Palazzo del Podesta, Florence. The surface was generally kept whole and not fluted, as in the analogous English form. The most characteristic Italian shield, however, was that derived from the angular Roman ones, such as those on Trajan's column, with the outlines curved into cusps. This is sometimes called the champfrien shape from its resemblance to the face-plate of horse-armour, but the appearance of the form at the time of the revived interest in classic art leaves little doubt of the source from which it was taken. Among others were oval shields, also of classic origin ; and the round-topped Norman shape also occurs very frequently. Triangular shields with concave outlines were also used.

In the use of more or less elaborate decoration the German artists participated. Virgil Solis and Jost Amman among others frequently used the scrolled shield, as Beham also had done. That English heraldry felt all these influences is evident in the examples from St. Alban's Abbey (Figs. 31 and 32), sculptures whose forms are directly derived from the tournament shield and were carved in the early sixteenth century.

The application of foliated ornament occurs in the Garter Plates early in the fifteenth century, in that of Henry, Prince of Wales, afterwards Henry V (Fig. 33), and more completely in the sixteenth-century shield, which bears the arms of the Abbey of St. Albans (here omitted), Fig. 32.

In the Elizabethan and Jacobean decoration there

is a reversion to the plain square shield, which usually occurs as a centre for scrolls and strapwork, the corners becoming slightly pointed, a feature which developed into the hideous eared shields of later times, when also

FIG. 31.—Sixteenth Century. FIG. 32.—Sixteenth Century. FIG. 33.

the decorated form had become the clumsy " ornamental " shield that was so long endured.

These various forms point to the useful fact that the shape of a shield is only limited by the invention and judgment of the designer. The only, and unfortunate, exception is the lozenge, on which the arms of ladies are placed in certain cases : an unfortunate shape because in most instances it is extremely difficult, if not impossible, to accommodate its bearings to it in a satisfactory way. Usage says that an unmarried lady must bear her father's arms, and a widow must bear her father's and husband's arms together on a lozenge. This is a point that cannot be ignored, for an isolated lozenge containing but one coat is an heraldic statement that the owner is unmarried : except the statement be modified by the association of other arms, as in the case

of peeresses in their own right. Again the necessity of being clear about the heraldic facts before attempting to depict them is evident. In one instance, at least, the arms of Her late Majesty Queen Victoria were drawn on a lozenge, in spite of the undoubted fact that " the Royal state is masculine." It is also for this reason that a Crest is borne by the Sovereign even when a lady occupies that exalted position.

The immense scope that is afforded by the variety of shield shapes is extremely valuable in adapting heraldry to general design, in fitting a shield to its space, in adapting it to its bearings, and in bringing its lines into proper relation to those of accompanying figures or ornament. It may also help in the expression of a general idea, as in the burnt-wood panel on p. 218, where there is a suggestion of rose-leaves in the edges of the shield.

It is obvious that as the statement which heraldry makes is a very definite one, its accuracy should be the first care, and that this vital consideration is frequently lost sight of is but too evident from the fact that even the King's Arms are as frequently maltreated as the King's English.

It will be needless to specify instances—they are not few—of works of great public as well as artistic interest wherein the arms have no real connexion with the matter they are supposed to illuminate, though doubtless the intention was right, and if it had been accurately carried out would have been appropriate enough. Sometimes the arms that are ascribed to the family of Fitzjames appear on the shield on which the artist thought he was depicting the Royal Arms of England.

From the Royal Arms of Scotland the distinctive tressure flory counterflory which encloses the lion is left out, and this occurs on the walls of a public library which happens to be the gift of a Scottish philanthropist.

Errors are also due to faulty intention, for if we have to deal with a subject which applies to the whole country it is manifestly wrong to use the lions of England only, to the exclusion of the armorials of the rest of the United Kingdom, and yet this is constantly done.

Careful observance of customary rules by no means precludes variety of treatment, however, but, on the contrary, affords ample scope for excellence of design in stating the heraldic facts with perfect accuracy. As already said, it is this symbolic statement that gives heraldry its peculiar value in decoration, for a similar effect of mass and line could doubtless be got in another way, but not the same quality of personal allusion.

It will therefore be necessary to ascertain how to distinguish in some way between the unessential, and therefore available, variation which is so valuable to design, and such departure from accurate rendering of the subject as constitutes heraldic mis-statement that may stultify the whole work. In this important respect guidance may be found, as already intimated, in the system of description called Blazon, in which should be expressed all that is essential, and from which everything that is not essential should be omitted.

CHAPTER III

Heraldic Rules

WITH the regular establishment of heraldry the need
for a technical method of describing the various bearings
at once made itself felt, and the system of Blazon was
the result. Like the heraldry which it described it was
admirably adapted to its purpose, being simple, per-
fectly explicit of the character, pose, and position of
its subject, without excessive minuteness in detail. In
time, however, it not only became more complicated,
as was natural, but it at last became a vehicle for the
pedantry which, succeeding the artistic feeling of the
Middle Ages, expended itself in the making of unnecessary
rules. By the time the seventeenth century was reached
it seemed to be thought to show the height of heraldic
knowledge to insist on every insignificant detail, and so
prevent the artist from deviating into anything more
excellent than was customary at the moment. Indeed
this pedantic affection for exactness in trifles sometimes
makes one wonder that in blazoning a maiden's face it
was not thought necessary to mention that it included
a nose between two eyes in chief and a mouth in base ppr.
As a guide to the degree beyond which freedom of treat-

ment may not go without destroying the heraldic validity
of the subject, blazoning should be assiduously practised,
however irksome and pedantic it may appear, until
a technical note of any armorials can be written with
precision and such a description be translated into a
sketch with equal certainty. After studying the system
as explained herein, I would recommend as practice the
endeavouring to properly describe the armorials in an
illustrated work, a Peerage for instance, with subsequent
reference to the authentic blazon for confirmation or
correction. Conversely a sketch should be made from
a blazon, and then compared in a similar way with the
illustration. For this purpose Foster's *Peerage and
Baronetage*, 1881–3, with its beautiful woodcuts after
drawings by Dom Anselm and Forbes Nixon, will be
of admirable service, and at the same time will familiarize
the student with excellent heraldic design. The achieve-
ments in that work are represented with great strength
and directness, and have much affinity with the spirit of
the mediaeval work, and are therefore worthy of careful
study. At the same time any tendency to make a style
(which may easily become an eccentricity) into an aim
rather than an incident should be carefully avoided.

Blazon is not intended to enable two persons to depict
a coat exactly alike in petty detail, but rather that each
in rendering the subject in his own fashion may be correct
in essentials, so that there can be no question of what coat
is intended. Similarly, when a Patent of Arms refers to
those " in the margin " thereof " more plainly depicted "
(i.e. more legibly than in the technically worded blazon),
it is not meant that the treatment (it may be bad) or the

exact quality of tincture (it may be discoloured) is to be copied, and this is by no means an unnecessary warning, as experience has shown.

In naming the parts *of the field* or general surface, it must be remembered that the shield of arms is regarded as being held in position in front of its bearer: the side towards the right shoulder being called *the dexter*, and that towards the left *the sinister*. Of these the former is " more worthy " than the latter; that is to say, a charge that is not centrally placed would be to the dexter rather than to the sinister side of the shield; this, it may be remembered, being the reverse of the manner of wearing medals and orders on the breast. The upper part of the shield is *the chief* and the lower part *the base*, the former naturally taking precedence over the latter. This is important in relation to the blazon of parti-coloured fields.

In order to facilitate the accurate placing of objects in their intended positions on the field its various parts were thus named (Fig. 34) :—

A. Dexter ⎫
B. Middle ⎬ Chief.
C. Sinister ⎭
D. The honour point, probably so named from its relative position to that of the heart in the human body.
E. The fess point, named after the ordinary which passes through it horizontally, as hereafter described.

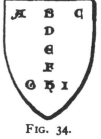

FIG. 34.

F. The nombril or navel point, another fanciful allusion to the human body.
G. Dexter ⎫
H. Middle ⎬ Base.
I. Sinister ⎭

Most of these terms have now become obsolete, but it is still necessary to know them with regard to their application in old blazon.

In modern blazon when it is necessary to specify the part of the field that is occupied, the terms *in chief*, or *in base, in dexter chief, in sinister chief, in dexter base*, or *in sinister base*, or, if in the sides of the shield, the dexter or sinister side simply, as the case may be. It will be rarely necessary, however, to use any other than the first two of these phrases, for the position of charges is in most instances understood from other circumstances.

Every blazon begins by describing the field, its divisions (if any) and colour. The partition lines by which it may be divided are named like the ordinaries, and may therefore be most usefully considered in connexion with them (*see* p. 47).

Heraldic tinctures, as they are all called, consist of metals, colours and furs. The metals and their technical names are : Or=gold, and Argent=silver. In painting, yellow is equivalent to gold and may be substituted for it ; as white may be, and generally is, substituted for silver. It may be noted, however, that when an animal is naturally yellow, and is blazoned *proper* (ppr.) it must be painted yellow and not gold.

The colours are : Gules, signifying red ; Azure for blue ; Vert for green; Purpure, purple ; and Sable, black. Though the terms are more immediately derived from Norman-French, the early language of chivalry, some of them at least are believed to have been derived from Eastern, probably Persian, sources. In practice they are considered to be completely anglicized and are pro-

nounced accordingly. This also applies to most heraldic
terms, but not to all, the practice in this respect being
somewhat arbitrary.

Tinctures are sometimes indicated by means of lines
and other marks, a system which arose in the beginning
of the seventeenth century, and was derived from the
line tints which had long been used in engraving to
distinguish contiguous spaces from each other, and
used in this way they were valuable and unobjection-
able because they were under control. When, however,
a colour meaning was given to the lines the designer
was no longer able to restrict their employment to where
they were artistically useful, but must use them through-
out or not at all. And the latter is, on the whole, the
more satisfactory way. On flat spaces, if the lines are
sufficiently pronounced to be legible, they may lead the
eye in a direction that is not helpful to the composition,
and on modelled charges or crests they have a flattening
and confusing effect that is very disagreeable. In some
instances the tincture lines have been used only in small
patches, such as in shadows, and this is least objection-
able, but is only possible in very simple cases. The signs
of the tinctures are as follows :—

Argent is shown by a plain surface.

Or is signified by spots and sometimes by slight
pecks which produce the appearance of a grain.

Gules by perpendicular lines.

Azure by horizontal lines.

Vert by oblique lines drawn downwards from dexter
to sinister.

Purpure by oblique lines from sinister to dexter, and

Sable by horizontal and perpendicular lines hatched
across each other (Fig. 35).

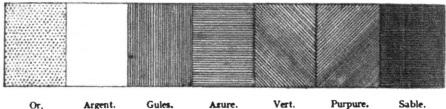

Or. Argent. Gules. Azure. Vert. Purpure. Sable.

FIG. 35.—The Tinctures.

The tinctures are usually contracted into arg., gu.,
az., vt., purp., and sa. for convenience.

It will probably be found that errors of memory are
most likely to occur from confusing the direction of the
lines which signify blue and red respectively; this may
be avoided to some extent by connecting the letters H.B.,
which distinguish what is perhaps the most used grade of
lead-pencil, with the fact to be remembered : Horizontal =
Blue. Also the fact that objects on the horizon are blue
may assist the memory.

The furs are as follows : Ermine, it is hardly necessary

to say, is white with black spots (Fig.
36). Ermines is black with white spots,
and is probably a purely heraldic inver-
sion of ermine. Erminois is ermine with
a gold ground instead of white, and Pean,
which is inverted erminois, has a black
ground spotted with gold. The actual
ermine being composed of many small

FIG. 36.

skins sewn together, the black-tipped tails formed a regular
powdering of spots. These, however, have from the earliest

heraldic times been represented by conventional forms of immense variety, which usually consist of a divided central portion with the addition of three spots above, the latter being sometimes embellished with diverging lines. The conventional version of ermine was even used in costume, being painted on the material which was used by those to whom the wearing of real ermine was forbidden by sumptuary law. It will be observed that the body of the spot has become turned upside down in its transition from the form of the natural tail.

 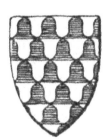

FIG. 37. FIG. 38. FIG. 39.

By a similar combination of small skins, in this case grey and white, *Vair* was formed (Fig. 37), and this fur also acquired a generally conventionalized shape, which became, in its late variety, somewhat like a series of the hideous eared shields of the eighteenth century. Vair is understood to be argent and azure in alternate spaces, the blue representing the grey part of the natural fur, and it is only when other tinctures are employed that they need to be mentioned in the blazon. In the latter case the term changes to vairy, or vairé, of such and such tinctures. One of the older forms of vair was made with undulating lines alternating with straight ones

(Fig. 38), and is obviously better than the modern form. Another early variety carried the curved lines up to the straight ones, and was drawn somewhat as though the angles of the modern vair were rounded into curves, the result being a pleasant form that is shown in Fig. 39. Vair may be of three tinctures or even more, and instances are mentioned, by Gerard Leigh for example, but such cases are very rare.

Potent is a fur similarly built up whose skins are in the shape of crutch-heads, and it is subject to the same colour conditions as vair (Fig. 40).

Counter-vair and Counter-potent have pieces of the

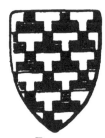

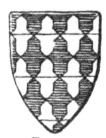

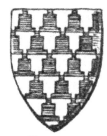

FIG. 40. FIG. 41. FIG. 42.

same colour opposed to each other, as in the example of counter-vair (Fig. 41), and it will be noticed that these variations of the simpler furs are inferior to them in that they lose the completeness of the counter-change. In both vair and potent the colour pieces are more frequently than not placed point upwards in relation to the metal ones, but there is no definite rule about this. An ancient form of vair which somewhat resembles potent is Fig. 42.

Having described the tinctures it will now be convenient to return to divisions of the field, the simplest possible

variation from a plain shield. A surface is *party per pale* (Fig. 43) when it is divided by a perpendicular line into two halves, *party per fess* (Fig. 44) when the line which equally divides the shield is a horizontal one, *party per bend* (Fig. 45) when it goes diagonally downwards from

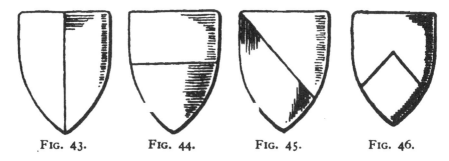

FIG. 43. FIG. 44. FIG. 45. FIG. 46.

dexter to sinister, and *party per bend-sinister* when the diagonal is reversed. The word *party*, however, has now fallen into disuse, and the terms *per fess, per pale* and so forth are considered sufficient. *Per chevron, per saltire*

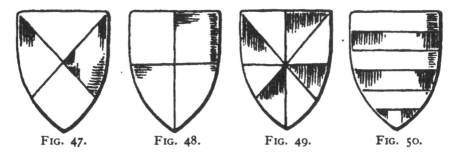

FIG. 47. FIG. 48. FIG. 49. FIG. 50.

and *quarterly* are as represented (Figs. 46, 47, 48). *Gyronny* (Fig. 49) is a combination of the two last named, and the number of its pieces being normally eight, any variation from that number must be expressly mentioned. *Barry* (Fig. 50) is composed of repeated horizontal lines, which

are odd in number, so that the spaces begin and end with different tinctures. *Paly* (Fig. 51) and *Bendy* (Fig. 52) are similarly composed of perpendicular and oblique lines respectively. *Chequey* (Fig. 53) is, of course, made into . squares by perpendicular and horizontal lines, and *Lozengy* (Fig. 54) similarly results from crossing oblique ones.

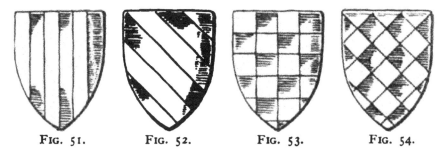

FIG. 51. FIG. 52. FIG. 53. FIG. 54.

Varieties of the latter form arise from a combination of perpendicular with oblique lines, called *paly bendy*, and of horizontal with oblique, which is called *barry bendy*. Both are of rare occurrence and perhaps resulted from bad drawing of lozengy.

The field being the first part of a coat of arms to be described, the character of its division, if any, precedes the mention of its colour. For example : per pale Or and Gules. Here it may be noted that a field may be party of two metals or of two colours, for the general rule against colour being placed upon colour or metal on metal does not apply in these cases, the spaces being but divisions of one plane and not parts that are superposed one on the other. Nor does it apply to objects that are charged on a *party* field, for in that case it is inevitable that the tincture of the charge must interfere with one or other of the tinctures of the field,

Nevertheless, when confusion would be very pronounced counter-change is resorted to, as for example (Fig. 55) : per pale arg. and az. three roses counter-changed.

In blazoning party fields the tinctures count from the dexter side when the divisions are perpendicular, and from the chief when they are horizontal. In cases of diagonal division it must be remembered that the chief has precedence over the dexter side, and therefore in a field "per bend or and gules," for instance, the space above the diagonal counts first and is therefore or. If this point is kept in mind, the difficulties that are frequently experienced in such blazon

FIG. 55.

disappear. Thus in *per saltire* the divisions count from the uppermost space, and in *gyronny*, this space being again divided by the perpendicular line, the alternation begins with that part of the chief which is nearest the dexter, or in other words, the first quarter of the shield is per bend. In bendy the space next above the middle diagonal may be taken for the first tincture as the key to the alternation.

Barry, Paly and Bendy are each understood to be composed of six pieces unless it is otherwise mentioned.

When chequey is applied to ordinaries, at least three rows or *tracks* are considered essential ; so that when there is but one row it is called Gobony or Compony, and is Counter-compony when there are two. The two latter varieties occur most frequently in bordures.

The objects that are borne on the shield are divided into

E

two main groups that are respectively called Ordinaries and Charges.

Ordinaries comprise those simple flat figures which are in most cases formed by divisions of the shield and generally extend to its edges. They are the Fess, the Bend, the Chief, the Pale, the Chevron, the Cross and the Saltire. Some of these have diminutives, similar figures drawn distinctly smaller and having separate names, and these will be found under their principals. Other forms, sometimes called sub-ordinaries are the Pile, Quarter, Canton, Gyron, Bordure, Orle, Tressure and Flanches.

Other objects, animals, flowers, trees, anything depictable, animate or inanimate, may be borne as Charges on the field, on ordinaries, or on each other.

The Fess (Fig. 56) is drawn horizontally across the shield and occupies the middle of it from side to side, and the blazon might be, for example, Or, a fess gules, i.e. a red fess on a golden shield. Where more than one occurs in the same coat they are necessarily smaller and are called Bars, e.g. Argent three bars sable.

When bars are distinctly arranged in pairs each pair is called a Bar-gemelle, thus Az. three bars-gemelles Or, means three pairs of bars.

The proportion of the ordinaries to their fields varies very considerably, and this for many reasons. When the ordinary is alone, when it is between charges or where it is itself charged, the proportion will change with the conditions. The character of such charges and therefore their weight in the composition must also be taken into account, for the adequate display of all the constituents of the coat is the object in view.

As an approximate proportion the width of an ordinary
may be taken as somewhat less than one-third of the
field when neither, or both, are charged; as a full third
when itself charged and on a plain field; and as rather
more than one-fifth when the field only is charged.

By similar niceties of design the sense of lightness
or weight may be conveyed, so that for decorative pur-
poses the shield may be brought into due relation with the
character of surrounding ornament. Colour also will
affect the apparent proportion, a dark object on a light
ground appearing smaller than it really is, and vice versa,

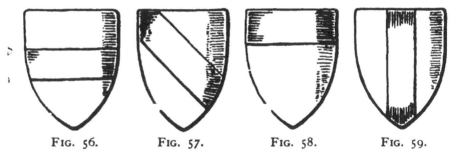

FIG. 56. FIG. 57. FIG. 58. FIG. 59.

and this requires careful attention in the counter-change
which occur in heraldry as in other forms of design.

The Bend is drawn from the dexter chief to the sinister
base (Fig. 57), and is sometimes accompanied by a smaller
bend on either side, when it is said to be *cotised* and must
so be distinctly described, as arg. a bend cotised sa.; if,
however, the cotises were of another tincture to the bend
the blazon would be, for instance, arg. a bend sa. cotised
gu., that is, a black bend between two smaller red ones on a
white shield. The word cotise is also used for other diminu-
tives that accompany their ordinaries on either side, and
there are instances of shields being said to be cotised by

their supporters. Where two or more bends of equal
width occur they are called bendlets, and when they are
raised above their normal position as in the Arms of
Byron and of Birmingham they are said to be *enhanced*.

The Bend-sinister is a bend reversed; that is to say,
descending from the sinister chief to the opposite base ;
indeed, it sometimes occurs in wood-carving merely by
reason of the carver having inadvertently turned his
tracing over. The bend-sinister is sometimes used as a
mark of illegitimacy. One of its diminutives, the Baton
(a small bend-sinister, whose ends stop considerably short
of the edges of the shield), is especially used with this
intention. A bend-sinister is not necessarily a mark of
illegitimacy. The old heralds indeed do not seem to
have marked a coat in this way in order to hold up its
bearer to obloquy, but simply employed the ordinary as
a difference.

A diminutive of the bend called a Ribbon occurs in the
Arms of Abernethy—Or a lion rampant gules, debruised,
i.e. passed over by a ribbon sable.

The Chief occupies the top of the shield from side to
side and has no diminutive (Fig. 58).

The Pale is drawn perpendicularly down the centre of
the coat (Fig. 59), and when one of a number is called a
Pallet, which again is sometimes called an Endorse when
it accompanies ·the pale as the cotise does the bend.

The Chevron (Fig. 60), usually drawn as a right angle,
may be varied to a very large extent as conditions of
space require ; it becomes unpleasant, however, when
more obtuse than a right angle. In later French and
Italian heraldry it is frequently drawn remarkably acute,

its point often extending to the top of the shield, and this form is usually found associated with very small and weakly drawn charges. When more chevrons than one are used together they are called Chevronels.

FIG. 60.

FIG. 61.

FIG. 62.

The Cross (Fig. 61) and its diagonal variety the Saltire (Fig. 62) are sometimes *voided*, as in Fig. 63, so that the field shows through, and may also be interlaced, as arg. a cross voided and interlaced sa (Fig. 64). *Parted and*

FIG. 63.

FIG. 64.

fretty is an equivalent term. Its proportion, even in shields of which it was the only bearing, was much narrower in mediaeval times than later.

The great variety of its form as a charge is referred to under that head, and some of its less usual forms as an ordinary are : Fig. 65, a cross quarter pierced ; Fig. 66, a

cross quadrate ; Fig. 67, a cross nowy ; and Fig. 68, a cross couped.

The Pile is represented in Fig. 69. When more than one occur they point towards the base, unless their posi-

FIG. 65. FIG. 66. FIG. 67. FIG. 68.

tion is otherwise specified, and their points may either be in a line perpendicular to their widest part or they may converge towards the centre; in the latter position they are blazoned " piles in point." Sometimes three piles are alternated so that there are " two in chief and one in base," the latter, of course, being point upwards between the other two.

FIG. 69.

With the important exception of the chief all the foregoing ordinaries, as bearings occupying the principal parts of the shield, are mentioned in blazon immediately after the field and before the charges, if any, as : Argent a bend between two fleurs-de-lis Gules, for example. The chief, on the other hand, is not blazoned until after the rest of the shield has been fully described.

Ordinaries may themselves be charged, and in that case the sequence in the blazon is : (1) the field ; (2) the objects

immediately on it ; and lastly, the charges with which the latter are charged. For example : Az. *on a* chevron between three roses Or, as many fleurs-de-lis of the field. It will be noticed that the fact that the ordinary is charged is mentioned early in the blazon, though the description of the charges is left till later in accordance with the sequence already stated. Also that the chevron and roses being of the same tinctures the word *Or* only follows the last of the objects to which it refers. Another point that is here exemplified is the avoidance of tautology by the use of the words " as many " instead of the repetition of the number three, and again in describing the fleurs-de-lis by tincturing them " of the field " instead of repeating az. This extreme objection to tautology is very characteristic of heraldic language, and where it is impossible to otherwise avoid repeating a tincture the ordinary word will be used in place of the technical one, as Gold in place of Or.

Having proceeded so far with the subject of blazon, two very convenient methods of noting heraldic facts may now be described. That which is called a " trick " is a slight sketch, in which simplification is carried to the ultimate extent by indicating with numbers the charges which are repeated. As an instance, the coat blazoned above would appear in trick thus (Fig. 70). In the other method, which is a sort of heraldic shorthand, the blazon would be written : Az. on a ∧ bet 3 ⧄ Or 3 ⚜ Az., the niceties of ordinary blazon in avoiding repetition being ignored.

FIG. 70.

VARIOUS LINES.—The lines with which simple objects
are drawn and fields divided are, normally, plain ones ;
but various others are also employed, and constitute impor-
tant differences between one coat and another. Those
in ordinary use are as follows (Fig. 71) :—

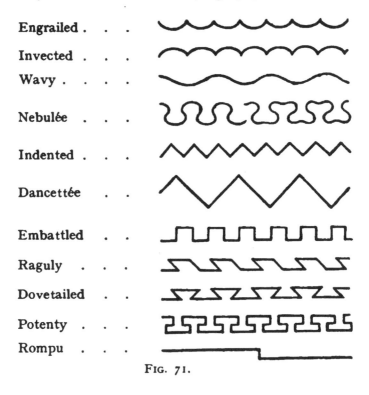

Engrailed . . .

Invected . . .

Wavy

Nebulée . . .

Indented . . .

Dancettée . .

Embattled . .

Raguly . . .

Dovetailed . .

Potenty . . .

Rompu . . .

FIG. 71.

Engrailed may be drawn with cusps of any suitable size
or quality of curvature. Its points must turn outwards
from an ordinary, and when used as a party line they point
to the dexter in per pale and upwards in per fess and per
chevron.

All lines other than plain ones must be mentioned in the
blazon in immediate connexion with the objects to which

they refer and before the tincture, as, Gules a bordure engrailed Or. As the only party line that appears to face in one direction, engrailed follows the general heraldic feeling in turning its point to the dexter or to the chief unless there is special reason to the contrary.

Invected is engrailed reversed, so that the points turn inward. Its use is comparatively rare and the effect is not very pleasing.

In wavy any form of regular undulation may be employed so long as there is no possibility of confusion with nebulée.

Nebulée is usually drawn in some modification of the two forms given above, but there is an old and interesting treatment in which a nearer, though still conventional, suggestion of clouds covers the ordinary, as in Fig. 72. This is a bordure nebuly equally with that drawn in the ordinary way.

FIG. 72.

Indented is composed of small serrations, while Dancettée usually consists of not more than three chevrons which, in the case of a fess, for instance, may be complete, or the series may begin and end with a half chevron as in the example. In early instances the angles are very acute, and in the case of party lines extend well across the field. In such a case the line should begin on one side of the shield and finish on the other in order to equalize the direction of the points.

Embattled, when applied to fesses and chevrons, is confined to the upper line unless the ordinary is blazoned " embattled counter embattled," in which case both lines

are similarly treated. When applied to a chevron the sides of the crenellations are usually kept vertical, as though in the wall of a sloping way, rather than at right angles to the ordinary, though the latter form also occurs.

Raguly, especially when applied to a fess or a pale, is suggestive of stumps of branches that have been lopped from the parent stem, and this probably indicates its origin. Thus the projections on both sides of the ordinary slope the same way, and, in many examples, they alternate. In the case of a cross they point along the limbs outwards from the centre.

Many of the heraldic lines are of very ancient usage, and the popular idea that they are signs of modernity is quite an erroneous one, some of them occurring as early as the reign of Edward I.

A line is Rompu when it is interrupted as in Fig. 62, and an instance of this occurs in the Arms of Allen, which is per bend rompu.

SUB-ORDINARIES.—The Canton, Gyron, Inescutcheon, Orle, Tressure, Bordure and Flanches are classed as Subordinaries. The fusil or lozenge (q.v.) and some others are also sometimes included in this division, but classification of this kind is of little practical importance.

The Canton (Fig. 73) is frequently a means of displaying an augumentation, a special distinction added to a previously existing coat, as in the arms of the family of Lane and others. It is drawn of any convenient size short of being possibly confused with the Quarter, the latter occupying the proportion of the shield that its name implies. The fact that even in modern coats the canton partially covers, if necessary, a charge near

the same part of the shield suggests that it was in its
origin an added mark of honour; and also because like
the chief, it is mentioned in the blazon only after the
main part of the shield has been described.

The Orle (Fig. 69) becomes a Tressure (Fig. 70) by the
addition of fleurs-de-lis, and when doubled and decorated
with alternating fleurs-de-lis on both sides the beautiful
"double tressure flory counterflory" of the Royal
arms of Scotland is formed.

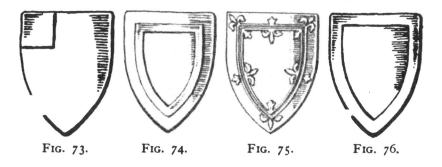

FIG. 73. FIG. 74. FIG. 75. FIG. 76.

Other ordinaries may also be made flory in a similar
way, and a partition line may be flory counterflory, so
that each division of the field interpenetrates the other
in a very beautiful counter-change.

The Bordure (Fig. 71) was extensively used in the
Middle Ages as an addition to the arms of a family by
which to distinguish its individual members from each
other, as it still is in Scotland, and in its application to
historic personages is a subject of great interest; for
example, the shield of John of Eltham bore the arms
of his father, Edward II, the lions of England, differenced
with a bordure charged with fleurs-de-lis, in allusion
to his mother, Isabella of France. The shield (Fig. 77)

appears on the tomb of his nephew, Prince Edmund, at Kings Langley, but a much finer example is that from

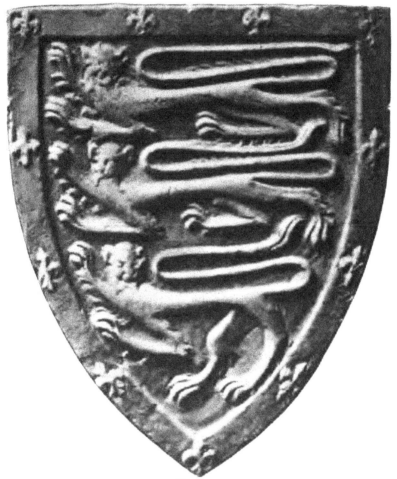

FIG. 77.
Arms of Prince John of Eltham. From the Monument to Prince Edmund of Langley at Kings Langley.

Prince John's own monument in Westminster Abbey, at p. 77. This part of the subject will well repay pursuit, though space forbids its further consideration here.

It should be noted that when a chief or a canton occurs in the same arms with a bordure it surmounts the latter, or rather the bordure stops when it touches the other, for both are usually represented as in the same plane. Also, when a coat with a bordure is impaled with another, as in the arms of husband and wife, the bordure stops at the junction with the other coat. Nevertheless, the charges on the bordure, if any, and of specified number, remain, with the rest of the arms, unaffected by its diminution.

The fact that the chief surmounts a bordure lends probability to the assertion that chiefs like cantons were at first honorific additions to pre-existing arms.

Flanches are represented in Fig. 78, and their diminutives, Flasques and Voiders, are sometimes met with in old works.

FIG. 78.

A shield of arms is said to be *charged* with the figures upon it, but the term charge is usually understood to mean some object other than the ordinaries just described.

Before proceeding further, however, it will be well to consider the various ways in which charges may be arranged with regard to the shield, to the ordinary and to each other.

A single charge whose position is not otherwise fixed by the blazon naturally occupies the whole shield, but when charges are repeated the arrangement is, of course, more complex.

The most usual number of repeated charges in a coat of arms is three, two in chief and one in base, an arrange-

ment obviously suggested by the space available on a
pointed shield, and in blazoning they are said to be *two
and one*. As a rule, however, this distribution is assumed
to exist unless another is specified. When the charges
are more than three their disposition must always be
mentioned, as : Gules six horse-shoes, three two a one,
Arg. and so on for ten or more, counting always from
the chief or top of the shield.

An indefinite number of charges equally distributed
over a surface, whether of field, ordinary or charge, is
said to be semée, as in the Arms of France that were
assumed by Edward III and his successors, az. semée-
de-lis or. As in this instance, a field semée of anything
was depicted as though cut from a large surface similarly
decorated, so that here and there at the edges a part
only of the figures remained. This early method has
been relinquished in favour of what was anciently
called Geratting, by so arranging the powdering of charges
that they do not touch the sides of the shield or any
other object with which they are associated. Consider-
able management is required to so arrange them that

FIG. 79.

they shall be equally distributed, and care
must be taken that they do not appear to
be *in orle*, as is explained below.

Somewhat similar to semée is what is
known as guttee or goutee (Fig. 79), a
means of covering a field or other object
by means of a kind of semée of drops,
which have different names according to
their tinctures. Thus when they are gold they are gouttés
d'or ; when argent, gouttés d'eau ; when gules, gouttés

de sang; azure, gouttés de larmes; sable they are gouttés de poix; and gouttés d'olive are vert.

It is quite permissible to blazon them by their tincture; thus " arg. gouttée de sang," would be equally correctly written, arg. guttée gules.

The direction of the ordinaries affords another excellent means of placing charges; thus, objects in a horizontal line across the middle of the shield are *in fess*, when at the top they are *in chief*, and so forth.

Similarly, charges one above the other are blazoned *in pale*. Here it should be noted that in pale and in fess do not mean occupying the *space* of a pale or of a fess, but merely that they are disposed in the indicated direction. Thus the lions of England are *in pale*, but should, of course, be drawn right across their field, and in a similar manner charges in fess extend from chief to base when their character admits of the extension.

In some instances a number of charges are placed on the field between others, as : three roses in bend between two roundles; but the result can rarely be made satisfactory as design, such a coat seeming to need the steadying effect of the lines of an ordinary.

Charges that are ranged round the field, as in the enamelled shield of William de Valence at Westminster, p. 176, are *in orle*; if the number of martlets were specified, the blazon would be so many martlets in orle; but if the number were indefinite, the term would be an orle of martlets.

When a fess or a chevron is between three charges the latter naturally fall into the position of two in chief and one in base, and that is the most usual number and

arrangement. Instances of greater numbers so disposed are rare among ancient examples, for in designing them

FIG. 80.—Arms of the Grocers'Company of London. Cartoon for mural decoration. Geo. W. Eve.

the pointed shield seems to have been kept always in view with the notable exception of Berkeley, Gu. a chevron ermine between ten crosses pattée Ar; but these

adapt themselves perfectly to the shield and chevron, being balanced by the large number above, as also do the cloves of the Grocers Company that are similarly arranged. Fig. 80 shows a rendering of the last-mentioned arms as designed to accompany work of the eighteenth century.

CHAPTER IV

Animals and Monsters

AMONG the forms that are characteristically heraldic the Lion, the symbol of courage, power and magnanimity, is most prominent and typical.

It has already been mentioned that the earliest heraldic lion, followed the Eastern examples with considerable fidelity, as may be seen by comparing the lions of the early MSS., such as Fig. 81, with those of the textiles which were the product of Oriental looms, and of such as were set up in Sicily with Oriental workmen in the twelfth century. These early examples were drawn broadly and simply as was fitting to the material in which they were expressed, and their shape and proportion approached that of nature. The lion of the early seals, such as Figs. 82 and 83, present the same characteristics. The former seal is that of Alexander First in the twelfth century, and the latter that of Henry, son of Swanus de Denehy, in the thirteenth. The attenuation which became so characteristic a feature of the animals in later

FIG. 81.
Thirteenth Century.

work arose from the necessity of clear definition of the object which was to serve as a distinctive badge that would be visible at a distance and when in motion, as has been already pointed out. The device was intended to be

FIG. 82. FIG. 83.
Device Seals. Thirteenth Century.

easily read under the various conditions óf use, and in complying with those conditions the early draughtsman well proved that splendid sense of design which distinguished him. To this end the object was drawn as large as the containing space would fairly permit, and its form was attenuated so as to allow the ground to show through in due proportion to complete the necessary clearness of definition. A figure thus treated became a symbol, rather than a representation of the intended creature, but was, nevertheless, in the best instances, full of character, vigour and vitality; that is to say, the qualities that were attributed to the animal, not its mere form, were the object of expression. The placing of the beasts in the shield and their proportion to it is always satisfactory at this time, and suggests that too much

care cannot be taken in trying to attain a similar excellence in present work, but by expressing qualities rather than by copying forms. Of the examples of lions

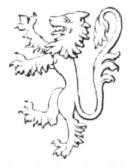

FIG. 84.—End of Twelfth Century.

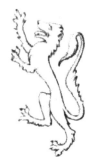

FIG. 85.—Late Fourteenth Century.

of various periods, Fig. 84 is taken from the seal of Henry de Percy, 1300. Figs. 85 and 86, a lion rampant and passant guardant respectively, are from the enamelled arms on the tomb of Edward III in Westminster Abbey. Fig. 87 is from a fifteenth-century shield of stained glass that is now in the Victoria and Albert Museum.

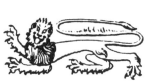

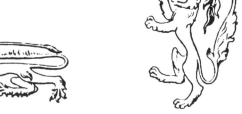

FIG. 86.—Later Fourteenth Century. FIG. 87.—Fifteenth Century.

The exact proportion which charges should bear to the field cannot, of course, be stated with accuracy, there being no ready means of measurement, even if such

were desirable, and it must necessarily remain a matter for artistic perception to find the just mean between crowding a space and failing to fill it. It is evident also that the proportion would be modified by circumstances, such as the character of the charge (whether condensed or dispersed), and also to·some extent by colour, with regard to the respective effects of light on dark or dark on light as affecting apparent size. It may, however, be suggested that the charges should be insisted upon to the fullest extent that is compatible with the general style of the design, the field remaining of such weight that the Scottish quarter of the Royal Banner, for example, if seen as a mass at a distance, will tell as gold rather than red. And after all is said, the actual balance must be left to the decision of the trained eye.

When strong outline filled in with colour is the method of working, due allowance must be made for the tendency of the line to become merged in the darker of the two tinctures; and the object will therefore need to be drawn slightly larger or smaller accordingly.

FIG. 88.

There are also illusions of an optical nature that are produced by certain combinations of lines. If, for instance, three pallets are charged upon a chevron, it will be found that the middle one must be appreciably wider than those beside it if the three are to appear equal. Fig. 88 shows this, though the fact is more clearly appreciable in a drawing on a larger scale.

The Pose of the Animals must be carefully observed

as being of the utmost heraldic importance, and must in the main be adhered to with complete fidelity. To neglect in this respect is due much of the bad heraldry which too often vitiates otherwise good work.

In the early days of the science, when the bearings were few, the nature of the creature was, no doubt, sufficient for the intended purpose, for there would be no other near with which to confuse it, and the pose was probably dictated by the form of the space that the animal was required to fill, but when it became necessary to distinguish between different bearers of the same animal, pose assumed a special significance and therefore became one of the principal means of heraldic distinction.

Of the two principal poses, rampant and passant, the former is more suitable to upright spaces and the latter to horizontal ones. When however a passant lion has to fill an upright space, such as a canton or a quarter of a shield, or a rampant lion to fill a horizontally flattened one such as the second quarter of the Royal Standard when it is constructed in accordance with Admiralty measurements difficulties occur. One such problem occurs in the arms of Cambridge University, Gules a cross Ermine between four lions of England, a Bible fesswise of the field clasped and garnished Or (Fig. 89).

It was the rampant position that was considered the typical leonine one, however, and therefore it was that the lions of England were called leopards in early times : not that they differed in their relation to the natural form, but simply that they were not in the understood leonine posture. It will be seen from

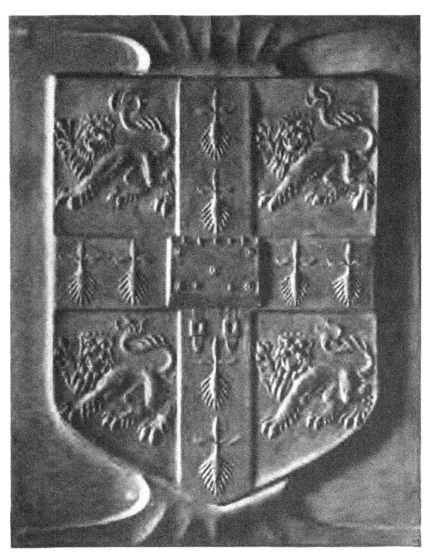

FIG. 89.—Arms of the University of Cambridge.
Panel in copper silvered and oxidized. G. W. Eve.

the example (Fig. 90) that rampant signifies an upright pose with all the legs separated in a suggestion of vigorous rage. This arrangement of the limbs is heraldically

FIG. 90.—Rampant.

FIG. 91.—Salient.

essential, for when the hind legs are placed together the position is called *salient* or leaping (Fig. 91). With regard to the heads of animals, it must be understood that in heraldry the normal position is in profile, and then it requires no special mention in the blazon. If,

FIG. 92.—Rampant
Guardant.

FIG. 93.—Rampant
Regardant.

however, the blazon is, for example, a lion rampant guardant, the head is turned until it looks straight out of the shield at the spectator (Fig. 92). *Regardant* is

when the head is turned still farther so that it looks backward over the shoulder (Fig. 93). In some early works the term regardant is used in the same sense as guardant, full faced, buf the position first described is what is now understood by the term.

The tail of the rampant lion, which in early examples was elaborated into a highly ornamental appendage, is usually held in an erect position, but there is no heraldic reason why it should not occupy any other position which the shape of the field might render desirable.

It seems to have been always believed that the rage of a lion was indicated by the agitation of the tail, and Leigh, writing in the sixteenth century, says : " When the lion is angry, first he beateth the earth and then his own backe with his taile." ' On the other hand, it is now asserted by wild beast tamers that a lion is most dangerous when his tail assumes the rigidity of an iron bar and possibly the first draughtsman to depict the Howard or the Percy lion, in his well-known and now stereotyped attitude with the tail extended horizontally, was aware of this.

It is sometimes said that the tail passing between the legs constitutes a definite heraldic variation, but this is extremely unlikely. The term ascribed to it of " coward " is much too dangerous to have been inten-. tionally borne on a shield which symbolically stood for its owner, except with some other symbol in a position of superiority, such as the eagle over the dragon in the Guelph arms. Most probably it was one of the trivial inventions by which the later heraldic writers sought to fix and give meaning to an accidental and unessential

detail. There are numerous instances of this free treatment of the tail when there could be no possible heraldic intention, and in every case it is apparent that some difficulty in arrangement was overcome, as in both the Great Seals for Scotland of Charles I the lion supporter has the tail between the legs, and it is not possible to consider this a Scottish joke, though the animal looks singularly mild and cheerful. However this may be, the tail may certainly go anywhere outside the legs. A lion's tail may be double or forked, and in that case the blazon says *double queued or queue forchée*. Both terms mean the same thing, for the double tail issues from but one root. In rare instances it is twisted into a knot, and is then said to be nowed.

Although the lion has been conventionalized, more or less, into a pattern, and his positions are always the subject of careful regulation, he is still susceptible of considerable variation of pose, within heraldic limits, based on the facts of anatomical structure ; so that while the possibilities of animal movement are observed, it may be designed to cover its field pattern-wise whatever the shape of the shield may be, and at the same time retain great vitality and power. The effort to express vigorous action without suggesting progression out of the space is not easy perhaps, but the contrary effect is very ludicrous, as is often apparent in modern mural decorations that are based on heraldic motives, rampant lions seeming to be walking placidly up a wall in a procession of their fellows.

The *lion passant* is depicted with all the limbs separated and the right forepaw raised (Fig. 94), and when its head

is full faced, affrontée, it is passant guardant, the position of the lions in the Royal arms of England, viz. Gules three lions passant guardant in pale Or. The most frequent error in rendering this coat is the turning the heads in profile, and it cannot therefore be too often insisted upon that lions so treated are not " lions of England " at all.

The shield at Canterbury that is ascribed to Edward the Black Prince has been already described as a most satisfactory example, which is in brilliant contrast to the modern instances wherein the lions occupy

FIG. 94.—Passant.

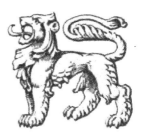

FIG. 95.—Statant.

a central column in a broad field with a wide blank space at either side of them. This perhaps arose from a mis-reading of the words " in pale " of the blazon, which were perhaps taken to mean " in place of a pale," whereas they mean " in the direction of a pale," i.e. one over the other but without lateral limits other than those of the field. Passant regardant has the head looking backwards as in rampant regardant. The lion statant (Fig. 95) stands on all four feet, and may be statant guardant or statant regardant, according to the position of the head as before mentioned.

Sejant is in the position of Fig. 96 and couchant that of Fig. 97.

The expression of vigour is the most important individual quality to strive after in the treatment of heraldic animals,

FIG. 96.—Sejant.　　　FIG. 97.—Couchant.

the line of the back and loins may be made to express lithe strength, and power be suggested by the massive shoulder, with the powerful fore-leg tapering to the wide-stretched and vigorous paw. Dignity and life should be in the pose of the leonine head and mane, and broad harmonious effect in the whole treatment. The widely spread toes were sometimes very much exaggerated, as in the Arms of John of Eltham (Fig. 98), but in character and drawing were much nearer the natural facts than the foot of a quiescent lion might lead one to imagine. This may be seen on a small scale in the domestic cat when she stretches her leg with her claws protruding.

When the lions of the later Gothic type lost the vigorous qualities of the earlier examples the toes lost their power and became like radiating leaf-forms.

The setting-on of the tail may also help the expression of vigorous life, its junction with the body being well marked instead of being allowed to flow softly out of

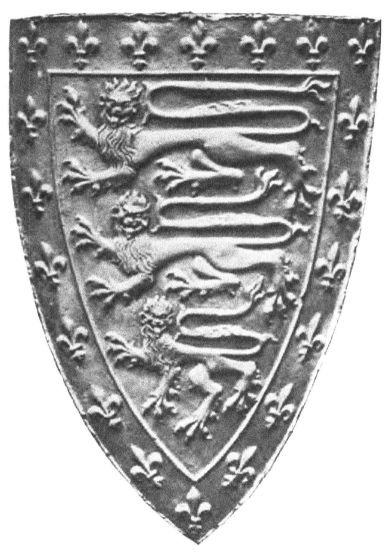

FIG. 98.—Arms of Prince John of Eltham.
Westminster Abbey.

the line of the back. This is well shown in Dürer's lion at Fig. 99, that splendid example of the best kind of Renaissance heraldry whose fine drawing, well-balanced design and beautiful technique have caused its frequent instance as a striking work of heraldic art. The illustration is reproduced from the very fine impression in the National Art Library at the Victoria and Albert Museum.

Both these examples are excellent for their good decorative distribution, the former shield being probably the best extant instance of that necessary quality.

In the lions of various periods it will be seen how the type altered from time to time, from that of the thirteenth-century MSS., which possesses a considerable amount of a natural leonine shape, through the attenuated beast of the later mediaeval period down to the Renaissance form in its two somewhat dissimilar styles : that of Germany, from which modern German heraldry is derived, which shows a strong survival of Gothic influence ; and that of Italy, from which appears to have been drawn the heraldry of the rest of Europe until the still recent Gothic revival here.

In modern German heraldry the lions have become so over-elaborated that in many instances the prevalent effect is one of fluffiness. Too much is made of the hair, especially in the legs, which are sometimes much more suggestive of the well-feathered legs of a dorking fowl than of the clean and powerful, though hairy, limb of a lion; and with the lost suggestion of vital energy goes any symbolic dignity that it expresses.

The later Italian heraldry and the style which followed it ultimately dispensed with attenuation in the animals

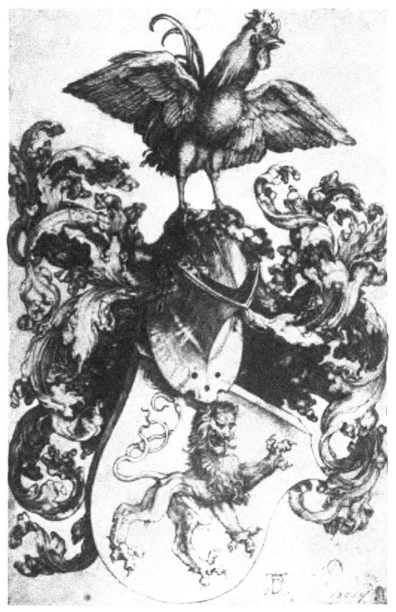

FIG. 99.—The Coat of Arms with a Cock. A. Dürer.

together with most of the other decorative qualities of the hated Gothic, and the efforts at naturalistic representation resulted in forms which at a little distance became mere undistinguishable blobs, to the complete defeat of the object of their existence. The rampant lions became tame and therefore ludicrous in the upright pose which, deprived of any suggestion of rage and strength becomes meaningless, while in what may be called the decorative treatment the suggestion of the creature and of its attributed qualities in a broad and simple way sanctions an arrangement which makes for decorative distribution as well as for symbolic expressiveness. Vigour also makes for the dignity that is an important consideration in serious design, for when once a ludicrous suggestion is attached to a thing it becomes inseparable from it. Probably the most frequent accompaniment of such want of vigour is the production of a feebly human expression which inevitably suggests the connexion with it of some trivial or ludicrous phrase. Now the grinning jaws of the early lions are never imbecile.

With regard to the strong characterization that is required valuable lessons may be learnt from the lions of the Assyrian bas-reliefs, one of which is represented here (Fig. 100). The accentuation of the principal muscular forms and masses is very striking, and presents suggestions of a method that lends itself well to the expression of heraldic character. It is not, of course, intended to import an Assyrian lion bodily into the shield, or that the Assyrian style should be visible in the resulting work, but only that the method should be studied and applied as a special means to a definite end.

The degree of detail and the amount of its elabora-
tion will depend on the size and general character of
the work. Sometimes mere outline will suffice, though
on a larger scale or in other conditions it would look

FIG. 100.—Lion from Assyrian Bas-relief.

empty. Thence to complete modelling embraces a
wide field of choice in which to find methods suitable
to all purposes. Under ordinary conditions a simple
broad treatment is much to be desired, definition being
obtained by few but accurately placed lines, such as

G

those of ribs and loins in the body, and of brow, jaw and mane in the head.

The degree of relief of charges should, of course, stop short of any suggestion of detachment from the field. This might seem too obvious for remark, but an example to the contrary, a large, and in many respects beautiful, work in coloured leather was recently to be seen in which, the arms of the Medici being the principal motive, the charges appeared to be suspended in front of the shield from which they seemed to be so distant as to cast full round shadows.

In adjusting a rampant lion or other beast to its field a skeleton sketch of the main lines of distribution may be usefully employed as a guide in first blocking out the animal, in the same way that similar diagrammatic forms are sometimes used in figure composition. On this the figure will be drawn, the head being thrown well back and the hindmost leg being brought towards the centre line so as to help the spacing in the dexter base of the shield.

Care should be taken not to make the higher of the forelegs too short, or the value is lost of the strong forward reach from the shoulder, which expresses the action while it helps the distribution.

In posing animals on a shield it must never be forgotten that not only is a pattern being arranged but that it is made with the body and limbs of a supposedly living thing.

Fig. 101 is one of the methods that suggest themselves, and passant lions may be spaced in a similar way (Fig. 102).

A lion's claws and tongue, of which he is *armed* and *langued* respectively, are gules except when he or the field is of that tincture, and in either of the latter cases he is armed and langued azure, as in the Royal coat of

FIG. 101. FIG. 102.

Scotland. This is taken as of course, and need not be mentioned in the blazon, though it very often is.

Demi-lions are usually demi-lions rampant, and in this form they were largely used as crests, which will be discussed later on. They are depicted as severed low down at the loins, and the tail is retained in most cases, though not always. When, as a charge, they are in contact with a line of an ordinary, as though arising from it, they must be described in the blazon as *issuant*.

Demi-lions passant or passant guardant are of more rare occurrence, the latter generally in conjunction with another object, as in the arms ascribed to the Cinque Ports on the seal of Sandwich (Fig. 103), where the demi-lions are joined to the hulls of ships. This evidently arose from the joining together by dimidiation or halving of two separate coats, viz. the Arms of England with one of local allusion : Az. three hulls of ships Or. By a similar method were evolved the Arms of the city of

Chester, wherein the lions of England are conjoined with the wheatsheaves of the Earldom.

Among the separate parts of animals used alone or in repetition a lion's head is a frequent charge, and it follows the general rule of being represented in profile unless otherwise described. The lion's leg, called a jamb, is also separately used as a charge, the tail being likewise thus employed. It must be remarked, that whenever a separate part of an animal is used as a charge the method of its severance must be carefully distinguished, whether *couped*, cleanly cut off, or *erased*, roughly torn away. In the latter case the erasure generally consists of three points or tufts, though not necessarily of that exact number so long as the erasure is sufficiently marked. It may, however, be noted here that a demi-lion as a crest is considered to be couped unless it is otherwise described, the junction with the helm usually disappearing within the torse that encircles it at that point.

FIG. 103.—Seal of Sandwich (Mayor's Seal).

Animals that can neither be described as actual nor purely imaginary are the so-called " heraldic " tiger and " heraldic " antelope, which have little apparent relation to their natural namesakes, but were perhaps evolved in the effort of an early artist to realize the wonderful description of some marvellous traveller. They have a family likeness, however, in their armed snouts and in their leonine tails, the latter being an

appendage with which the mediaeval artist was fond of finishing off his creatures in default of more accurate information.

The poses of the lion are followed in a general way by other animals, both natural and " heraldic " ; but in many instances the attitudes are called by different names for different creatures, a practice that was usual in mediaeval times, and also has its present examples, such as that two partridges are a brace and two hounds a couple, which need hardly be further specified. The stag, emblematic of speed and sport rather than of combative virtues, has a special set of terms, which were naturally borrowed in part from those used in hunting. Thus he is " *at gaze* " when standing with his head affrontée, but when he stands with his head in profile he is *statant* like any other beast ; *springing* when in the salient position, *trippant* when he is walking, *at speed* when running, and when couched he is *lodged*, and so he must be described in the blazon. His antlers, which are called *attires*, must, if they are of a different colour, be carefully mentioned and also his hoofs in a similar case, e.g. Azure a stag trippant Arg. attired and unguled (i.e. hoofed) Or.

A distinction is made between the stag and other horned animals in that the latter are said to be *armed* with their horns, as in the crest of the Duke of Bedford, a goat statant Arg. armed Or.

Horses and other maned animals, real and imaginary, are *crined* of their manes. Thus, the supporters of the Goldsmiths Company (Fig. 104) are unicorns or, armed, crined and hoofed arg. (in some examples purpure). This treatment of the Goldsmiths' arms was designed,

FIG. 104.—The Arms of the Goldsmiths Company of London. Cartoon for mural decoration. Geo. W. Eve.

Portion of a Pageant Car, with Heraldic Monsters. By Albert Dürer.

Griffin from the Triumphal Arch of the Emperor Maximilian I. Dürer.

like those of the Grocers Company at p. 64, to harmonize
with early eighteenth-century decorations. The unicorn
has a horse's head and body with the legs and cloven hoofs
of a stag. Its twisted horn issues from the middle of its
forehead, and its tail is that of a lion, the foregoing ex-
amples which have horses' tails being extremely rare
exceptions to the general rule.

Of other imaginary animals the Griffin or Gryphon
is probably the best known next to the unicorn, seeing
that its name is that which is popularly applied to most
non-natural beasts. Evidently derived from one of
those creatures by which early eastern art expressed the
conjunction of various attributes, it came, like many
other monsters, to be implicitly believed in as an actual
beast until a comparatively late date. Thus Gerard
Leigh has something to say of griffins which " bear great
enmity to man and horse, though the man be armed and
on horseback yet they take the one with the other quite
from the ground and carry them clean away. I think
they are of great hugeness," he goes on, " for I have
a claw of one of their paws which should show them
to be as big as two Lyons ! " In another place Leigh
refuses to believe something that he had heard because
he " had not seen the proof thereof "·!

The griffin is half eagle and half lion, the head fore-
part and wings being those of an eagle and the rest of
the body with the hind legs and tail are leonine. The
head of a griffin has ears, and these serve to distinguish
it from that of an eagle when it is used alone.

A curious variety of griffin, borne by the Marquis of
Ormonde, is wingless, has two horns on its head and

groups of rays issuing from its body, and is termed a male-griffin, for some inscrutable reason. It should be noted that the term for a griffin in a rampant position is *segreant*, all other poses being described in the ordinary way.

The treatment of the composite animals naturally followed that of the creatures which entered into their composition, while the Dragons, more purely imaginary creatures, have suggestions of a snakelike character in their scales and annulations.

In continental heraldry the dragon has but one pair of legs and behind them the body diminishing into a snakelike tail, which sometimes terminates in a barbed end. This form we term a Wyvern, reserving the word dragon for the four-legged variety.

The conception of a dragon varied greatly, the prevailing characteristic in many instances being a hard scaliness somewhat suggestive of the Chinese and other oriental types. In other examples greater sinuosity and a more leathery texture is apparent, recalling to mind the idea of the " loathly worm " of some of the mediaeval dragon legends. As a symbol of evil, terrible but overcome, it is associated with St. George and with St. Michael, and also appears, with more personal allusion, in the well-known device of the Guelphic faction in their contest with the Ghibellines.

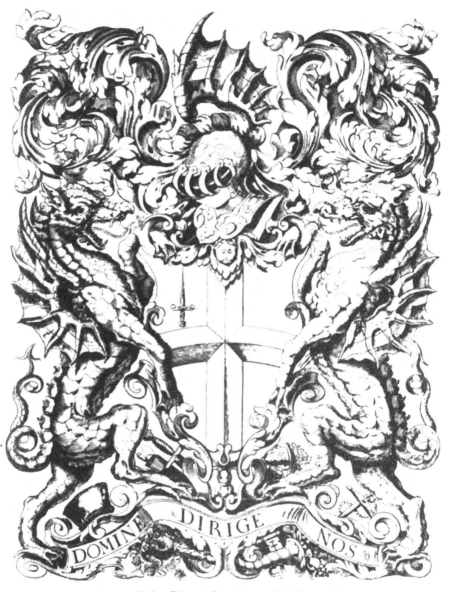

Arms of the City of London.　Wallis.　1677.

Wyvern (so-called "Dragon")
From Paradin, "Devices Heroiques," 1557.

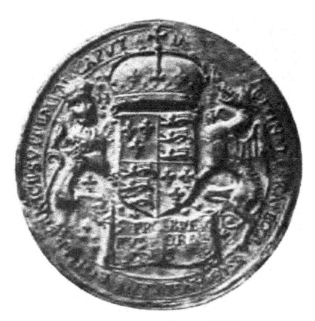

Privy Seal of Henry VIII.

CHAPTER V

Heraldic Birds and other Figures, Animate and Inanimate

IN the same way that the lion asserted its pre-eminence among heraldic beasts the Eagle, the most powerful of birds of prey, was adopted as the symbol of victory from a time so early that one hesitates to set a period to it, for in Chaldea and Assyria, 4000 B.C., the eagle typified conquest, even as it did in the Middle Ages. The especially characteristic attitude of the heraldic eagle when it is said to be *displayed* is first found in these early picture writings of the East, and from thence through countless stages comes to adorn the surface of the shields, to whose decoration its spreading form and radiating lines so admirably lend themselves. The pose is, of course, a natural one, as one may see when a gull hovers and backs in the air; but its decorative power and its adaptability to a shield shape are so striking as to suggest its invention for the purpose. The same necessity for clear definition that influenced the drawing of the mediaeval lion caused the eagle to be treated in a somewhat similar way, and the feathers of the wings being wide spread with ample clear space

between them, while the body became to some extent
attenuated, made the figure as conventional as the lion,

FIG. 105.—Shield of the Emperor from the Tomb of Prince Edmund
at Kings Langley. Early Fifteenth Century.

and similarly adaptable to decorative distribution on a
surface.

A good example of the heraldic eagle of the Middle

Ages is on one of the shields that decorate the tomb of Edmund Plantagenet at Kings Langley, Herts (Fig. 105). This, the eagle with two heads of the Holy Roman Empire, alludes to Richard, Earl of Cornwall, who though he was never actually Emperor, got so far as to be elected King of the Romans in 1257, and the arms of the Empire are constantly ascribed to him.

The skeleton sketch that is useful in blocking out an eagle in its space will take some such form as Fig. 106.

In the mediaeval period eagles were always shown on shields in the pattern-like displayed position, whether they were single or double headed, until Renaissance heraldry in its reversion to classic types introduced the eagle of the Roman Ensigns and Monuments, which thenceforth has had to be taken into account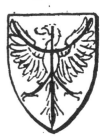

FIG. 106.

when eagles are described in blazon. Thus it is now necessary to state whether the bird is displayed, is close or is rising. An eagle is close when it stands in profile with its wings folded, and is rising when it stands in the same general position but with its wings raised. An eagle in the position of that of the Roman Ensign is sometimes blazoned " an eagle with wings displayed," and must not, of course, be confused with " an eagle displayed." When they are flying they, like other birds, are said to be volant. They are *armed* and *membered* as to. their beaks and feet when difference of colour renders it necessary to mention those details. Other birds are rarely if ever displayed.

Falcons usually have bells strapped to their legs with

thongs called jesses, and then are blazoned as *jessed* and *belled*. They are sometimes *hooded* also. The hood covering the eyes has an opening for the beak and is usually decorated with a tuft of feathers.

A cock is said to be *armed* with his beak and spurs, *crested* as to his comb, and *jowlopped* of his wattles.

A peacock when it carries its train raised and fully spread is blazoned, with great and obvious propriety, "a peacock in his pride," but simply as a peacock, without qualification, when the tail is trailed.

The pelican, the well-known emblem of maternal love, is shown standing in her nest and feeding her brood with blood from her breast, and with her wings in a displayed position with the points downward in an attitude of protection. In this position she is called a pelican in her piety.

As an imaginary variant of an actual thing it may be convenient to refer here to the martlet, the very distinctive heraldic bird without feet, the "martlette of the sunne," as old armorists call it. It is shaped like a swallow but without feet, for it was believed to live entirely in the air. Hence it was assigned as a mark of cadency to the fourth son, who, being so far from succession to the land, had only his own powers to sustain him (see Fig. 294).

Martlets form part of the arms that are ascribed to Edward the Confessor, though in the example at Westminster Abbey the birds distinctly have feet and may perhaps have been meant for some other bird altogether, perhaps doves, whose symbolism of peace caused their early appearance among Royal insignia.

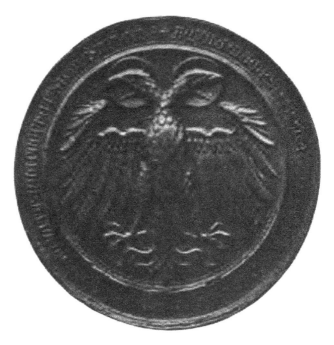

Seal of the Emperor Sigismund, as King of Hungary.

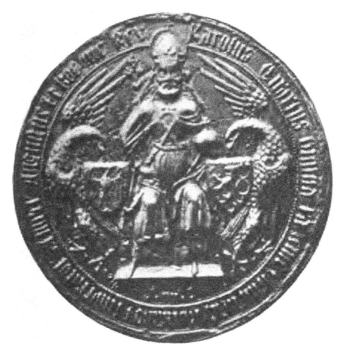

Seal of Charles IV. as Emperor.

Italian Medal, attributed to Bartolo
Talpas, XVth Century.

Seal of Dauphiny,
1404.

Italian Medal by Pisano, 1441.

Of imaginary birds the phoenix is most interesting as a symbol of the perpetuation of life, and early writers never tired of describing in elaborate detail how the fabled bird, which they, however, accepted and believed in as a natural fact, effected his rejuvenescence through fire of his own kindling. Therefore the phoenix is represented in heraldry as resting upon its pyre. In recent times it has been customary to depict the bird as shaped like an eagle, but in earlier examples the head was crested like a peacock. Its proper colour was purely fanciful, some examples of great beauty being blue and gold, the preponderance of tincture varying with the fancy of the artist.

The Harpy of classic story appears in heraldry in the shapes of eagles with the faces and breasts of women, and this appears to have been the only figure, with one exception, which combines the human form with that of a bird, for the bird-headed beings of the Assyrian bas-reliefs and other forms of Eastern art were not among those adopted into our heraldry, though there are a few instances in German work. The exceptions are the swans with women's faces that in the fourteenth century decorated some of the hallings, or hangings of tapestry or embroidery, as especially emphasized versions of the chivalric symbol of womanhood that the swan was considered to be. For this reason it was adopted as a badge at a time which assiduously fashioned its manners after the traditionary chivalry of King Arthur and his knights, and when every kind of poetic and symbolic heraldry reached its fullest development.

Fish.—Of heraldic fish the Dolphin may perhaps be

considered the most distinguished, mainly from its association in former times with the heir to the throne of France; but it is occasionally met with in our heraldry, generally perhaps as typical of fish in general, as in the arms of the Fishmongers Company of London. It is represented with its body curved, and is then said to be *embowed*, and it also occurs in the other position referred to below. When it is blazoned *proper* its colour, heraldically, is green with red fins and tail.

Other fish occur as punning allusions to their owners' names, e.g. the Lucies (pike) of the family of Lucy, whose arms are one of the quarterings of the Duke of Northumberland.

A fish when placed horizontally across the shield is blazoned *naiant*, or swimming, and when perpendicular as though breathing on the surface it is *hauriant*.

HUMAN FIGURES.—The human figure appears heraldically as representing religious or symbolic persons, and in combination with other forms it makes those composite figures which express a conjunction of symbolic ideas. A woman's head and breasts joined to the body of a lion made the well-known Sphinx, a figure closely associated with Egypt, to which country and to services rendered therein it usually alludes in modern heraldry. The Greek sphinx is composed of the head and bust of a woman joined to the body and legs of a dog, and in addition is winged. Its occurrence is rare in heraldry, a recent instance being the Greek sphinx sejant, which is the crest of the University of Leeds.

In conjunction with a fish's tail the body of a woman forms the Mermaid, the beautiful Syrena of old writers,

Arms of Schwingshärtein, a Nuremberg family.
German, ca. 1580.

The device is a punning one, the figure waving hair being in
allusion to the name of the family.

Printer's Mark of Grimm & Wirsung, Augsburg, 1521.
From a volume by Erasmus. Hans Weidlitz.

SOLI DEO GLORIA

Bookplate by Albert Dürer. *Circa* 1520.

who never tire of telling how, like the harpy, she charms the shipmen with her song. Nevertheless, she was of sinister character, " glad and merry in tempest and heavy and sad in faire weather." She is usually represented holding a looking-glass in which she regards herself while she combs her long hair. The male of the species is called a Triton, and usually holds a trident as the symbol of naval dominion. Indeed he is sometimes called Neptune, and crowned with a spiked crown, the form known as an Eastern crown that is described and illustrated under that head. Another semi-human form is the Centaur, the favourite badge of King Stephen, the classic monster, half man and half horse and armed with a bow, that is sometimes called a Sagittarius.

Male figures were frequently described as Savage Men, and were represented rough and shaggy with hair, and with wreaths of oak about their loins, the blazon being : a savage man ppr. wreathed about the loins with an oak wreath vert. In some instances they were wreathed about the temples also.

Heads of both sexes, arms and legs, are used as charges and more frequently as crests, and are described as couped or erased, at the shoulder or the neck, as the case may be.

The whole Arm from the shoulder is shown bent and is then blazoned, an arm *embowed*. It should also be stated in the blazon whether the arm is dexter or sinister, and whether, if not naked, it is vested (and if so of what colour), or in armour, when it is described as an arm *vambraced*. *In armour* is often substituted for the later term. Pairs of arms grasping an object, drawing a bow

or wielding a hammer, are also met with. When the arm does not extend beyond the elbow it is blazoned a cubit arm, and its position, whether erect or otherwise, must be specified.

Human hands are borne by several families into whose name " Main " enters, either as Tremaine, Maynard, etc., and among other families by the O'Neils, and in the well-known badge of Ulster, the distinguishing badge of a baronet. They are usually depicted erect and couped at the wrist, and are assumed to be open unless it is otherwise stated.

Anything depictable may be used as a charge, but in this wide field there are still certain particular objects, that single themselves out for more detailed treatment than the rest, and of these the cross in its many varied forms, the rose and the fleur-de-lis are the principal.

CROSSES.—In a system of heraldry which took its rise from a military Christianity the cross naturally became a much-employed symbol under the various forms which the necessities of distinction or decoration suggested. Although it has been dealt with to some extent under the head of ordinaries, it is as a charge that it reaches its greatest variety and beauty. The plain cross with limbs of unequal length, which is called a passion cross, is sometimes placed upon steps or degrees, as in Fig. 107, when it may be described as a cross calvary.

Of the more decorative varieties those which terminate in a manner suggested by the fleur-de-lis are among the most usual and beautiful. Probably many of them were decorative before they became distinctive, for among the early sculptures are many examples of decorated crosses

with foliated ends which follow none of the familiar forms and are obviously purely ornamental.

Crosses in general are drawn with limbs of equal length except where the shape of a shield suggests the lengthening

FIG. 107.—Cross
Calvary.

FIG. 108.—Cross
Flory.

FIG. 109.—Cross
Fleuretté.

of the lower limb in order to satisfactorily place the object in its field, but the intention is that the limbs are to be considered equal and not like those of the passion cross. The width of crosses may be considerably varied, for difference consists not in the proportions of parts to each other but in essential variations of form. The floriated, or otherwise varied, cross may therefore be made of any pro-

. FIG. 110.—Cross Patonee.

FIG. 111.—Cross Moline.

portion that the arrangement of the shield may suggest; that is to say, the same adaptability exists in these crosses as in the ordinaries, and their proportions may and should be varied in relation to the field they occupy and

H

the charges with which they are associated. Though the floriated crosses are all derived from one source, their various shapes have long become fixed and now constitute heraldic difference. It will be useful therefore to observe that the end of a cross flory (Fig. 108) may approach very closely the form of a fleur-de-lis so long as confusion is

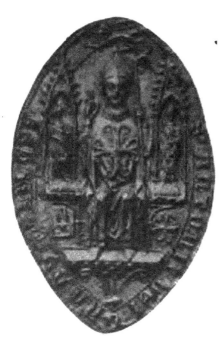

not caused with the cross fleuretté (Fig. 109), in which the fleur-de-lis appears joined to the cross rather than as though developed from it. The cross patonee (Fig. 110) differs from the cross flory merely in that the limbs of the former increase in width outwards, the lines radiating from the centre in a very pleasant way. In early shields the two latter forms are used indifferently for each other, as in the arms ascribed to Edward the Confessor, and in such cases choice may, of course, be made of one or other form; but it is obvious that when definite distinction between similar forms has been arrived at it should be observed and followed in later renderings.

FIG. 112.—Seal of Anthony de Bec, Bishop of Durham, 1283–1311.

The cross moline (Fig. 111) has ends like a fer-de-moline or millrind. A very beautiful example occurs on

the seal of Anthony de Bec, Bishop of Durham at the end of the thirteenth century (Fig. 112). This form of cross moline was distinguished by writers of a late time from the ordinary form with more pointed ends as a cross recercelée, but it was really the same thing under a different name.

The cross patée or formee (Fig. 113) is that which occurs on the Imperial crown and other Royal insignia. This is a very graceful form when the limbs are well divided and are drawn with pleasant curves, as in the crown in Fig. 164. In

FIG. 113.—Cross Patée.

later examples there has been an unfortunate widening of the ends until they almost touch each other at the corners with the result that the figure has the appearance of a square that is pierced with four radiating vesica-shaped holes and hardly that of a cross at all.

The cross crosslet (Fig. 114) becomes (in Fig. 115) a

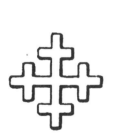

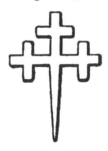

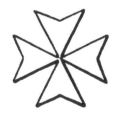

FIG. 114.—Cross Crosslet.

FIG. 115.—Cross crosslet Fitchée.

FIG. 116.—Maltese Cross.

cross crosslet fitchée by its lower limb being pointed, in allusion to the temporary cross thrust upright into the ground in order, it may be, to serve as a symbol of hope and consolation to a dying soldier. It must not be

supposed, however, that every coat with a cross crosslet fitchée originated in the Crusades. Other crosses may be fitchée in a similar way, the point taking the place of the whole lower limb as in the example, but in some cases it is made to merely continue the lower limb, or, in the case of a cross patée fitchée, to issue from the middle of the lower end, and in such cases the cross is said to be *fitched at the foot*.

The eight-pointed or Maltese cross, a development from the cross patée (Fig. 116), is one of the forms most used in the insignia of Orders of Knighthood, the Order

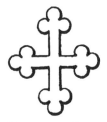

Fig. 117.—Cross Bottonée. · Fig. 118.—Cross Pomell. Fig. 119.—Cross Urdée.

of the Bath, for example, and of St. John of Jerusalem among others, and is one of a group of crosses distinguished from each other by the number of their points. A cross of fourteen points occurs in the badge of the Order of St. Michael and St. George, and consists of seven limbs of two points each.

The cross bottonée (Fig. 117) is sometimes thought to be a corruption of the cross crosslet, whose corners are frequently rounded in early examples, or it may indeed have been designed to represent buds, as old armorists say, and if so is a perfectly intelligible and expressive symbol.

Crosses pomell (Fig. 118), urdée or clichée (Fig. 119), potent (Fig. 120), furchée (Fig. 121), are some of a large number of crosses that are but rarely used.

The cross tau, derived from the Greek letter of that name, is the cross of St. Anthony (Fig. 122).

FIG. 120.—Cross Potent. FIG. 121.—Cross Furchée. FIG. 122.—Cross Tau.

Crosses may at any time be represented as in relief, which again may be accented by means of a central arris or ridge which gives lines of light and shade; and this treatment is especially suitable to metal work, as is witnessed by many beautiful examples on church bells among other things.

Care is necessary, however, in black and white drawing that the indication of an arris does not suggest that the cross is " party " in any way.

THE FLEUR-DE-LIS is one of the forms derived from a remote antiquity to become a widespread symbol throughout the whole of mediaeval heraldry. Probably derived from the iris or some similar flower form, it is found in the most ancient and the most modern decoration. Even the recent excavations of the palace of King Minos at Knossos in Crete disclosed forms of this figure on the wall frescoes. Its ornamental beauty as well as its spiritual symbolism easily account for its heraldic pre-

valence, and even before regular heraldry was formulated the emblem had a quasi-heraldic existence on the crowns and sceptres of the Royal seals. Its decorative value needs no pointing out, for its graceful lines are not only beautiful in themselves but are easily adapted to harmonize with almost any form with which they may be in ornamental or heraldic relation.

Of the examples that are given here Fig. 123 is taken from the seal of King Louis VII of France, early in the twelfth century, on which it appears as the termination of a sceptre. The more distinctively heraldic

FIG. 123.—Early FIG. 124.—Late FIG. 125.—Late
Twelfth Century. Twelfth Century. Twelfth Century.

form occurs on the oval counter-seal of his successor, Philip II, on which it appears as a badge without a shield, about the year 1180 (Fig. 124). A very beautiful form of the thirteenth century (Fig. 126) is also of French origin, and that which occurs on the shield of the Black Prince may be considered typical of the fourteenth century (Fig. 127). As in all these instances, the fleur-de-lis generally has but three leaves, but in some early examples the whole five petals of the iris are suggested by the inclusion of intermediate forms between the three principal ones (Fig. 125). These were sometimes leaflike, as in Fig. 128, an example of the fifteenth cen-

tury, but more usually are thin stems which terminate in small flowerlike forms. A further beautiful example is the common seal of Godmanchester, co. Hunts

FIG. 126.—Thir-
teenth Century.

FIG. 127.—Fourteenth
Century.

FIG. 128.—Fifteenth
Century.

(Fig. 129). Fleurs-de-lis are then said to be seeded (a term that was probably made by some late armorist in giving a meaning to a form he did not understand) or florencée, from the invariable character of the fleur-de-lis, the " Lily of the City," in the Arms of Florence (Fig. 130). The elaboration of the simple leaflike forms began as early as the middle of the fourteenth century at a time when the decorative sense was untrammelled, and it is in the freely designed illustrations of the MSS. that the first examples are found. The illustration (Fig. 131) is after one

FIG. 129.—Seal of Godman-
chester, Co. Hunts.

of a number of them that are repeated in various colours, but of similar form, in a book of the poems of Convenevole

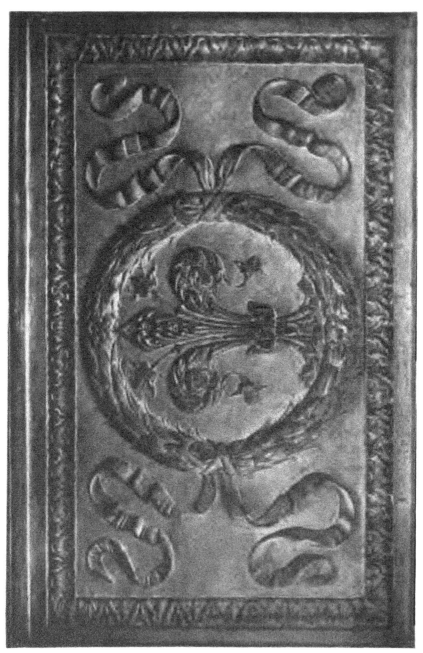

FIG. 130.—Fleur-de-lis from the Pedestal of the Lion, Florence. Donatello. Fifteenth Century.

da Prato, Petrarch's tutor, which was made and painted with miniatures and other ornaments for Robert of Anjou, King of Naples, about the year 1340, and was probably executed in Florence. It is somewhat surprising to find at so early a date an example of the highly elaborated

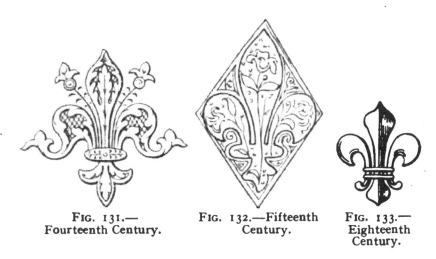

FIG. 131.—
Fourteenth Century.

FIG. 132.—Fifteenth
Century.

FIG. 133.—
Eighteenth
Century.

form which became very general in the later Italian decoration.

A beautiful example of the decorated fleur-de-lis of the fifteenth century has already been referred to (Fig. 128).

About this time also instances occur of fleur-de-lis of the simpler form but with decorated surfaces, as in that from a fifteenth-century book of the hours that is one of the illustrations to the Comte de Laborde's treatise on " Les Fleurs-de-lis Heraldiques et les Fleurs-de-lis. Naturelles," *Revue Archaelogique*, in which the conventional fleur-de-lis (Fig. 132) is decorated with natural lilies.

Like other decorative details the fleur-de-lis rapidly deteriorated in the general artistic decadence that followed the Tudor period, and during and after the latter half of the sixteenth century the beautiful and characteristic grace of line was lost, and the form became blobby and heavy, as in the eighteenth-century French example (Fig. 133), while the coarse and ugly shapes that are commonly seen in ordinary modern work make it difficult to believe that they could have been derived, even remotely, from so beautiful a source.

ROSES.—As a Royal badge a golden rose was used by Edward I, and was depicted with a stalk and leaves similar to the badge of the Maltesta in Italy in later times. In such cases it must be blazoned "leaved and slipped," otherwise it would be rendered as the conventionalized flower alone, the only leaves shown in the latter being those of the calyx, which appear between the petals and are heraldically called *barbs*. These are frequently mentioned on the blazon, e.g. a rose gules barbed and seeded ppr., the seeds being the centre. Of the conflicting roses that brought such ruin on the gentry of England the red rose of Lancaster had been the badge of Henry IV, as the white rose irradiated was that of Edward IV, the latter badge resulting from a combination of the rose with the sun, which was another Yorkist emblem. Henry VII united the red and white rose badges, as he had united the great rival houses that they symbolized. Sometimes a single rose was made per pale gu. and ar, or else quarterly of those tinctures (in the former case the white half retained the rays that usually surrounded the white rose of York), but the method which has come

down in general use is that of a double rose, the white within the red, or vice versa. In this form Henry VII made it part of the collar of the Order of the Garter, and thus it appears sculptured on the walls of St. George's Chapel at Windsor. In many instances the York rose retained its rays and the rose of Lancaster was placed within it, as in Fig. 134, which is sculptured on the exterior walls of the choir. In many of these the ends of the petals do not turn over as is most usual, but the modelling indicates a somewhat

FIG. 134.

FIG. 135.

similar form. An interesting example of the Tudor rose as used by Queen Elizabeth is that which was found deeply incised in the wood of her coffin in Westminster Abbey (Fig. 135). This Queen signified the union of the Roses in yet another way in the badge that had been her mother's, in which the tree-stock which supports the white falcon sprouts with red and white roses on the same stem.

The Tudor rose has been united by dimidiation to many other badges, to the pomegranate and to a sheaf of arrows by Queen Mary, and to the thistle by James I

and his successors, of whom Queen Anne used the two emblems growing from one stem, as in the present Union badge of the rose, thistle and shamrock. The Tudor rose crowned still remains the Royal badge for England.

THE HARP.—As the Arms of Ireland as well as for the beauty of form with which it may be invested, the harp ˙s of the greatest interest both generally (as the symbol of minstrelsy) and appropriately; for the fame of the Irish as harpists was widespread even in the early Middle Ages, when they were among the finest of the world.

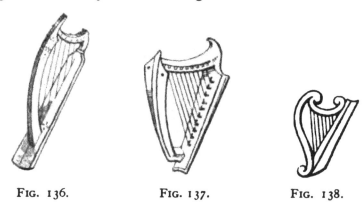

FIG. 136.　　　　　FIG. 137.　　　　　FIG. 138.

And although any symbol, whatever it may be, becomes hallowed by association, it cannot but be felt that the harp is peculiarly fitted to be the emblem of a people so full of artistic and romantic enthusiasm.

The heraldic harp was at first very simple and always graceful in form, following that of the minstrels, the small harp that was played resting on the knee or held suspended from the neck. Examples of the minstrel's harp are Fig. 136 from a thirteenth-century French MS. and Fig. 137 from a Tudor MS.

As a device for Ireland, it first appears on the Great

Seal in that of Queen Elizabeth (Fig. 138), when it was used as a badge and was ensigned with the Imperial crown, as are all Royal badges.

This type of harp is the same as that in the Wappen und Stammbuch by Jost Amman, 1579, and was evidently the shape that was in heraldic fashion at that period.

In the next reign it became definitely the Arms of Ireland, as is so quartered on the Royal Shield by James I, where it has occupied the third quarter unmoved throughout the changes of its fellow quarterings.

Its form continued to follow more or less that of the minstrel's harp until the time of Charles II, when the familiar winged figure was made its principal characteristic (Fig. 139). This, however, has no special heraldic significance, but is merely a variety of ornamental treatment.

While it presents opportunities for the highest efforts of art in the treatment of its figure, as is evidenced by Mr. Alfred Gilbert's beautiful harp on the tomb of the Duke of Clarence at Windsor, in the majority of instances it is altogether without the grace which is its reason for existence, even when it does not quite descend to the unlovely lumpiness of Georgian and later times. The possible advantages of its greater weight in the design as compared with the slighter form, a weight which tends to effect satisfactory balance with the other quarters, are counterbalanced by its disadvantages, while the addition of Celtic tracery to the minstrel's harp makes it more completely allusive and helps the composition at the same time. Nevertheless the figure harp may be very beautiful.

The simpler form is now very generally reverted to,
and when artistic reasons direct the choice, there are
no heraldic considerations that need fetter it. The Arms
of Ireland are blazoned : Az. a harp Or stringed Arg.

FIG. 139.—The Great Seal of Charles II for Ireland.

Before leaving for a time the further consideration of
the shield it will be convenient to refer to the very
beautiful method of relieving and enriching surfaces
which is called Diapering, and is a notable feature of
the more elaborate kinds of heraldry. Numerous and
excellent examples of its use may be found on the sculp-

tured shields of the monuments and chantries, as well as on incised brasses, in enamels and in stained glass.

Coming into heraldic use in the thirteenth century, it was soon extensively applied to the decoration of armorial shields and especially of their fields and ordinaries. In some instances charges also were diapered, but only when they were flat in character and when the general treatment and material lent themselves to the method. In most cases it was confined to plain surfaces. The patterns were in many instances derived from those that had been employed from ancient times in textile decoration.

Whenever diapering is applied to a shield it is purely ornamental in character, and in many instances is geometrical in plan, having no forms that could possibly be mistaken for charges, and so be likely to interfere with the clear statement of the arms. The example is one of the many beautifully diapered shields that decorate the shrine of the Percies in Beverley Minster. In sculpture proper, when the design was cut out of the surface, a pattern such as that of Fig. 140 was found very suitable to the material and to the method of working it; when, however, the diaper was modelled up, as in the gesso decoration of ceremonial shields, or was incised in reverse, as in a seal, the design frequently took the form of flowing lines as the readiest means of getting the ornate effect that was required. An example of this latter method may be referred to in the Great Seal of Henry IV at p. 18, Fig. 2.

In the early examples the diaper, like the semé already referred to, was treated as though it were a piece of an ornamental fabric stretched over the shield and passing be-

hind the charges without being affected or displaced by them.
The Renaissance work shows the diaper more especially
adapted to the occasion, as in a Florentine shield from

Fɪɢ. 140.—Diapered Shield from the Percy Shrine in Beverley Minster.
Fourteenth Century.

the Palazzo Guadagni and now in the Victoria and Albert
Museum, which is beautifully decorated in raised lines of
gesso which follow the ˌoutline of the figure at a little

FIG. 141.—Diapered Shield in Painted Gesso at Alloa House. The Arms of Henricus de Erskine. 1224. Geo. W. Eve.

distance from it, and the rest of the decoration accommodates itself to the shape of the spaces in a manner that is especially satisfactory, as conveying the impression of being carefully designed for its particular purpose, with each part in due relation to the others.

The illuminations of the manuscripts were frequently diapered with designs drawn in lines of gold on the ground colour, and a lighter or darker tint of the ground colour was similarly employed, sometimes also in combination with gold. Indeed, the possibilities of diapering as surface decoration are almost without limit if it is reasonably handled. Its effect in enriching and adding interest to simple forms and spaces is shown in the treatment of the Arms of Henricus de Erskine (Fig. 141) and the shield of John, fifth Lord Erskine, and his wife, Lady Margaret Campbell (Fig. 142), two of the series of shields executed in painted gesso for the hall, Alloa House, Clackmannanshire. It is very useful in monochrome, as in engraving for instance, as a means of distinguishing contiguous spaces ; in the way that line tints were employed to do before a colour value was ascribed to them. Being, of course, completely under control to be employed or omitted at will, it has none of the objections of the tincture lines.

The tone effect of diapering must be taken into account, and the consequent emphasis of the charges, unless their character is very elaborate and broken up, and in that case there may be a tendency to confuse their lights and thus obscure and spoil the whole effect. Discretion is therefore very necessary in applying that which properly handled is a very useful and decorative device. It has

been said that diaper must have no design of heraldic
significance, and this must be so wherever it is employed

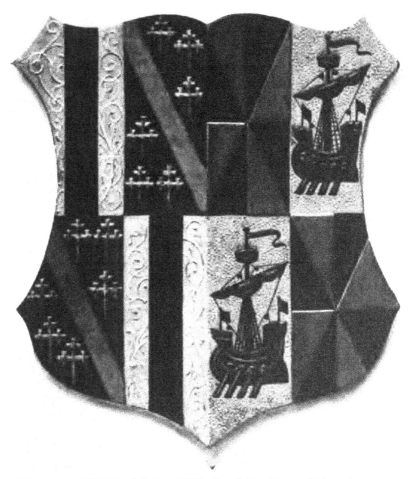

FIG. 142.—Shield of John, Fifth Lord Erskine. Painted gesso.
Geo. W. Eve.

on the actual armorials. When, however, it is used as
a background or other extra-armorial decoration the con-
verse is the case, and badges and charges of an allusive

character become the most suitable motives that can be employed.

Diapers of complete arms occur on a box of champlevé enamel in the Victoria and Albert Museum, whose decorations consist of lozenge-shaped spaces filled with the arms of de Valence and others, and in the similar work on the table of the tomb of William de Valence in Westminster Abbey. In the portrait medals the background was often enriched with armorial diapers of distinctive charges, such as the fleur-de-lis background to the head of Louis XII and the ermine one of Anne de Bretagne, both of which are excellent examples (Fig. 143). Similar diapers applied to architectural features are alluded to at p. 205.

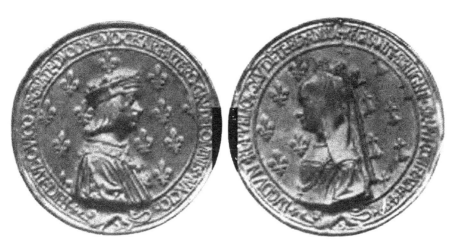

Fig. 143.—Medal of Louis XII and Anne of Brittany. Fifteenth Century.

CHAPTER VI

Helm, Crest and Mantling

THE treatment of the helm and mantling is a matter of especial interest both as a significant part of an achievement of arms and as that part of it which affords a great amount of freedom and variety in artistic arrangement, for the lines of the helm, the character of the mantling, its direction and flow, and to some extent its colour effect, are like the shape of the shield, at the disposal of the designer to do as he will or can with them.

With regard to the shield, which in course of time developed into a merely ornamented surface on which to bear a device, the sense of personal allusion was always retained, even when the close association of armorials with a military idea became to a great extent weakened, but a more essentially warlike character was always ascribed to the helmet and crest, as is evidenced by their omission from the arms of ecclesiastics and, in many instances and with great propriety, from those of corporations. This feeling may also have influenced the small size of the helmets of the later sixteenth century onwards. The intention, however, was not strong enough to dispense with them altogether as the mediaeval men did, and the result was merely to weaken the design in

including the helmet and crest in a somewhat shamefaced way.

In the stately ceremonial of the tournament, helm and crest played no less distinguished a part than the shield, for those military sports which took so firm a hold on the vigorous tastes of mediaeval chivalry were accompanied by brilliant ceremonial, in which heraldry found its widest field of display in all kinds of sumptuous application to the dress and decoration of the scene.

The lodgings of the knights and nobles were distinguished by paintings of their armorials, and banners and pennons projected from the windows. The tribunes of the Ladies and of the Judges of the Tournament were gay with badges brilliant in colour and of endless variety of form, while the combatants themselves in surcoats and shields of Arms and with crested helms and armorial horse trappings, exhausted the heraldic possibilities of personal adornment.

On a day before that which was fixed for the combats the helms and crests of the tourneyers were brought together with much ceremony and were arranged in due order to the satisfaction of the Judges of the Tournament. Each had its owner's banner suspended over it and, all being ready, the Ladies were conducted round the Hall, when if any one of them, by touching a crest, accused its owner of any fault or crime against chivalry he was seized, tried and punished, according to the magnitude of his offence and the custom of the Tournament.

The helm and crest of the Chevalier d'honneur, the knight selected to attend the Lady of the Tournament and at her bidding to extend the " Merci des Dames "

which forbade further attacks on a combatant unfortunate in the mêlée, were the objects of especial ceremonial, and (he being withdrawn by his office from active participation in the combat) were taken from his head with much courtesy by the Judges and the Herald and were solemnly given in charge of the Ladies until such time as his duties should cease at the close of the Tournament. Until that time an esquire or gentleman bore them aloft upon a lance staff near to the Lady of the Tournament.

With regard to the helm, it will not be desirable to discuss its development as armour through the various forms which preceded those which were employed to support heraldic crests; and it will suffice to begin with the early form, which was more or less cylindical, as in Fig. 144, and afterwards developed into the more complex curves and projections of the tournament helm.

FIG. 144.—Thirteenth Century.

At first, comparatively short and resting on the camail which covered the head, in time it was made longer, until the helm rested on the shoulders, and being buckled back and front to the body armour became, as it were, part of it, and besides being a better defence was able to support the additional pressure of a crest (which though fashioned of light material was still of considerable weight) with a minimum of fatigue to its wearer. The crest was attached to the crown plate of the helm

by means of laces, or by small bolts or other fastenings which passed through holes made for the purpose. It appears improbable that crests were used to any general extent in actual battle, and for the best of all practical reasons, that a crest had been found to be a very dangerous ornament which, at close quarters, served as a handle, while the laces held, by which to pull down the wearer's head, and King Stephen is said to have been among those that suffered in this way. That they were used in battle to some extent is evident, and Viollet-le-duc, in referring to the abuse of the Tournament, points out that the feudal nobility attempted to treat war itself like a grand tournament and appeared on the field extravagantly arrayed with long surcoats and lambrequins that encumbered their movements and gave them an easy prey to simple archers and similar workmanlike troops.

The shape of the helm was naturally susceptible of much variety but its essential structural character remained the same throughout, and consisted principally of three parts, the crown plate and two others for the front and back of the helm respectively. Sight was provided for in one of two ways, either by leaving an opening between the crown and front plate or by piercing the latter with horizontal openings which were strengthened by an additional piece, generally in the form of a cross, and so splayed as to deflect a point that had struck near the opening. Both opening and reinforcing piece may be of value in design, the former from its strong line which must always be reckoned with, and the latter for the opportunity it affords of introducing

decorative detail where it may be useful. It is interesting to observe that the back of the helm is of thinner plate than the front, thus dispensing with weight where it was possible to do so. In the later forms of helm, which were fastened by straps to the breast and back, the buckle and the methods of rivetting it to the plates afford other opportunities for utilizing structural details ornamentally. (Fig. 145.)

FIG. 145.—Fifteenth Century. Tilting Helm.

The perforations which facilitated breathing were generally on the right-hand side, and though there were instances of their being on both sides it was very unusual in view of the fact that the tournament attack was from the left, and that although the tilting spear had a coronal instead of a point, care would still be taken to give as little hold as possible to the weapon.

This refers to breathing holes, spiracula, in the front plate, but there were also openings, sometimes of considerable size, in the backplate behind the vertical joint, through which the knight could hear and perhaps, by turning his head, see and speak to the squire who attended him.

In the fifteenth century the demand for greater mobility and less weight in the armour that was used for actual battle had produced the Helmet or small helm, having a front which opened and a more or less flexible neck, the Bascinet, the Salade and other forms of

head armour ; and thenceforward the great helm was reserved for the uses of the tournament.

An example of helmet at Fig. 146, after Viollet-le-duc, will serve to explain its structure. The vizor, in two parts, opens upwards on a pivot, and the front opens sideways by means of a hinge to permit the helmet to be put on, and though there was a great variety in shape and construction they were all modifications of the methods of

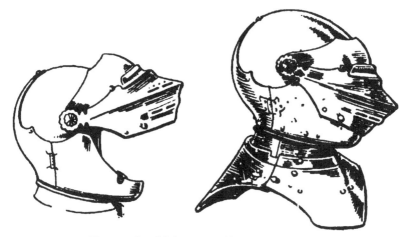

FIG. 146.—Helmet. Fifteenth Century.

the example. The head was capable of movement, the laminated plates of the gorget giving a certain amount of flexibility from side to side as well as up and down, provision being also made for some amount of turning movement. As pieces of defensive mechanism helmets were very excellent, but were rarely associated with crests in the time of their actual use—though they were frequently so represented in the later times when heraldry had become out of touch with the armoured period and did not

trouble to go farther back for its crest support than the most recent form of closed defence for the head.

In all armour, and much besides helms is used in heraldry, it will be found useful to acquire a practical knowledge of its structure and method of working and also the practical reasons for the form of its various parts. By so doing it will become unnecessary to search for a model for every need, rather it will be possible in the case of a figure to draw the man and put the armour on him in the form that seems most suitable. Forms of greater or less simplicity can thus be designed as circumstances may dictate, as it may be desirable in the interests of light and shade to elaborate or minimize the details. Armour should be so designed that its principal lines help the composition and express the form in the most forcible, suitable and simple way. In an arm, for instance, which is of frequent occurrence as a crest, it should be observed how the gauntlet has its defence added to the glove, how its wrist fits over the arm piece, the arrangement of the elbow piece, the cubitiere, on its inner and outer sides with regard to the hollow of the arm, and so forth. By thus familiarizing oneself with the essential structure, it becomes possible to handle the subject with confidence in design, so that perspective, light and shade and the harmonious relationship of lines may be helped, while the structure appears convincingly right.

Besides the closed helm which was used in the joust, the mimic duel with lances, a more open variety was used in the tourney, for in the latter, which was fought by opposing parties of men armed with blunted swords

and with wooden maces, there was no attack with the point to be provided against, and it was therefore possible to lighten the armour by means of perforations and to open the face by substituting bars for plates. In the helm shown at Fig. 147 it will be noticed that not only

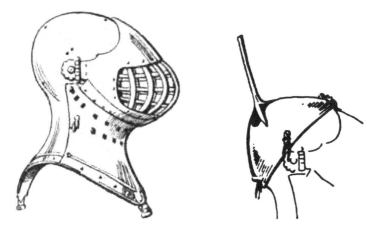

FIG. 147.—Tourney Helm, after Viollet-le-duc. Fifteenth Century.

is the face open, but there are numerous holes in the upper part of the gorget, and the breast-plate and other parts of the armour were also plentifully perforated. Such armour for tourneying was frequently modelled in leather instead of metal, the lighter material being a sufficient defence against sword and mace, though it would have fared badly against the more concentrated lance shock of the joust, and therefore when the lance was also permitted in the tourney more efficient armour was worn.

Fig. 147 shows a form of appliance for fixing the crest by means of a sort of skull cap, which was laced to the helm through the holes provided for the purpose.

The earliest decoration of symbolic though still merely general significance on the helms of the Middle Ages was the reinforcing piece surrounding the two sight openings, that was made in one of the many forms of cross ; and the coronets and decorative fillets which denote high rank. These latter were succeeded about the beginning of the fourteenth century by the actual crests, which were sometimes repetitions, modified or not, of the device on the shield, sometimes of a different nature altogether.

The first attempt to decorate the top of the helm appears to have been by panaches of feathers, perhaps also of horsehair, for which representations in gilded leather or other more permanent material were afterwards substituted. As early as the ninth century movable crests of coloured leather had decorated the head armour, being fastened back and front to the bronze or iron cap. These were purely ornamental, except

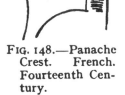

Fig. 148.—Panache Crest. French. Fourteenth Century.

so far as difference of colour may have made them personal to some extent. An example of the middle of the fourteenth century appears as Fig. 148. Some of the panache crests retained their feathery character and ultimately became crests that were in every way heraldic, while others were developed into a fan-like form which itself served as a field for the display of a device or even of the whole arms as in the case of Sir Geoffrey Louterelle's crest that is quoted by Boutell. These ornaments appear to have been purely decorative

additions to the helmet, and could have had no defensive value; on the contrary, the angle formed by the base with the crown of the helmet would, if rigid, have provided lodgment and purchase for a blow which might otherwise have slid off.

Heraldic crests came into definite use about the beginning of the fourteenth century and soon became of very general application on seals and in other armorial ways.

The Tournament crests were large and boldly designed and were constructed of various light materials such as leather, paper and canvas, worked over a wicker frame; the surface details were modelled in fine plaster, and the whole was painted and gilt. Few ancient examples exist in this country, the most notable being that of Edward the Black Prince which accompanies his shield at Canterbury. Abroad they are more numerous and Fig. 149 is an excellent example of them.

This spirited dragon's head, of Florentine work of the fifteenth century, is modelled in gesso over a wood core, and was painted and gilt. It is noteworthy that in this instance the torse is modelled with the crest.

When a device became a crest it was generally modified to some extent in order to fit it practically for its position. Hence the frequency of the demi-animals, which, while admitting of more secure adjustment to the helm, retained all the vigorous and symbolic qualities of the whole figure. Animals' heads were also largely used and are equally satisfactory from the point of view of design, because of the ease with which their lines may be made to harmonize with those of the supporting helmet.

When a lion or other animal was used whole it was generally in a statant position, as it is in the Royal Crest of England, Percy and others, for that was the most stable posture in which such a modelled object could be fixed to a helm. In such cases the animal looked directly in front of it and faced as the helm did.

Flat objects, the sun in splendour for example, were placed edgeways to the front, so that they were best seen from the sides, but in some crests, the device, especially when a fleur-de-lis, was formed of two planes which intersected a each other at right angles, so that the com-plete form was visible from every point of view.

FIG. 149.—Dragon's Head Crest from the Bardini collection. Florentine. Fifteenth Century.

The mantling, or lambrequins, hung from the top of the helmet, being fastened to it by laces, and over it the torse, formed of twisted silk of two or sometimes more tinctures, encircled the crown of the helm below the crest.

The artistic treatment of the crested and mantled helm was nearly always satisfactory during the whole period of the tournaments until they ceased in the sixteenth century, but about the middle of that century began the unfortunate increase of restrictive rules that were devised with so little regard to their practical artistic application. In place of the great helm which had previously been used in the way that was best suited to the display of the crest, that is to say in profile or nearly so, the lighter helmet was substituted, and it was also decreed that it should be varied in shape, twisted about and opened and shut, according to the rank of its owner, but with total disregard to the crest. So that we have a lion standing sideways on its helmet and even looking down the back of it. For in the worst cases a helmet may be seen turned completely round, while its crest remains in the original direction. This arose from the stupid application of the excellent rule that helms when more than one are employed should be posed with regard to some common centre of interest; an obviously proper and artistic method, but it should be equally obvious that when the helm turns the crest must turn too.

Although it will in most instances be possible to ignore these rules, for the bearer's rank will usually be sufficiently indicated in some other way, it is, of course, necessary to know them, and the present rules for helmets of rank are as follows :—An Esquire or gentleman has a helmet of steel with gold ornaments and it is posed in profile with the vizor closed. The position is not interpreted very strictly, however, and the helmet may be three-

quarter face or may make an even nearer approach, in reason, to the full affrontée position. This fortunate latitude affords a way by which, when the use of the small helm is insisted upon, the crest and its support may be brought into intelligible relationship.

A Knight's or Baronet's helmet is similar to that of an Esquire, but is borne full faced with the vizor open.

It is difficult so see any reason for multiplying indications of rank which is already marked in other ways, though the difficulty certainly exists in the case of a Knight (with a Baronet there is of course none), but it would be easy to devise some distinguishing mark on or about the shield or on the helmet itself if the authorities would give a ruling in this sense.

The helmet of a Peer is of steel or silver and gold, the front having bars or grilles instead of a movable vizor, and its pose is profile wise, similar to that of the Esquire's helmet. Its bars are usually five in number, and attempts to signify exact rank by the number of bars have not resulted in any rules that are observed.

The Sovereign and Princes of the Blood Royal have barred helmets of gold which are placed affrontée.

The modern reversion to the tournament helm as a support for the crest was begun in the illustrations to Foster's *Peerage* by Dom Anselm and Forbes Nixon in 1880 and with what advantage may be seen by inspection of that admirable work.

There can be no question of the superior value of the great helm from an artistic point of view. Its strong simplicity makes it especially suitable as a support for a crest that is treated in a bold and expansive manner and

K

its bold curves compose well with the lines of the mant-
ling and shield.

The central position which the helm occupies is neces-
sarily an important one, and in order to avoid over-
accentuation it should be so designed as to be a link
between the shield and the crest, and not be permitted
to concentrate attention on itself. The avoidance of
such undue prominence is helped by the tilting forward
of the helm, a position which tends to make the horizontal
lines, of the " sight " for instance, curve upwards and
so help the composition, with respect to the crest,
while the strong line of the front ridge coming down
in the direction of the shield is also valuable.

The forward lean of the helm is always noticeable and
probably points to its being carried on a staff as already
mentioned, for its highest part, which would be the point
of support, being usually behind the centre, would tend
to throw it forward and so bring it into some approach
to the degree of inclination that it would have when it
was on the head of a charging knight.

The difficulty of dealing with modern crests usually
arises from their having been designed with regard only
to their representation on flat surfaces, but the problem
may be solved to some extent—it is frequently impossible
to do so completely—by carefully adjusting the crest and
helm to each other and by placing them in the aspect
that produces the best effect and at the same time ex-
presses their character most fully ; and for this a sketch
model in clay or other plastic material will be found
very helpful.

The leaving out of sight of all methods and materials

other than those employed for the immediate purpose in hand has resulted in most unfortunate, and in some cases ridiculous, crests which could never have been used in the ancient way, and now if they have to be carved in relief or in the round, as mural decoration or as the newel of a stairway, show themselves wholly inadaptable to reasonable treatment. On the other hand the early crests are always " possible," for the mediaeval herald was naturally familiar with the appearance of an actual crest modelled in the round, though he may never have modelled one himself, and so his design is always structurally right. But what can be said for some modern examples, a dove flying over water for instance? It seems to have been forgotten until recently that heraldry ever had a real existence or could possibly be carried out in more than one way, and the result was that anything that was suitable to a flat shield was thought equally appropriate for a crest so long as it was sufficiently differenced from other bearings. A few experiments with a lump of clay would have shown the fallacy of this idea, and incidentally might have saved many a family, often in spite of itself, from being labelled for ever with an absurd bearing.

As, however, we cannot always choose the heraldic motives with which we have to deal we must make the best of the refractory ones, as well as of the rest, and the structural side of the subject may be regarded as the direction in which the solution of difficult problems may be found. As an example, let us take a rampant lion and pose it on a helm, and it becomes obvious that if it is taken from a shield without modification it will

look ridiculously insecure on one leg as it is generally posed, Fig. 150, but that it is much improved if arranged in firmer relation to its base, the helm, as in Fig. 151.

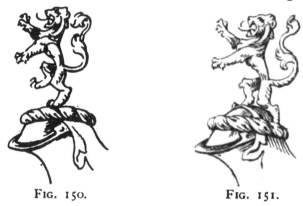

FIG. 150. FIG. 151.

Another difficult kind of crest is that which is differenced with a row of objects in front. For instance : In front of a tower between two wings three fleurs-de-lis ; which is usually drawn as Fig. 152, although wings would never have been modelled fore and aft in that way. If the solidity of a crest is kept in mind the model would come out

FIG. 152. FIG. 153.

something like Fig. 153, and on similar lines the most unpromising material may with a little pains be made presentable by the use of sketch models in the round.

▶ When two helmets and crests occur together they turn towards each other and so naturally help the unity of design, and when there are three, the outer ones turn similarly towards that in the centre. If, however, the crest be of such a nature that it cannot be turned about, it will of course be preferable for the crest to dictate the position of the helm rather than to repeat the senseless fault of the helm and crest facing different ways.

The arrangement about the helmet of the Torse or Wreath is of considerable importance. It should always be treated as a silken favour wreathed round the helmet, and not as a support for the crest, to which it is merely a decorative accessory. An unfortunate phrase which has been used in blazoning crests, from as early as the sixteenth century, may be answerable for much ridiculous treatment of the wreath as a solid object, viz., *On* a wreath, etc., which suggests a material connexion between it and the crest, and resulted in the stiff rods which were balanced on their centres, or, when two crests were used, were treated as platforms on which the crests stood on either side of, and away from, the helmet.

That this method of blazoning a crest is not unavoidable is evident in a draft of the grant of a crest to the Grocers Company of London in which the formula is " uppon the healme a camell golde bryded sable berynge two bagges of peper," etc.

In early times the colours of the torse had no relation to those of the shield, being adopted in a purely fanciful way, but in the course of time the present custom was arrived at, namely, that the wreath should consist of

the principal metal and colours of the arms, as shown by their priority, in the blazon.

As the torse was composed of pieces of silk of different colours twisted together, the colours appear alternately, six spaces being generally shown, their alternation beginning on the dexter side with the metal, as most heraldic alternations do, for the idea was that metal was more "worthy" than colour, but there is nothing essential in this. In some instances the torse resembles drapery cut into leaves, as in Fig. 154, a fifteenth-century example from the Palazzo del Podesta, Florence.

FIG. 154.

Its place is sometimes taken by a decorative circlet called a crest coronet, which, however, is no indication of rank, though it is probably derived from the practice at a time before coronets signified specific degrees of nobility, when it often appears encircling the helmets of personages of high rank. Later, when coronets were beginning to take the form that soon became regular, the crest of a Peer was made to issue from a coronet, as in that of Richard Earl of Warwick, on his tomb. An excellent practice, and one quite in harmony with heraldic feeling, that there has been some attempt to revive in modern times. Other coronets that occur in crests and are also used as charges are described at p. 271.

The MANTLING or LAMBREQUIN, that depends from the helmet, and is a most valuable asset to the de-signer, was derived from some such protection to the helmet as the surcoat was to the body armour, and like it was soon made to serve decorative purposes. The surcoats, mantles and other garments of the four-

teenth century, being ornamented with dagged edges cut into various tongue-shaped patterns, the mantling naturally followed their example and thence proceeded to other ornamental development, very simply at first, but continuing with ever-increasing elaboration until it became, in many instances, similar to the contemporary architectural tracery. Its early form is shown in Fig. 155, and the beginning of its decorative development in Fig. 156. An even earlier instance of dagged edges to drapery occurs on Trajan's column, in the decoration of a tent.

FIG. 155.

Though the mantling probably remained comparatively simple in actual use its treatment in the illuminated

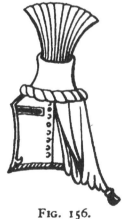

FIG. 156.

MSS. and on monuments shows a very ready acceptance of its ornamental possibilities, both as a decorative adjunct to the armorials and also as a link between them and other decoration. During the Middle Ages it followed the method of the Gothic tracery in dividing and sub-dividing in groups of three, which curved and interlaced in infinite variety.

In addition to being laced to the helm it was, in some cases, secured by two straps which were rivetted to the helm on either side and buckled at the back. It was also frequently decorated with badges, and in some cases the coat of arms was wholly repeated on it. It sometimes took the form of a cap which fitted over the

helm, and was continued behind, and a curious example
of a tourney helm with such an ornament is Fig. 157, after

Viollet-le-duc, which is part
of the equipment of a knight
about to tourney, whose sur-
coat is charged with a double-
headed eagle, and, he being
about to encounter with swords
and therefore having no shield,
the charge is repeated on the
helm in the bold and effective
manner here shown. On the
stall plate of Gaston de Foix
as a Knight of the Garter,
part of whose arms is Or three
pallets Gules, the mantling has one side similarly striped
with gold and red. Examples of mantling charged with
badges are also to be found on the Garter stall-plates.

FIG. 157.

The practice of decorating the surface of mantling
is still carried out to some extent in that of a Knight of
the Garter, as it hangs over his stall in St. George's Chapel,
the coloured side being sewn with a twisted ornament
in lace and spangles. The edges are jagged with cuts
in accordance with the theory that that was the origin
of the ornamental form. A far-fetched reason for what
was after all a purely ornamental development.

The office of mantling being a purely decorative one
suggests that its treatment, as form, should be such as
to support and supplement the lines of the shield and
its contents, and to assist in linking together the whole
composition. It will therefore avail itself of the well-known

Bookplate of John Stabius, Professor of
Mathematics. Dürer.

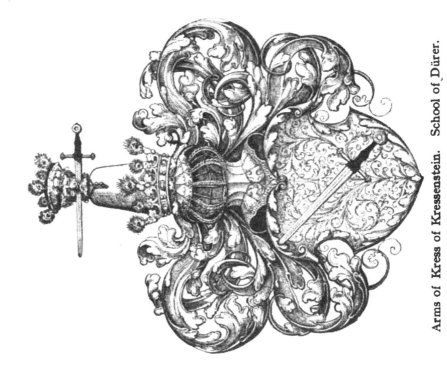

Arms of Kress of Kressenstein. School of Dürer.

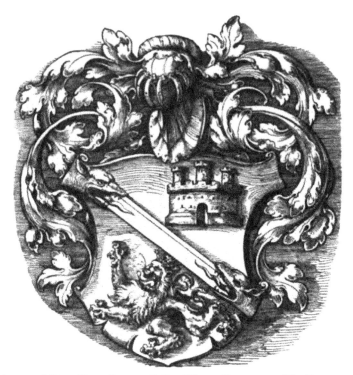

Arms of Don Pero Lasso di Castilla. German, 16th Century.

Armorials by Dürer.

power of curves to emphasize what they enclose and will find endless variety of design in the way its lines may be made to help each other in direction and force.

The facility of folding over the edges will be found extremely useful in correcting balance as well in form as in tone and colour, and its use in this way is practically without limit. Such foldings should of course be designed in due relation to the general direction of the mantling, so as to assist its swing and flow, or else be obviously and intentionally opposed to it. In other words, there should be intention in every detail.

It will also be noticed how valuable are straight lines, either in the Arms or as the top of the shield, to play against the curves.

It has been indicated that the treatment as regards form is practically untrammelled, but as to colour there are certain rules that must be observed. In the Middle Ages there were no rules other than sumptuary laws, to which it is probably due that ermine came to be painted on mantlings and caps of maintenance in the same conventional way that it appeared on the shield. Otherwise, mantlings were merely governed by fancy until late in the sixteenth century, except that in the latter part of that period it had become customary for those of Peers to be doubled, i.e. lined, with Ermine. With the seventeenth century began a uniform mantling of Gules ; doubled with Ermine for Peers and with Argent for those below that rank. Perhaps the colours were considered national as being taken from St. George's cross on its argent field. The present rule is for the mantling to be of the colour and metal first

mentioned in the blazon of the arms, as the torse does, and it dates from the end of the eighteenth century. The exceptions to this general rule are as follows :— The Sovereign's and the Heir Apparent's arms are mantled Or, and doubled ermine, as also are those of the other Princes of the Blood Royal. Peers formerly used the first colours of their blazon also doubled with ermine, as they still do in Scotland, but otherwise they now follow the general rule. However one may regret the older custom which produced variety of colour in the surroundings of the arms themselves and so gave scope for much beautiful arrangement, the established custom should certainly be observed, however reluctantly, and colour relief be obtained in other ways ; such as by treatment of the background where such is practicable. Of course modification of tone still remains available.

It is sometimes held that arms that were granted at the time when red and white mantlings were usual, and were mentioned in the blazon of the Grant, should now and henceforth be so accompanied, and this would seem to be a case when choice of method would be legitimate. The description in the blazon, usually so binding, is here of little force, for it was in such cases a mere routine phrase which conveyed no distinction of one case from another, and the change of official custom may be taken to have superseded the former rule. Certainly it is not permissible nowadays to colour the mantling without reference to the arms or without warrant from properly transmitted custom.

CHAPTER VII

Armorial Accessories

THE armorial shield, and, in a rather less degree, the crest, are in an especial sense essential parts of an heraldic achievement, and have always been considered fully representative of their bearers. Therefore they may be used together, or singly, without the supporters or other accessories to which their owner may be entitled. On the other hand, supporters, though they may be employed without the arms to support badges or monograms, have, in that case, little more than the force of fanciful devices.

Supporters were in their origin badges which had acquired permanence by custom in the same way that the arms of the shield had acquired it at an earlier time. Thus, in addition to the regular armorials which so profusely adorned the Seals, certain badges were freely used which from association acquired in many cases a permanence by frequent recurrence equal to that of the arms with which they were associated. In this way lions appear in many of

FIG. 158.—Seal of John de Segrave (c. 1300).

the Great Seals'
notably in those of
Edward III and in
the beautiful seal
of Henry IV. Such
emblems were
placed decora-
tively in any spaces
that were suitable,
and in the simpler
seals the intervals
between the cir-
cumscription and
the more or less
triangular shield

FIG. 159.—Seal of Anne Countess of
Devon.

within it invited their display, as in Fig. 158, the seal
of John de Segrave
(c. 1300), which has a
garb on either side of
the shield. In Fig.
159, the seal of Anne
Countess of Devon,
lions occupy similar
spaces, but with their
backs to the shields.
The seal of Ralph
Neville, Earl of West-
moreland, Fig. 160,
shows greyhounds,
which, though of sub-
ordinate proportion,

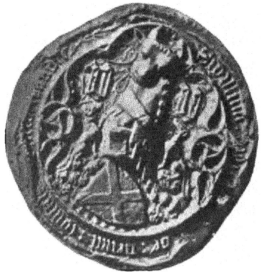

FIG. 160.—Seal of Ralph Neville, Earl of
Westmoreland.

have assumed the regular pose of supporters; while in the splendid seal of Edmond Beaufort, Duke of Somerset, Fig. 161, the finely designed supporting figures have complete heraldic force. Another fine example is that of William Lord Hastings, Fig. 162. The con-

FIG. 161.—Seal of Edmond Beaufort, Duke of Somerset.

nexion between ancient Badges and the Supporters in present use is easily traced, and, as one instance of many, it will suffice to mention the white lion Badge of Mowbray, which has become one of the supporters of the Duke of Norfolk. The actual recognized use of these accessories appears to have begun at the end of the fourteenth century; and to have become firmly established in the following one.

FIG. 162.—Seal of William Lord Hastings. Fifteenth Century.

The idea that supporters originated in fantastically dressed pages at a tournament seems to have little or no foundation, and though there may have been some such representation of already established devices, later statements on the subject have probably been much over-valued.

Viollet-le-duc quotes an instance of a celebrated tournament, which was held on May Day, 1346, at Chambery, when Amedee VI of Savoy had his shield hung on a tree and guarded by two lions. The interesting fact is mentioned that the shields, helms and crests of the knights who figured at this tournament remained in the Church of St. Francis at Chambery, until 1660 or thereabouts. Then the church was redecorated, and in the disregard for antiquity, which we find so difficult to understand, the relics of chivalry disappeared.

At first and for a considerable time the proportion of supporters to the arms was very satisfactory, being bold without over emphasis, but during the sixteenth and following centuries, a tendency to increase their size was felt, and it is in this respect that modern sculptured heraldry is lacking in balance, for to over-accentuate the supporters is necessarily to minimize the arms, and so divert interest from the central motive.

When the space to be filled by the achievement demands it, the pose of the supporters may be varied to a considerable extent, but the rampant position should always be adhered to when it is possible. Where, for instance, the space is wide, as on a mantelpiece, there is no heraldic objection to placing the figures in a couchant position on either side of the shield, an

arrangement that has been frequently resorted to in Friezes.

‣ Sanction is given to this freedom of treatment by the fact that it is not usual in blazoning supporters to specify the heraldic attitude, except in so far as it affects the pose of the head. That is to say, if the head is in the normal position, in profile, the figure is blazoned, for example, a lion Or. If it were guardant or regardant, the fact would likewise be mentioned but not the general pose, rampant or anything else.

In the fifteenth and sixteenth centuries the supporters were sometimes employed in pairs, and sometimes singly, to hold up the banners of arms that were represented in heraldic manuscripts or sculptured on monuments, and they were then usually placed in a sejant position. In some instances, more frequent in Italy and Germany than in this country, supporters bear crested helms on their heads in a very curious way. An English instance is on the seal of Edmond Mortimer, A.D. 1372, mentioned by Boutell.

On the seals of the fifteenth century onwards, the supporters were freely adapted to the available spaces, without much, if any, regard for actual physical support to any other part of the achievement. It was heraldically sufficient that they were present, and the rest was left to the taste and skill of the designer.

The variety of supporters has of course increased with the number of those entitled to bear them, and creatures are now used which, though perfectly suitable in an allusive way, are not equally adapted to the ordinary heraldic treatment, and the result of working in an outworn groove

appears when Troop horses, Camels, Elephants, and so forth are seen climbing up the side of a shield, instead of standing beside it. Admit that the rampant attitude in an animal that does not ramp is not obligatory, and the difficulty is easily overcome with every advantage to the dignity of the composition.

The idea of moral support would also be much to the advantage of symbolic human figures that are already burdened in a variety of ways, for the sight of a figure, with both hands full, trying to obey a non-existent law as to touching the shield that it "supports" is pathetically ridiculous. Nevertheless, the hold on the shield is of value in linking a design together, when it can be effected without violence to ease and probability.

Too great freedom of natural treatment is not desirable, for it is out of harmony with the especial decorative quality of heraldry, so that one objects to the natural animal supporters that characterized the illustrations of the eighteenth century, prowling from behind the shields, not as heraldic error, but as wanting in dignity as decorative design.

As a general rule, with some few special exceptions, the right to bear supporters is confined to Peers and Peeresses and to the highest classes, Knights Grand Cross or analogous ranks, of Orders of Knighthood. Knights of the Garter, of the Thistle, or of S. Patrick are entitled as such to bear Supporters, but as members of those orders are now invariably Peers, the question does not arise.

Figures of Angels and Amorini that are not considered to have the technical qualification of heraldic supporters

FIG. 163.—Amorini Supporters from Venice.

are of constant occurrence in ornamental art, and symbol-
ical figures holding the shields of arms are posed in the
spandrels of arches with admirable effect and perfect
propriety, and the fact that symbolic figures are sometimes
adopted as actual heraldic supporters can hardly be
allowed to cramp decorative art in so important a par-
ticular, nevertheless the distinction should be recognized.

At Venice there is an admirably designed incised
tablet in which Amorini stand beside the shield, each
supporting on a pole one of the two large crests, Fig.
163; and the demi-angels which support the Royal Arms
on the spandrels of the screen of Henry V. Chantry at
Westminster, and the series of similar figures holding
Badges in various parts of the Abbey should also be noted.

Another admirable work in which Amorini figure is
the fine panel of the Arms of Cardinal Wolsey, which
faces the Crown Court at Hampton Court Palace, Fig.
164, a work that is no less remarkable for the strength
and bold relief of its heraldry than for the grace and
beautiful modelling of the figures.

Under the head of supporters reference may also be
made to the eagles, double or single headed, on which
in certain cases armorials are borne as a mark of special
privilege. The arms of Princes and Peers of the Holy
Roman Empire are borne on the double-headed Imperial
Eagle, like those of the Duke of Marlborough as Prince
of Mindelheim, as a privilege inherent in their rank. The
single-headed eagle of the Kingdom of Prussia supports
in a similar way the armorials of The Countess of Derby,
to one of whose ancestors, Lord Carnarvon, Ambassador
at Berlin at the end of the seventeenth century, the

privilege was granted by Frederick William I. It therefore appears on her book plate, which I am permitted to reproduce here, Fig. 165.

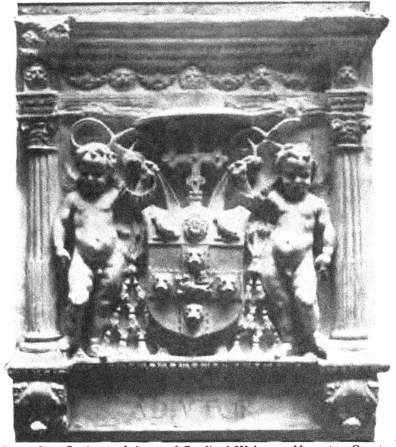

FIG. 164.—Sculptured Arms of Cardinal Wolsey. Hampton Court Palace.

Other accessories consist of Crowns, Coronets, Insignia of Order of Knighthood, Mottoes, Symbols of Office, Medals or any other emblem of personal dignity or ornament.

The principal of these, the Imperial Crown, was, in its earliest form, a decorated circlet which was frequently of a most beautiful and elaborate character, but whose decoration, apart from its general form, had not acquired specific symbolic force, unless the fleur-de-lis that sometimes appeared as part of it may be so regarded. If so, it was probably introduced with the same idea of religious symbolism, as an emblem of the Resurrection, or of the Virgin Mary, or of the Trinity, which caused it to be used on sceptres and in other ways. The crowns of the early seals show traces of arches in some instances, but it was only in the time of Henry V that the crown, the one that succeeded the "golden care" of Shakespeare, finally became arched.

The number of the arches, as of the fleurs-de-lis and the crosses pattée that were added, varied from time to time, but since the restoration of Charles II the essential details have remained constant, though the general shape has changed with the contemporary taste in other ornament. A considerable variety of form is also found in the same period, the arches in Tudor times having sometimes the Gothic pointed character, as it appears in Fig. 166, on the reverse of the beautiful golden Bulla with which Henry VIII sealed the treaty of the Field of the Cloth of Gold. In this instance it will be observed that the number of arches is doubled, and the fleurs-de-lis and crosses pattée proportionately increased. In a similar way the Scottish Royal Crown is represented with an unusually large number of crosses and fleurs-de-lis on the rim.

In other examples, notably those sculptured on St.

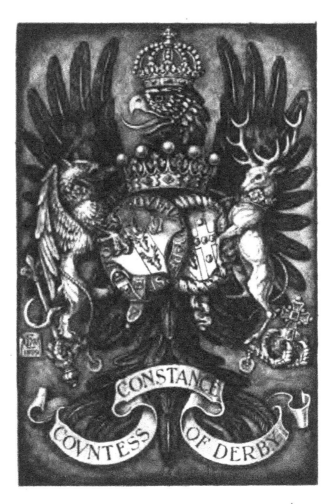

FIG. 165.—The Countess of Derby's Bookplate.
Geo. W. Eve.

George's Chapel in Windsor Castle, the arch is much flattened and the crosses and fleurs-de-lis stand high on the rim, thus producing a certain squareness which is very happily suggestive of strength. It was this type of crown that influenced the treatment of those on the present Royal bookplates. In the seventeenth century the arches were depressed where they cross, and in the Georgian period the extent of the depression was very considerable, as may be seen in the maces of that time.

It seems to evidence the want of intention, and that ignoring of symbolic value that was characteristic of the time, for otherwise the idea would cer-

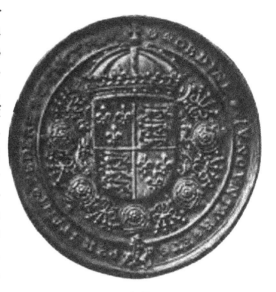

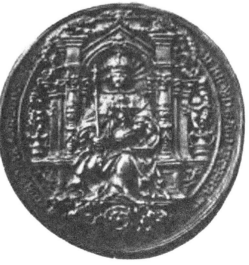

FIG. 166.—Golden Bulla with which the Treaty of the Field of the Cloth of Gold was Sealed. Sixteenth Century.

tainly have suggested itself that the orb, the emblem of sovereignty, should be held strongly up, and the crown be made to suggest its adequacy to its pre-eminent dignity.

Doubtless this was in sympathy with the somewhat heavy curves of other ornament, but its effect is commonplace, weak and unfortunate. The general character of the present-day shape is a return to the more beautiful pointed arch, and Fig. 167 is the form approved by His Majesty for official use. It is to be understood that

FIG. 167.—The Royal Crown as sanctioned for official use.

this does not refer to the actual crown, which has remained much as it was in the time of Charles II, but to its heraldic equivalent.

The decoration of the arches may take many forms, sometimes consisting of large pearls, as in the usual way, sometimes of architectural crockets as in much of the carved decoration, or as jewelled running ornament composed of national Badges, or of oak-leaves and acorns as in that which is known as the Imperial State Crown. A fine example of the Tudor crown occurs in the stained glass roundel of the Arms of Queen Jane Seymour, in which the arches are crocketted, and the crosses have the cusped character that was prevalent at this period, Fig. 168.

In the jewels on the rim, no attempt is usually made to copy those of the actual crown and great variety of jewelled decoration is therefore possible. The gems are most often represented of antique form, that is to say, cut *en cabuchon*, instead of in facets, thus presenting

a decorative simplicity that is very suitable to ornamental effect.

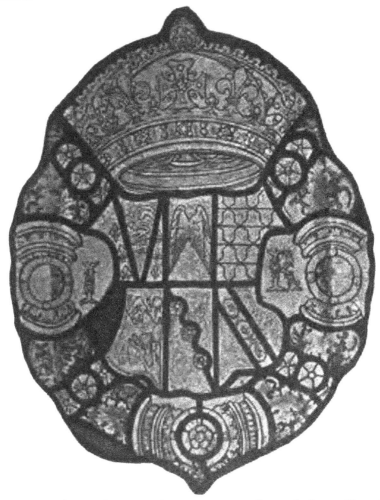

FIG. 168.—Arms of Queen Jane Seymour, Stained Glass Roundel. Sixteenth Century.

With regard to the cross on the orb the former remarks concerning crosses pattée are especially applicable, and in addition it should be observed how much more satis-

factory it is for the lines of the lower limb of the cross to be produced from the circumference of the orb than for the corners to be projected beyond it. In the latter case the cross has the unfortunate effect of being balanced on the orb instead of rising from and being part of it.

The essential form of the crown, then, is a circlet heightened with crosses and fleurs-de-lis alternately, from which rise two arches that spring from behind the crosses pattée and uphold the orb, which is itself surmounted by a cross.

Care is necessary in order that the curves of the arches may be kept sufficiently flat, for otherwise too much tendency to a half-circle may result.

The crosses and fleurs-de-lis offer remarkable opportunities for strong, graceful, and varied treatment, and if they are kept fairly high, and well defined, the dignity of the design is much enhanced.

The cap which is enclosed in the actual crown is of purple velvet, but is represented heraldically as of crimson, and is lined with ermine, which being turned up at the edge, appears round the lower rim.

The Coronets of the sons and daughters of the Sovereign have similar circlets to that of the crown, but are not enarched, except in the case of the Prince of Wales, who has one arch supporting an orb. The latter coronet is usually drawn from a point of view from which the complete arch is seen spreading from side to side. Fig. 169.

Other Princes and Princesses bear coronets that are varied according to nearness to the Throne, the grandchildren of the Sovereign having ducal leaves in place of two of the crosses, while nephews have similar leaves

in place of all the fleurs-de-lis. This must not be taken as an invariable rule of heraldry but as an indication of the system that is observed in framing the Royal Warrants by which alone the right to these coronets, and also to the Royal marks of cadency (q.v.) is conferred.

FIG. 169.—Coronet of the Prince of Wales.

Royal coronets, other than that of the Prince of Wales, do not change automatically as private marks of cadency do, but being arranged under the same Royal Warrant by which the arms are assigned, they remain as so designated until they are changed by the same authority.

The Coronets of Peers were definitely assigned to the various ranks by warrant of Charles II, having by that time become developed into distinctive forms, as the Crown had been, from the circlets which in themselves were marks of high rank and were so used ceremonially in conferring 'a title.

The coronet of a Duke is composed of eight ornamental leaves of equal height, wrongly called strawberry leaves, set on a rim which is ornamented with jewel-like tracery but not with actual gems. Eight being the full number of leaves, five of which are visible in representation.

A Marquis's coronet has four leaves alternately with an equal number of silver balls, called pearls, which are set on points to the height of the leaves, and the coronet is always represented as so posed that three leaves and two balls are visible. It is directed that in all

coronets the balls shall be of silver and not counterfeit pearls.

An Earl's coronet has eight balls raised on high points and showing between them leaves which are set low down. Five balls and four alternate leaves are usually shown. This form is evidently derived from the beautiful coronet that is sculptured on the tomb of Thomas Fitzalan, Earl of Arundel, 1445, and in the same way that the coronet of another Earl of Arundel (A.D. 1487) foreshadowed that of a duke. The former of these is very fine, having groups of three pearls on alternate points, and with the leaves also on points to the same height as the others.

A Viscount's coronet is a circle with surface decorations which, like all the preceding, is as in that of a Duke and has sixteen silver balls set close on the rim, and of them nine are shown.

A Baron's coronet has six silver balls, also set directly on the rim and not on points, the circlet in this instance being plain, i.e., without indications of jewel forms.

In the warrant of Charles II it is directed that all the coronets shall be worn over a cap of crimson velvet lined with ermine, and having a tassel of gold at the top. This cap, however, is not an essential part of the coronet, although a head covering of considerable distinction in itself. During the greater part of the Middle Ages the temporal peerage consisted principally of earls and barons, the former distinguished by the circlet of gold, which was variously decorated, and the latter by a cap of crimson lined with fur. For military purposes, the coronet was fixed to the helmet, and at other times it was placed, for practical reasons of comfort among others,

round the cap which formed part of contemporary cos-
tume, as may be seen in many of the beautiful French and
Italian medals of the fifteenth century, notably in one
of Louis XII at the end of that period. Fig. 143.
In another composition of about the same time, a head
of King Herod has a crown which encircles a cap of the
shape usually ascribed, in modern times, to a Cap of Main-
tenance. The last-named head covering is one of much
interest as an early subject of privilege, although but
little appears to be known about it. Its shape was
obviously not its distinctive quality, and it must therefore
have been the material or colour which constituted its
especial value; and having regard to the sumptuary
restrictions concerning the wearing of ermine, among
other things, it seems probable that its lining of this fur
was its distinctive quality, and that being prohibited to
those of inferior rank, it would naturally be the cap that
would be associated with a coronet when it was actually
worn. Thus was formed the prototype of the coronets as
described in the warrants of the end of the seventeenth
century, when caps of this character had ceased to be part
of the ordinary costume of people of position. The cap is
therefore a means of wearing the coronet and no indication
of definite rank and may certainly be omitted in heraldic
design, since it adds nothing to what is signified by the
coronet itself and is not an essential part of it.

This view would appear to have been the contemporary
official one, for many of the Garter plates subsequent to
the warrant of Charles II have no caps to the coronets,
and that of John, Duke of Argyle, 1700, may be cited as
an example, among others.

By the before-mentioned warrant, the use of the ermine-lined caps was extended to barons equally with other ranks of the peerage.

The rank of Baronet, also hereditary, is of two classes, one of which was instituted in 1611 to encourage the plantation of Ulster, and the other in 1624 for the plantation of Nova Scotia. All new creations of the rank of baronet are of the former kind, and the Badge consists of the well-known red hand of Ulster on an argent field. This is borne on the coat of arms either on a canton or on a small escutcheon, whichever is most convenient, and if the latter it may be anywhere on the main shield in the same way that a mark of cadency is placed. The Badge of a Baronet of Nova Scotia is an actual jewel like that of an order and usually appears below the shield pendent from its ribbon of orange tawny silk. It is also worn round the neck like the insignia of an order, and consists of an oval medallion on which is the Cross of St. Andrew behind a shield ensigned with the Imperial crown and charged with the Arms of Scotland, and on the margin of the badge is the motto "Fax mentis honestæ gloria."

The Insignia of Orders of Knighthood are also among the most important and decorative accessories, either surrounding the shield, such as collars, the Garter, and the motto circle of other orders ; or suspended below it as crosses and jewels.

Knights of the Garter surround the shields of their arms with representations of the Garter inscribed with the motto of the order, "Honi soit qui mal y pense," in the well-known way. It was formerly light blue, but since the time of George I has been of the dark rich colour to which it

has given the name of Garter Blue. The buckle, motto and other embellishments are of gold and it is now edged

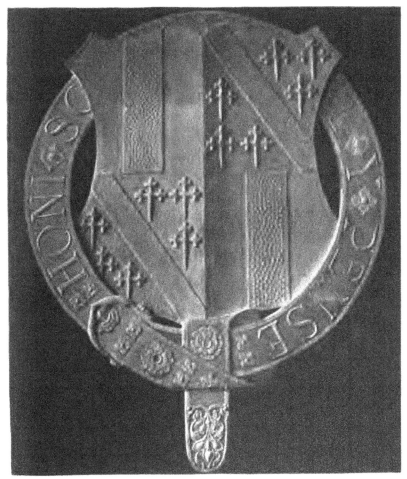

FIG. 170.—Arms of John second Earl of Mar, K.G., 1634. Modelled gesso, afterwards painted. Geo. W. Eve.

with the same. This last, however, is purely decorative, but has become usual from about the sixteenth century. The motto begins above the buckle, which is always

placed in the dexter side, and may be in any character of lettering that seems fit. Fig. 170 shows a gartered shield from the series at Alloa House. The collar consists of twenty-six small garters (in allusion to the Sovereign and twenty-five Knight Companions), each enclosing a rose, alternately with an equal number of knots, the whole being joined together with links of gold. It is notable that the roses are Tudor ones, the collar having been added to the insignia of the great Order by Henry VII, and are a red rose within a white one and a white within a red alternately. Depending from the collar is the representation of St. George slaying the Dragon, the jewel which is known as the Great George. Composed of gold and enamel it was frequently richly jewelled, and otherwise treated as a splendid subject for artistic elaboration. When the collar is used with the arms it is placed outside the Garter. These constitute the insignia that are immediately associated with the shield, but there are in addition the Star, the Ribbon and the Lesser George. The Star is worn on the left breast, consists of groups of rays, in silver or diamonds, arranged in eight points, and bearing in the centre the enamelled Cross of St. George encircled with the Garter.

The Lesser George, the jewel which is worn pendent at the side from the ribbon of the order which is worn over the left shoulder, consists of an oval badge of a similar group to that of the Great George, but placed within the Garter which forms a frame to the badge. It will be noticed that the Great George has no containing form. The Collar when it surrounds the shield is placed outside

the Garter, and either one or both may be used to enclose a crest or other device. In thus using the collar of an order in a decorative way, it will not be necessary to represent the actual number of pieces in it, but only their nature and the proper order in which they occur, and a considerable latitude may be taken in treating the details so long as their essential character remains clear.

The custom of encircling arms with the Garter has influenced the whole British practice with regard to orders of knighthood, other orders using in a similar way the motto-circle which forms part of their badge.

The foreign practice is to use the collar with its badge to surround the arms, or in other cases to suspend a badge from its riband below the shield.

A knight of several orders uses principally that which is of superior rank either alone or in conjunction with others. In the latter case the emblem of the superior is innermost in surrounding the shield ; and is the dexter of two, or the most central of a greater number, when dependent from it. When, however, some special allusion is intended the insignia of an inferior order may be used alone.

Thus in the case of an achievement that was to be used in connexion with a specific order, the insignia of that order would be properly used to the exclusion of one of superior rank.

It will be understood that the heraldic bearing of such insignia is a privilege that need not always be exercised, and when it is, may be used in a variety of ways. Thus the Garter may closely surround the shield in the familiar way or may encircle the whole achievement as in some

coins and medals, or even be straightened out as in the design of some of the Tudor bookbindings.

In view of cases that have actually occurred, it should be noted that stars of orders must not be suspended below a shield as a badge may be, though they may be embodied in accessory design in a suitable way. That is to say, that only those decorations should hang below the shield which actually have a pendent character and hang from collars, ribbons, and so forth, while stars may decorate panels, be enclosed in tracery, or be employed in any other way that is not unsuitable to their naturally *appliqué* character.

The Order of the Thistle has a Collar composed of thistles alternating with a badge made of four sprigs of the ancient rue interlaced, the whole being enamelled in the proper colours. Depending from the centre thistle of the collar is the Badge, a star of eight points bearing the figure of St. Andrew supporting his white cross. His gown is green and the surcoat purple, and he stands on a mount of green. When not used with the collar the Jewel hangs from the dark green ribbon that is worn over the left shoulder. Fig. 171 from the series at Alloa House shows a method of treating the collar in gesso photographed before painting. The star of the order consists of a silver St. Andrew's cross having rays issuing from its angles and bearing in the centre a thistle within a circle of green enamel, that is edged with gold and bears in golden letters the motto, " Nemo me impune lacessit." It is this circle and motto that are placed round the shields of the knights of the order and sometimes with the collar in addition.

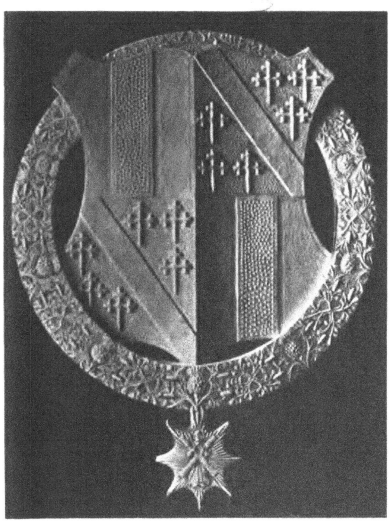

FIG. 171.—Shield with Collar of the Order of the Thistle.
Arms of John, sixth Earl of Mar, K.T. Gesso,
before painting. Geo. W. Eve.

M

The Knights of the Order of St. Patrick surround their arms with the sky-blue circle of that order inscribed with the motto, "Quis separabit," and the date MDCCLXXXIII. The Collar is composed of roses and harps alternately, tied together with knots of gold. The roses are double and are white within red, and red within white alternately, like those of the Garter collar. In the centre is an imperial crown ensigning a harp from which hangs the badge of gold, oval in shape, and surrounded with a wreath of shamrocks which encloses the circle of light blue enamel on which is the motto and the date MDCCLXXXIII in golden letters. Within the circle is the cross of St. Patrick, Gules on a field Argent, surmounted with a trefoil slipped and with each of its leaves charged with an imperial crown, Or. The star is of eight points, the perpendicular and horizontal rays being larger than the diagonal ones, and bears the device within a motto circle exactly similar to those of the badge, but without the shamrock wreath. These are the three principal orders which form a group that is somewhat apart from the rest.

In the foregoing orders consisting, as was customary in earlier times, of a Grand Master and of Knight Companions ranking equally among themselves, the amount of insignia associated with their arms is unimportant as a mark of rank, the simplest being equally efficacious heraldically with the more elaborate. In the case, however, of orders which are divided into classes, the different parts of the insignia have acquired a special importance as indications of rank within the order which must be very carefully observed.

Taking the Order of the Bath as typical, the lowest rank, that of Companion (C.B.), is shown by suspending the badge below the shield. The next grade, Knight Commander (K.C.B.), in addition to the suspended badge, encircles the shield with the motto of the order. And finally, a Knight Grand Cross (G.C.B.) adds to the preceding the collar of the order round his arms, outside the motto circle. It must be noted that the order has two divisions, civil and military, whose badges differ. The rest of their insignia is identical, except that a wreath of laurel accompanies the motto circle of the Military Division.

CHAPTER VIII

Methods and Materials

THE methods of painting heraldry have changed very little from those that were employed in the early MSS. In the unfinished Bible at Winchester Cathedral, of which the illuminations are in every stage of progress from the sketch to the finished work, the sequence is clearly shown. First, the design lightly sketched in with fine charcoal or a leaden stylus, then carefully gone over with a black line. The gold masses put in and burnished and then the colour. Shading and correction of the outline followed, and finally the high lights put a finish to the work.

Vellum, a fine parchment made of calf skin, is the most suitable surface for heraldic painting in watercolour, although paper, which includes various " boards," is useful for students' work and for preliminary drawings. The colours bear up, and gold acquires an appearance of solidity on vellum which cannot be obtained on paper. No doubt the surface is somewhat difficult to deal with at first and painting on it has a technique of its own, but there is nothing that cannot be overcome if it is approached in a practical way. The colour of vellum varies from a yellowish white to darkish

ivory colour, a variety that is due to the natural colour of the skin. It can also be obtained in positive colours, the kind that is used in book-binding. It is somewhat thickly coated on one side with a chalky preparation, and if this side, the front, is used it requires delicate handling, for it is easily injured by the scraping that may be necessary for erasure, so that a rough spot of skin appears through the preparation and the surface can only be restored with great difficulty. Unless, therefore, it is necessary to use both sides as for a leaf of a book, the back of the skin will be found preferable. It is a little darker in tone and not quite so smooth, is tolerably hard and bears erasure well, but the knife requires deft handling, and then small corrections can be made with it successfully, for colours do not penetrate vellum very far, though when properly prepared they adhere to the surface with ample tenacity. It will be found very desirable to keep vellum clean rather than to trust to subsequent cleaning.

As it is difficult to properly remove pencil marks except with the knife, the design should first be made as fully as necessary on paper or other surface, and transferred to the vellum by tracing or rubbing down or by pouncing. The best way of transferring a design is to go carefully over the back of a tracing of it with a sharp pencil and having carefully placed it in position on the vellum to rub it down with a knife held slanting, a palette knife will do very well, and in that way the lines are clearly transferred to the vellum without the depression on the surface that a point is likely to make. Tracing down the design with a style and coloured transfer paper is

less satisfactory owing to the blurring of the line, unless the point used is very sharp and then it is likely to cut through. In making the preliminary design the colour composition with regard to such parts as are susceptible of free treatment (such as the mantling) should be carefully noted so that nothing experimental need be tried on the vellum. Unless both sides of the skin are to be used it is well to strain the vellum over an ordinary frame by means of glue or with small tacks at frequent intervals, first well damping it on the reverse side to that which is to be used. A piece of cardboard should be placed between the vellum and the frame to give support to the surface and help to throw up the colour, care being taken, however, that the vellum though damp is not actually wet or it will stick to the cardboard in patches with disastrous effect. Having the design traced on the vellum the next step is to lay in the gold. This is provided in shells or cakes and is painted on very evenly with a sable brush and when dry is burnished with an agate burnisher, or a tusk does very well.

Burnishing is facilitated by first gently passing the finger tip over the gold, and a piece of card or other firm substance should be placed behind the work during the whole process, or, when a high degree of polish is desired, a piece of plate glass may take the place of the card. But it must be remembered that over-burnishing deprives the gold of its beautiful colour and tends to blackness.

The principal colours are then laid in their places and their quality will depend of course on the taste and intention of the artist, but in the absence of necessity for modification, the traditional strong brilliance will pro-

bably be sought after and the colours will be used in their fullest strength and purity. For red, Vermilion is unapproachable in its place, has great body and is therefore easy to use. For blue, Cobalt is very beautiful but is somewhat difficult to lay from its want of opacity, a quality which is not improved by the glycerine which is used in " moist " colours. French ultramarine or French Blue (it is known under various names) forms when mixed with white a fairly efficient substitute for cobalt and presents no difficulties in laying.

Green. The most brilliant is of course Emerald Green, but as it is extremely difficult to lay and easily works up it is much feared and avoided. It is very useful in combination with greens of lower tone mixed with white to lighten them. Green oxide of chromium (not chrome green) is excellent in this way and possesses good body.

The white will be Chinese White, made from oxide of zinc, which does not change colour as the lead whites do. The latter, however, are extremely useful for temporary work, such as for design that is to be carried out in other materials, when the drawing is no longer of consequence after it has served its purpose.

The difficult colours Cobalt and Emerald Green can nevertheless be laid satisfactorily by means of patient trial, the result depending on that skill of manipulation which can only come by much practice as well as on the exact degree of moisture with which the colours are used. Indeed, it may be well to point out, especially for the benefit of those who are familiar with watercolour sketching, how comparatively dry all the colours

are worked in illumination. Tints, even, are best put on with a sparely filled brush in a manner that approaches a scumble much more nearly than a wash. This will be found most troublesome in tints that are painted on the vellum itself, as in white mantling, for instance, or in objects that are " proper," and anything like a wash with a full brush being impossible, a certain amount of stippling will probably become inevitable. The work is certainly somewhat difficult, and too much disappointment, therefore, should not be felt at the failure of first efforts. Shortly, the effort should be directed to getting the colour on with as little moisture as will suffice, so that the surface of the vellum may not become wet and disturbed.

The principal masses of colour being in, such dividing or other strong lines as occur will be drawn with black. A drawing pen will probably be used for straight ones and in this also care must be taken that the black, lamp black or ivory black, is not too diluted, or it will probably spread, especially when in contact with colours that contain glycerine or waxy constituents.

This done, the next stage of the work, if it is to have the elaboration of the real illuminated MSS. rather than of the diagrammatic Rolls of Arms, will be to model up the forms with shadow colour, using carmine or crimson lake to shade vermilion with the addition of a little sepia when stronger colour is required. Blue will be shaded with French blue to the required tone, and green with darker green.

The lights may then be put in with light tones of their respective colours. Gold is shaded with a low tone of

yellow as a general shadow colour and with umber, and is sometimes high lighted with Naples yellow and white. In accessory decoration gold may be shaded with green and finished with a darker tint of the same colour.

In the colour treatment of mantling the tone may well be kept low in relation to that of the shield to which it will thus lead up and give value.

Instead of lighting with tones of their own colour the parts in which modelling is suggested, a very beautiful and decorative effect is produced by the mediaeval practice of heightening the whole design with gold in lines which coalesce into masses on the high lights and trail off into the shadows where also they help to define the form in a very effective way. This use of gold throughout the work serves at the same time to harmonize and pull the whole thing together into unity. It is a method which requires considerable skill of hand and clearness of intention, for the lines must be drawn with firm certainty, but when successful is most effectively beautiful.

In the treatment of the helmet its relative importance in the composition must not be forgotten, nor its brilliancy in combination with its central position be allowed to attract undue attention. The broad shadow which its body takes in its forward tilted position is very useful in keeping down the general tone, in colour work as well as in black and white. Also it may be remembered that helmets were themselves painted and their rivets gilt.

In painting on paper, where yellow is substituted for gold, Cadmium will be found to be the most useful kind of that colour.

Until the invention of moist colour the pigments were

obtained in powder and mixed with gum water, a great
deal of small knowledge being required in order that the
colours should not rub off the surface on the one hand,
or crack or otherwise misbehave on the other. Gold was
mixed in the same way, but if with too little gum it
rubbed off and if with too much it refused to burnish.
Nevertheless, the colours when so mixed have a certain
advantage in having more body, and a better because
less waxy surface. However, the greater convenience
of moist colour is undoubted and in some of them the
surface is very good. So-named luminous body colour
made by Newman of Soho Square has been recently
tried with very satisfactory results, the cobalt among
the " difficult colours " being particularly good.

The notable revival of Enamelling has restored to
heraldry a very beautiful means of expression, one
which has proved from the twelfth century downwards
to be especially suitable to its subject, as well from its
broad simplicity of treatment as from its permanence
and beauty. In this connexion one's thoughts inevitably
turn to the stall plates of the Knights of that Most
Noble Order of the Garter in its Chapel in Windsor Castle,
and one is led to hope that they may once again be done
in a way not unworthy of their splendid and monumental
predecessors of the old days.

Enamel entered to an enormous extent into the decora-
tive metal work of the Middle Ages. Altars, Church
vessels, and crosiers, caskets, nefs and other domestic
objects, the girdles and clasps for ladies' use, as well
as the details of military trappings were among the
many things that were adorned in this manner. The

massive military belts that were worn below the hips and were indicative of high rank were especially rich in goldsmiths' work and enamels, infinite pains and enormous sums being spent on their execution.

Of the various methods of enamelling that which is known as Champlevé is especially associated with Gothic art. Among the most interesting of the personal orna-

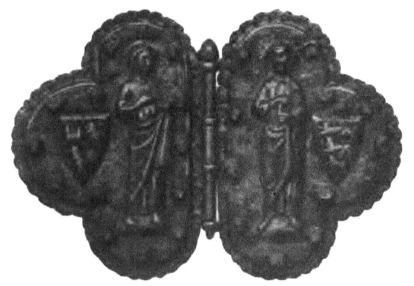

FIG.˜172.—Queen Eleanor's Cloak Clasp. Champlevé Enamel.
Thirteenth century.

ments is the cloak clasp of Queen Eleanor, wife of the warrior King Edward I (Fig. 172). Here the arms of her husband, England, with those of her own blood, Castile and Leon, unite to make a unique fastening to the Royal mantle of that Queen " of Good Memory." This clasp was probably made at Limoges, where Champlevé enamel was certainly produced as early as the latter half of the twelfth century and probably

earlier, the art having been imported, it is said, from Venice, whither it had come from the East.

At this same time heraldry was coming into systematic form, and enamel was soon employed to display it on the Royal and other monuments, beginning perhaps with the memorial slab to Geoffrey Plantagenet, Count of Anjou (father of Henry II), who died in 1151, which is now in the Museum at Le Mans.

The succeeding centuries are increasingly rich in heraldic enamels, the shields in the monuments of Edward III and his Queen, Philippa of Hainault, and on the magnificent tomb of William de Valence, Earl of Pembroke, in Westminster Abbey, may be taken as examples. The shield on the latter monument is reproduced by Boutell and others and will well repay study, especially when it is rendered in the colour which is necessary to a full appreciation of its beauty (Fig. 174).

Towards the end of the mediaeval period began the Garter Stall Plates already alluded to as still to be seen on the panels of St. George's Chapel, which date from the early fifteenth century, though some of them relate to personages of an earlier time.

These have most fortunately been brought within reach of study in the valuable facsimile reproductions in the work by Mr. St. John Hope, which includes in its scope the plates which were executed down to nearly the end of the fifteenth century. As examples of heraldic composition they are invaluable, for although the deterioration of the Gothic was already begun, they possess to a remarkable extent those decorative qualities that their modern successors so unfortunately lack.

Enamel itself consists of a rather dense glass coloured with metallic oxides, and must not be confused with the enamel colours which are employed in painting on porcelain. The latter are vitrifiable but not vitrified material; that is to say, in them the metallic colours in powder are mixed with powdered glass, and the whole becomes fluxed together when the work is fired in the kiln or muffle, while in true enamel the glass and its colouring are intimately combined from the first. By way of definition it may be said that enamel work is therefore an arrangement of one or more layers of coloured glass on fused metal.

In Champlevé work the design is first outlined on a metal plate, usually copper, and then, by means of gravers and chisel-like tools called scorpers, the space which is to receive the enamel is cut out to the necessary depth, from $\frac{1}{32}$ to $\frac{1}{20}$ of an inch, the rather rough surface that is left by the scorper serving as an additional key to the enamel (see Fig. 173), which having been ground to a powder and moistened with water, is then placed in the cavities prepared for it, and, after being carefully dried, is put into a muffle raised to a red heat, and thus fired until the enamel is fluxed. The work is then allowed to cool, is smoothed and polished, and the metal parts may then be gilt. Champlevé is usually executed in opaque enamel; that is, in glass made opaque by an admixture of oxide of tin.

In very early specimens two or more colours are found in contact in one space, but this is extremely difficult to do, and the resulting line is a somewhat ragged one in European work, though wonderful effects of opaque colours are produced by the Japanese. Since the thir-

teenth century each colour, in Western work, fills its own space.

The design, must, from the nature of the work, be kept very simple without too much subtlety of line that might

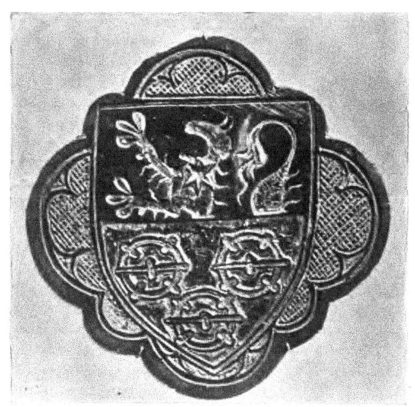

FIG. 173.—Plate prepared for Champlevé Enamel.

be lost in the cutting, and the laying of the enamel will be facilitated if the angles of small spaces are not made too pointed. The principal qualities of form will consist in good distribution and well-balanced masses rather than in expression of detail. The outlines of charges

which are in colour on metal, or vice versa, are formed by the edges of the sunk spaces and such further definition that may be required, such as the marking of the junction of the further legs with a lion's body, is effected with a line of the ground colour laid in a groove cut for the purpose. This perfectly natural method of drawing with the materials that are immediately concerned has resulted in some singularly inept modern examples of heraldry, where the limbs are deliberately represented as detached from the bodies, as though there were something mysteriously mediaeval in such an unreasoning travesty of a perfectly simple expedient.

Where one colour approaches another, as in the de Valence shield (Fig. 174), it will be necessary to leave a narrow rim of metal as an outline, and where the work is sufficiently large other details of form will be shown in a similar way. Diaper also may be thus drawn in lines of metal among colour, as is shown here in the running ornament, or by lines of colour in metal, as the case may be.

The gilt outlines of the de Valence Champlevé shield somewhat suggest the effect of Cloisonné work, the way in which the Byzantine enamels were executed; but this method has been little, if at all, employed heraldically. In it the spaces to be filled are made of flat wires that are bent to the requisite form and soldered into their places on a metal plate, and the work then proceeds as in Champlevé.

In the fifteenth century, when Renaissance art was beginning to look at things in a new way and was discovering new methods by which to express itself, a new kind of enamel work took the place of the more formal

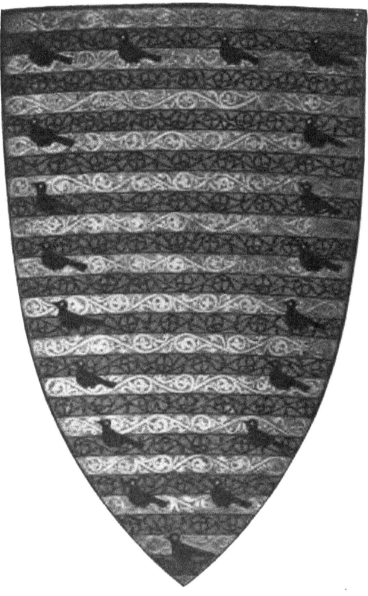

FIG. 174.—Shield on Champlevé Enamel from the Monument
to William de Valence, Earl of Pembroke, in
Westminster Abbey.

Champlevé, just as a freer kind of heraldry was about to supersede the decadent Gothic. This became known in time as "Limoges Enamel," though, as we know, that place had been celebrated for enamel in another form for hundreds of years. This painted enamel did not, however, take the place of Champlevé on monuments, rather the use of enamel in that way died out. Probably the painted plaques were too tender for the purpose, and in any case the treatment would have had to be much

FIG. 175.—Arms in Limoges Enamel. Part of a Triptych by Nardon Penicaud.

modified to bring them into harmony with monumental conditions. Although the method was new the treatment of the subjects was largely that of the missal paintings, and figure compositions, both sacred and secular, were accompanied by decorative borders into which heraldry naturally entered. Fig. 175 is an heraldic example of this method as it was practised by the celebrated Nardon Penicaud.

This kind of enamel is done on a smooth plaque of

N

thin copper or other metal which has been slightly domed for the purpose. It is covered with a coat of enamel which forms the ground, the back also being enamelled in order to equalize the contractile strains, and fired. The design is then painted in white of suitable thick- nesses, which on being fired form tones with the ground colour according to their relative opacity, and the result is called grisaille. This is a very charming form of decora- tion in itself, and is frequently done with that intention. Usually, however, coloured enamel is painted over it, the work being carefully fired at each stage, a very anxious process, and finally it may be heightened with gold after the manner of the illuminations. An additional method of obtaining decorative effects, in diapers, etc., presents itself in the power of scratching the painted gold with a needle before firing. Fig. 176, executed in this manner, is a plaque that is the property of W. H. Weldon, Esq.

From the capacity of painted enamel to imitate the effects of the illuminations it presents few technical difficulties as design. Its practice, however, is another matter, as may be imagined when the risk of the numerous firings is taken into account.

A form of enamel that is occasionally used for badges and similar heraldic subjects is that which is called bassetaille. In this method the subject, usually in the form of a medallion, is carved in low relief and the trans- parent enamel fluxed completely over it, the surface being afterwards ground and polished. The varying thickness of the enamel, from the deepest part of the relief to the highest, gives a quality of gradated colour that is extremely beautiful. In a badge or jewel of this kind

FIG. 176.—Enamelled Plaque. Crest of W. H. Weldon, Esq., C.V.O.,
Norroy King of Arms. Geo. W. Eve.

there is, of course, a rim raised to the height necessary
to contain the enamel and extending above the highest
point of the carved subject.

Still another method is that which came into use in
the fifteenth century for jewels, and is known as plique-
a-jour, a kind of transparent Cloisonné which is said to
have been produced by Cellini, who certainly knew of
it. It is an extremely difficult process, but the effect
is remarkably precious and jewel-like, the enamel being
fired into a design which has been built up of bent wire
and soldered together like Cloisonné without the bed-
plate, so that the work looks like a miniature piece of
stained glass (as indeed it is) and of great beauty. In
a similar way a design may be cut out or saw pierced
through a plate of metal and filled with enamel à jour.

In all methods of enamelling, a drawing of the design
must of necessity be first made, and it is of course
essential that the designer should have a practical know-
ledge of the methods that are concerned, the design
and the finished work being necessarily interdependent,
and though written descriptions are useful to indicate
the nature of the processes nothing can supply the
place of actual experiment under competent instruction.
Familiarity with the practical side of art craftsmanship
need not imply an intention to produce the work itself,
but is absolutely necessary to adequately designing for it.

Enamel is increasingly employed in commemorative
tablets and in objects of ceremonial use, and is also
used with equally charming effect on the decoration of
cabinets, jewel caskets, and other boxes to which as
wedding gifts or other presentations, heraldry, properly

marshalled and well executed, is peculiarly appropriate. To such purposes the "Limoges" painted method readily lends itself, especially when the general design is of somewhat ornate character. With regard to the mounting of enamels, metal as framework seems especially suitable to their perfect display, as the setting to the gem, and so when a plaque is used to decorate a wooden panel it is well to introduce metal as an intermediary. But, nevertheless, I have found a well-cut ebony frame very satisfactory in itself, and the matter is clearly one for experiment.

Champlevé and Cloisonné go well with the more severe styles of design, both ornamental and heraldic, in fact, enamel goes best with styles similar to those with which it was associated in the early practice. The one with the freedom of the Renaissance, the others with the greater severity and strength of the Gothic.

For salvers, inkstands, lamps and other utensils heraldry in Champlevé enamel is very suitable and it is somewhat remarkable that it is not more often employed in place of the engraving which is usually inappropriate because of its lack of decorative quality.

METAL.—Although heraldry in metal work has so wide a range, from the massive bronze gate to the badge worked on a buckle, that it can only be partially dealt with in a general work, it is desirable to touch upon such parts of so large a subject as may help the student to find in early work good examples for present application. The value of the beautiful metal coffret, the jewel case of the Middle Ages, for instance, to the designing of the modern box, whether it be intended for a

similar use or as the repository of a city's thanks to a hero, is obvious. Even the obsolete weapons of early times may be made useful for their decoration, as admirable models for the making of trowels and other ceremonial implements whose after character as souvenirs of interesting occasions renders them suitable to, if indeed it does not demand, heraldic or symbolic decoration.

Of the large work the stately bronze doors of Henry VII's Chapel in Westminster Abbey are among the most distinguished examples in their perforated design of work whose duty is rather that of a gate than a door. The panels are filled with badges in pierced work, the Beaufort Portcullis, Henry's favourite badge, the Falcon and Fetterlock of York, the entwined roses of York and Lancaster, and the Royal Monogram, all telling their story in terms of beautiful metal work. Within is the monument with the effigies of the King and Queen recumbent on the tomb, while at the foot amorini support a shield of arms and at the corners are placed angels who once held crowns. Designed by Torregiano and executed by him or under his direction, it is without doubt the most splendid and complete heraldic metal work of its time and style in this country. Over the gates in the grille which surrounds the tomb are the Royal Arms, France and England quarterly with the dragon and greyhound supporters. The latter was the badge of the Nevilles, but the former, the Dragon of Cadwallader, was of especial value in the King's eyes. It denoted his descent from Llewellyn and King Arthur, and perhaps he liked to feel that his greatness was not wholly dependent upon York and Lancaster. It had

been flown, on a flag of the Tudor colours, argent and vert, on the field of Bosworth when the " White Boar " was slain and his crown was plucked from the hawthorn bush into which it had fallen and placed on the head of the victor. As badges, the dragon and the greyhound are repeated on the upper part all round the grill and in its parapet portcullises and roses alternate in the cuspings of the tracery. One of these dragons is shown in Fig. 173. Even the great candle sconces are Tudor roses placed horizontally, which support crowns whose crosses and fleur-de-lis form a decorative rim. As heraldic design the proportion of the parts, the vigour of the animals and the excellence of the spacing (and this may be especially seen

FIG. 177.—Dragon from the Grills in Henry VII's Chapel, Westminster Abbey. Sixteenth Century.

in the supporters over the gates) leave nothing to be desired, while the general arrangement of the repeated heraldic motives in a decorative and yet reticent way is as admirable an example as can be found.

Relief in metal work, cast or wrought, was very fully employed in the Renaissance monuments in place of the flatter treatment which preceded it. The mediaeval

FIG. 178.—Memorial Brass to Sir J. de Brewys,
Wiston Church, Sussex.

memorials more frequently employed the flat decoration done in Champlevé enamel fixed into the spaces of sculptured stone, or else the incised metal slab, somewhat similar in its method of production, which is known as a Monumental Brass. These are so comparatively numerous and of such admirable workmanship as to form one of the most interesting and instructive means of studying most that pertains to good heraldry. They were executed with great care, and afford examples of almost every kind of application of

arms and badges to costume. Their wealth of heraldic lore is ably set forth in the works of Creeny, Waller, and others, and a single illustration must suffice here. Fig. 178 is the interesting brass to the memory of Sir John de Brewys, which is in many respects typical. The figure of the knight in his armour, his hands in an attitude of prayer, his head resting on his great helm, which bears his crest, and his feet on a couchant lion. Around him are shields of his arms six times repeated, and between them on little scrolls the words " Jesus " and " Mercy " many times occur.

The method of work is very similar to that of the Champlevé enamels, allowing for the difference in scale, the lines being boldly incised in the metal with chisel-like tools and then filled in with black or colour much after the way of the niello and enamel of the smaller and more precious work, a hard waxy composition being used as the colouring material.

Among the smaller metal work of domestic use, the firedogs, firebacks, hinges, locks and other parts of furniture, there is no lack of examples. The slabs of cast iron that are known as firebacks were very generally used as spaces for heraldry, the emphatic central position which they shared with the chimney-piece making them similarly appropriate. With the revival of dog-grates the accompanying fireback has also returned to favour, and a study of old castings therefore becomes additionally necessary. The Tudor examples are usually very excellent and bold in design, as in that illustrated here (Fig. 179), which displays the Royal Arms, probably of Henry VIII. In a form of

work which is to be subjected to the action of fire, and even to be seen for the most part through lighted fuel, a design is obviously fitting in proportion to the degree of elimination of unessential detail that is effected, and in the case in point this has been most efficiently done. The arms, and the lower part of the centre generally, are much fireworn, but anything of this nature simpler

FIG. 179.—Armorial Fireback. English. Sixteenth Century.

and finer in pose and modelling than are the supporters it would be difficult to find, while the proportion and spacing of the whole composition leave nothing to be desired. Fig. 180 is another well-designed Tudor example, the arms being those of Queen Elizabeth, who sometimes used the greyhound for a supporter as her father had done, instead of the dragon.

Fig. 180.—Armorial Fireback. English. Sixteenth Century.

It must be remembered, in designing firebacks, that the work is to be carried out by casting and should therefore be of suitable character. Casting is necessary because every time that wrought iron becomes red-hot and cools again it scales, and so loses a considerable thickness of material in a comparatively short time,

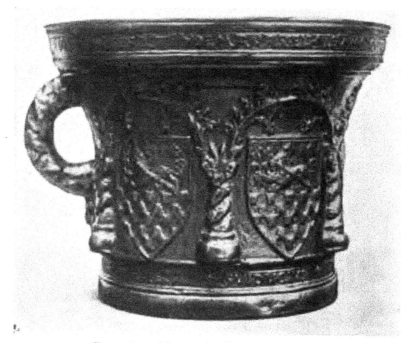

FIG. 181.—Mortar in Cast Bronze.

a disadvantage that does not exist in the cast metal. The design in most cases is treated panel-wise within a raised border, but in the later backs the outline of the design, of the mantling and crest, sometimes formed the edge of the fireback without a containing rim. A space at the bottom, the part that was most embedded in the fire, is frequently left plain, or simply fluted.

Fig. 181 is also interesting as heraldry in cast metal, which in this case is bronze; and an Italian example is found in the arms of the Martelli, cast in bronze by Donatello (Fig. 182), which has much spirit, but lacks the excellent distribution of the same creature on the decorative shield for the Palazzo Guadagni now in the Museum at South Kensington.

The elaborate hinges, clasps, and locks of doors and coffers that were often enriched still further with coats of arms are also of great interest and appear to have been made subjects of lavish decoration before the larger domestic belongings were so treated. Of the decorations of lock-plates the German example of the Imperial Eagle from the Town Hall, Nuremberg (Fig. 183), is interesting as an instance of great simplification of form to suit the material in which it

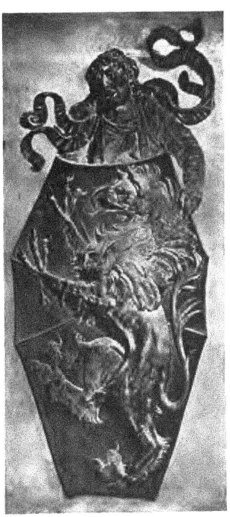

FIG. 182.—Arms of the Martelli, by Donatello.

Fig. 183.—Lock-plate. German. From the Town Hall, Nuremberg.

Fig. 184.—Decorated Hinge in Pierced and Chiselled Metal.
German. Seventeenth Century.

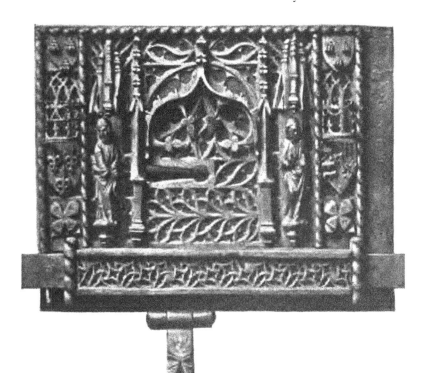

Fig. — Lock-plate.
Chiselled Iron.
French.
Fifteenth Century.

is expressed. Fig. 184 is another but more ornate example of the treatment of pierced and chased metal.

The French lock-plate in chiselled iron (Fig. 185) was in the Spitzer Collection, and is decorated with the crowned Arms of France, and with Navarre, Aragon, Bearn and Bourbon quarterly and with a coat at top repeated on

either side, consisting of three pommes de pin, or pine cones. The fleur-de-lis in Gothic tracery on the hasp is also notable. Fig. 186 bears the crowned Arms of France surrounded by the beautiful collar of St. Michael. Below is the well-known monogram which combines the initials of Henry II and of Diana de Poitiers, and her badge of crescents forms a circular device interlaced within the guilloche border, and a further allusion to her goddess namesake occurs in the bows and arrows at the sides.

FIG. 186.—Bolt-plate.
French.
Sixteenth Century.

A fellow bolt-plate in the same collection has the Arms of France dimidiating those of Medici and Dauphiny on the shield at top, and in place of the crescent badge below, is a rainbow in clouds and surrounded by laurel; and the monogram, a double K for Queen Katherine, is several times repeated.

A very beautiful work, also in chiselled iron, is the panel of the armorial insignia of the Emperor Charles V, the Arms with the Columns (the latter rising from waves of

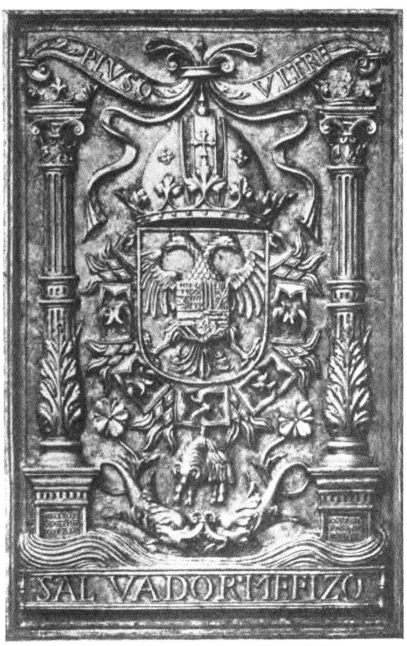

FIG. 187.—Panel in Chiselled Iron. Sixteenth Century.

the sea, being the device that represented the Pillars of Hercules and the motto "plus oultre" (Fig. 187). The arms are encircled with the collar of the Toison d'Or very boldly treated. The work is Spanish of the early six-teenth century, and is notable for its exquisite finish as well as for its general excellence of design and drawing.

Examples of keys, also from the Spitzer Collection, are given in Figs. 188 and 189. The former bears the

 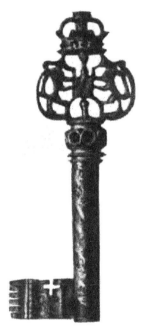

FIG. 188.—Key with the Arms of an Archbishop. Eighteenth Century.

FIG. 189.—Key. Eighteenth Century.

arms of a Cardinal Archbishop, and the latter, which is excellently pierced and chiselled, has two lions support-ing a badge, a crowned castle. Each is of good design, its

use and material having been well considered so that it is of a decorative shape that does not impede its usefulness. The latter is full of minute and exquisite detail, indistinguishable in the illustration. Besides the decoration of the barrel with a spiral band, there are eagles' heads on its wards and the words " vive le roi " are twice inscribed on it in letters of gold.

The beautiful and elaborate repoussé and engraved work that was very largely employed in the decoration of metal in the Middle Ages and the Renaissance, found full scope in the magnificent armour in which the greatest artists and the most skilful craftsmen combined their forces to make a gift that should be worthy of a princely hand. Repoussé decoration consisted for the most part of the allegorical and mytho-

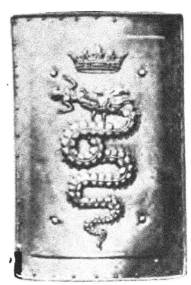

Fig. 190.—Repoussé Buckler in the Royal Armoury, Stockholm.

logical subjects that were so fashionable at the period, and comparatively little heraldry was done in that way. Engraving and etching, on the other hand, were extensively used to decorate metal with arms and badges.

In the execution of repoussé work a metal plate is fixed down to a bed of pitch, a material which affords an efficient support while being soft enough to yield to the shaping metal as it is hammered and punched into

the designed form. The work is afterwards chased and finished on the face, but the essential quality is, of course, that of being modelled into relief from behind. A very beautiful piece of repoussé work is the quadrangular buckler, of late six-teenth-century work, in the Royal Armoury at Stockholm, which was bought in Holland by Charles XV of Sweden (Fig. 190). The design is a fine bold treatment of the Arms of the Visconti, and the workmanship is probably Italian. There is a backplate with repoussé arms in the same collection.

The powder horn (Fig. 191) in the Royal Armoury at Dresden is a very good example of the treatment of heraldry on a small object,

FIG. 191.—Powder-horn with Armorials. The Royal Armoury, Dresden. Sixteenth Century.

and incidentally shows the practice of placing helms on the heads of supporters in order to display some of the crests.

Engraving being extensively used to cut decorative

bands of ornament on the armour, was naturally the method adopted for ornamenting the blades of weapons and other flat surfaces. Indeed, it was from the engraving for ornament's sake that engraving for the purpose of reproduction by printing was evolved by Finiguerra, the famous Florentine goldsmith, in the middle of the fifteenth . century. This interesting experiment, if it were an experiment and not a practice whose application had been before unnoticed, is said to have been made on a piece of plate, a pix, of which the only impression is said to be in the Bibliothèque Nationale, Paris. Engraving was also preliminary to niello work and to damascening, two somewhat analogous methods of decoration, that are peculiarly suitable to the ornamentation

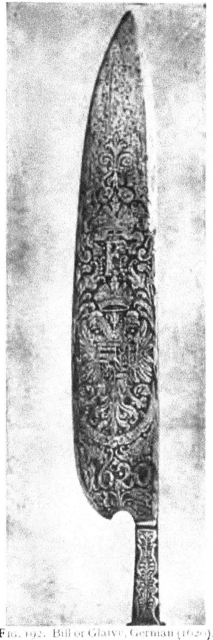

Fig. 192. Bill or Glaive, German (1620).

of metal. In the former the lines of the engraving are filled with a sort of black enamel which is fixed in its place by heat, while in damascening the design, drawn with boldly cut lines on the steel, is filled in with gold or other metal hammered in with mallets, and the whole surface is then polished.

The halberds and partisans that were of the nature of ceremonial weapons, the arms of body guards, for example, were usually decorated in some such way. The bill or glaive (Fig. 192) is a good example of German work of its period, and the halberd (Fig. 193) is a very interesting specimen of French work of a little earlier date.

These examples will be found valuable in their bearing on the decoration of ceremonial tools such as the trowels with which foundation-stones are laid.

In engraving a surface for subsequent treatment with another metal or with enamel the process itself will dictate the use of a strong and suitable method of cutting. When, however, the engraving is to stand on its own qualities it is important to bear in mind the difference between engraving that is employed as decoration and that intended for printing. This distinction has frequently been lost sight of, with the result that there is much engraving of the sort that, however well it might print, and in some cases this is more than doubtful, it certainly does not decorate; while fine bold cutting that is done in the right way will realize the value of the play of light on the incised line, and the consequent ornamental effect. In this connexion it may perhaps be permitted to define shortly the technical distinction between etching and engraving. In etched work, then, the design is bitten

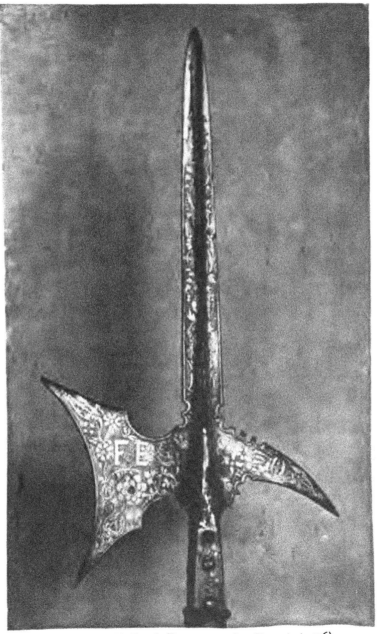

FIG. 193.—Halberd, Damascened. French (1596).

into metal with an acid mordant, while engraving is done with a cutting tool.

Etching is largely evident in the decoration of metal, frequently taking the form of lowering the background by biting-in with acid, and thus leaving the design

FIG. 194.—Cistern in Cast Lead.

to appear in masses of polished surface in contrast with the darkened colour of the bitten metal, and the details are put in with lines that are etched or engraved, as may be most convenient.

An important quality of this kind of treatment is

that while the objects are enriched and very expressively decorated their practical efficiency for work is in no way impaired, and this may fairly be taken to be a conclusive test of right decorative treatment.

Interesting features of Renaissance dwellings were the rainwater heads, cisterns, fountains, statues and other garden accessories that were cast in lead; architectural fashions which are again coming into vogue with the returning regard for the style of the Renaissance. The cistern (Fig. 194) is an heraldic example in cast lead, and Fig. 195 is a fountain in the same material. The latter is Dutch work of the early

FIG. 195.—Fountain in Cast Lead. Dutch. Seventeenth Century.

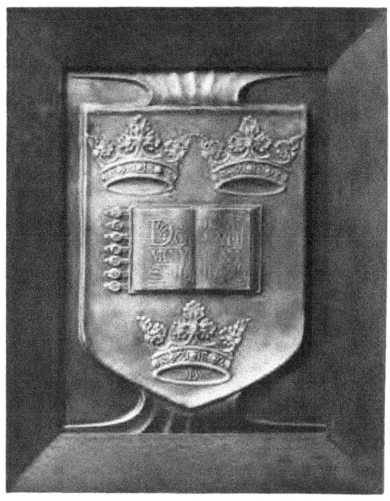

FIG. 196.—Arms of Oxford University. Panel, Copper, silvered
and oxidized. G. W. Eve.

seventeenth century, and was brought from Bois-le-duc. The motives, eagles displayed, lions' heads and the lion rampant of Holland which holds in its paws a sword and a sheaf of arrows, are thrice repeated round the central pipe, which is surmounted by a crown.

Yet another method of metallic production is shown in electro deposited replicas of modelled designs such as Fig. 196, a panel treatment of the Arms of Oxford University, which may be considered in connexion with its fellow of Cambridge, Fig. 89.

CHAPTER IX

Architectural Decoration

In its application to architectural decoration heraldry put forth some of its finest work as became one of the family of the " mother of the arts," and it was in architecture too that the modern revival of heraldic art began, much in the same way that the Renaissance had first made its influence felt in the decoration of the monuments of an earlier time.

The sculptured heraldry of the Middle Ages was confined to the monuments and chantries, such as those of Westminster Abbey, Peterborough, Kings Langley, Canterbury, Beverley and many other places whose sculptured shields are memorials no less of the personages whose arms they bear than of the vigorous art of their time. Certain it is that even in the worst periods the heraldic decoration of architectural objects continued to show a greater degree of excellence than was generally evident in other forms of heraldic expression.

With the growth of the Renaissance, domestic architecture and its attendant decoration, in which armorials were displayed, increased enormously in extent and beauty, and the colleges which were founded or rebuilt

in the early sixteenth century followed in the decoration of the chapels and halls the excellent examples of their predecessors, but in the new and adaptable style that had come into fashion.

Henry VIII patronized art with enthusiasm as a part of his general rivalry with the magnificent Francis I, and his example was followed by the new families who were taking the place of the old nobility that civil war and the scaffold had nearly exterminated, in building stately mansions, many of which stand as present examples of the skill and thoroughness with which the work was done.

In France the beautiful châteaux which still remain as store-houses of heraldic and other artistic wealth were built during the same period under Charles VIII, Louis XII and Francis I, and it is difficult to describe in adequate language how perfectly they displayed their characteristic devices with a dignity that was without one touch of obtrusiveness.

Fontainebleau, Blois, Chambord and many another stately building testify to the taste and magnificence of their owners as well as to the skill that was lavished on their making. Fig. 197, the Gateway of the Château de Blois, is especially interesting for the employment of badges and heraldic diapers. The porcupine badge of Louis XII appears over the doorways as it does within, while the main archway is flanked by columns ornamented with a diaper which encloses in its reticulations the fleur-de-lis of France and the ermine spot of Brittany. A range of similar columns is in one of the interior courts. Fig. 202 is an example

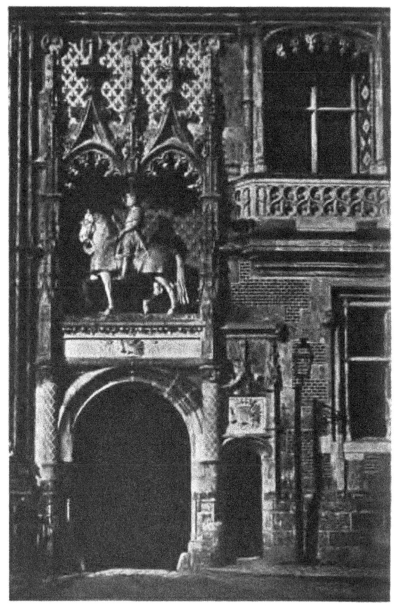

FIG. 197.—Gateway of the Château de Blois. (Restored.)
Fifteenth Century.

of the badge-adorned fireplaces in the château. The whole is a restoration, very little indeed of the original work having remained.

In Spain extremely bold and vigorous heraldic sculpture was placed over doorways and under windows, but it was often executed with magnificent effect in large rectangular panels at the sides of the principal entrance. Fine examples are at the doorway of the Hospital at Santiago and at that of the University Library at Salamanca.

Italian examples are found in the Florentine wall decoration in the Palazzo Vecchio and Palazzo del Podesta, in the composition of which small shields bearing the symbols of Saints and the arms of cities were usually associated with the principal device.

Heraldic groups were also employed with excellent effect on angles of buildings, breaking the straight line in profile in a very satisfactory way.

In the scheme of heraldry for a house the principal position on the exterior was over the main entrance, and there the armorials of the owner were boldly displayed, arms of alliance and genealogical trees being reserved for the more intimate surroundings of the interior.

Other parts of the exterior were ornamented with less elaborate insignia such as seemed to fit the spaces that offered themselves, badges being freely used in this way as well inside as out. Chimney stacks and other flat spaces were relieved with panels, and ridges and pinnacles were adorned with figures of heraldic significance in relation to the family of the house.

In arms in relief, whether in large mural decorations or in the minute workmanship of a seal, contiguous spaces, which in flat painting would be considered divisions of the same plane, are distinguished from each other by sinking the surface in parts or by means of diapering. The quarterly shield of Henry IV on his great seal (Fig. 2, p. 18) has the field of the English quarter sunk so that the edge of the French quarter being higher takes light or throws a shadow which defines the space. Additional emphasis is given to ordinaries by strongly bevelling their edges which then reflect light in the same way. And diapering, which has been already referred to, may have the effect of raising or lowering the tone of the decorated surface, according to the amount of light it reflects or of shadow that it includes.

The mantling that occurs in sculpture, especially when done in wood, does not hesitate to go to the fullest extent in the direction of free ornamental treatment, and in thus seizing upon the decorative possibilities of its so lightly fettered character it may form a connecting decoration between the constituents of an heraldic scheme which might otherwise have a certain effect of spottiness.

The pose of the heraldic elements of the design may also be made to help materially the general unity of effect. Thus the helmets of a series of armorials may be faced towards a central point, such as the altar in a church, or the hearth or the daïs of a secular apartment. Shields may be inclined in a common direction with similar intention and all the heraldry have definite relation to its surroundings. It should be remembered, however, that in thus posing the elements of a series,

a shield must be treated as a whole, and the contents must not be altered in sympathy with the direction of its regard.

FIG. 198.—Frieze in Sgraffito.

A form of external decoration which has been but little used for heraldry, though it is one which is readily adapted to the purpose, is that kind of cement work in layers that is known as Sgraffito. Examples of this method of work are shown in the friezes, Figs. 198 and 199, in which

FIG. 199.—Frieze in Sgraffito.

the heraldry adds interest to very graceful design, and in the panel of the Armorials of Pope Paul III (Fig. 200). In Sgraffito work the design is drawn through a coat of

P

moist plaster on to a lower one of another colour, much
as etching is drawn through the ground on to the copper,
and like it is, in its simplest form, a line art.

Heraldry in interior decoration found its first appli-

Fig. 200.—Arms of Pope Paul III (Farnese). Panel in Sgraffito.

cation in the actual shields, which were hung on the
walls of the great Halls of mediaeval strongholds, was
closely followed by the similar use of the more ornate
ceremonial ones~and continued in the tapestries and
embroidered hallings which were the wall coverings of

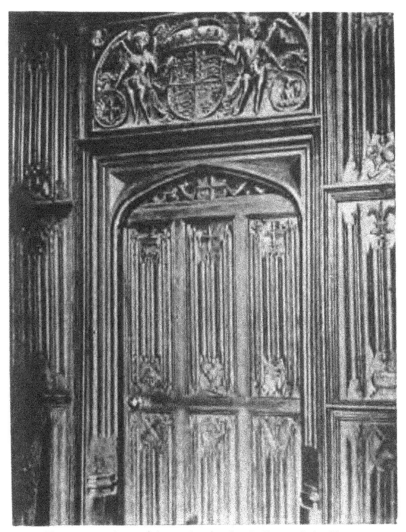

FIG. 201.—Armorial carving in the Gallery of the Vyne,
Hampshire.

the halls and chambers. Some of these are still extant, and many others are mentioned in the wills of great personages and in the household accounts of the time.

At the end of the fifteenth century panelling was superseding the decorative draperies and sculpture was taking the place in domestic buildings that it had long held in ecclesiastical ones, the heraldry which had been displayed in beautiful needlework being executed in carving that was no less beautiful in another way. Plaster work also came largely into use for interior decoration.

Many instances of beautifully applied heraldry are given in Mr. Gotch's admirable work[1] and notably the doorway and panelling of the Gallery of the Vyne, Hampshire, Fig. 201, which I am permitted to reproduce here. The doorway is adorned by arms supported by amorini and the panelling is full of shields and badges ; the appropriateness of the work is immediately felt, and there is nothing obtrusive, everything " occurs " with an inevitableness that is delightful.

In the decoration of a room the fireplace is naturally the central feature, to which in some cases the heraldry is confined ; in others, and the larger number, it covers the panel above, the decoration varying in amount from a carving in the centre of the frieze of the chimney-piece, or on comparatively small centres of panelling, to the whole armorials fully displayed. Fig. 202 is an example of badges employed in this way, and is another of the many representations of the devices of Louis XII and his Queen, Anne of Brittany.

These large chimney-piece achievements are produced

[1] *Early Renaissance Architecture in England.*

in a variety of ways, being sometimes sculptured in stone or wood, but they are also cast in plaster or modelled *in situ* in the same material.

FIG. 202.—Fireplace in the Salon Louis XII Château de Blois. (Restoration in the style of the Fifteenth Century.)

In the decoration of ceilings complete armorials and even shields of arms are by no means so much used as are badges and other fanciful devices, the intersections of ribs and the centres of panels being naturally selected for the purpose. Two examples of ceiling bosses consisting of wreaths enclosing a shield of the Royal Arms

and a fleur-de-lis badge respectively are from ceilings at
Hampton Court (Fig. 203), for which also I am indebted
to Mr. Gotch's work.

The upper divisions of wall panelling are especially
suitable for a series of shields and badges when they are
at a sufficient height to bring the heraldry above the line
of the eye. This will probably be in carved work, the most

FIG. 203.—Ceiling Bosses from Hampton Court Palace.
Sixteenth Century.

direct and natural way of decorating wood, but shields
in colour, flat or in relief, may occupy the panels with
very satisfactory effect. A frieze is also an obviously
suitable space for such a purpose, whether the decoration
be modelled or painted, or both.

Among the materials suitable for interior decoration
gesso is an excellent means of obtaining relief in work
that is to be painted, and it is more readily handled than

modelled plaster, from the ease with which it can be kept moist. In early work the smaller details of monuments were frequently modelled in this material, as were the arms on some of the stone shields in Westminster Abbey ; and on the decorative panelling, on which jewels and enamels were also modelled and painted.

Gesso is simply the Italian name for Plaster of Paris, burnt gypsum, but is technically understood to mean a preparation of plaster or other material which depends for its hardening on the solidifying of some cohesive medium, usually a form of glue, and not on chemical action in the material.

Methods of making gesso are described by Cennino Cennini in the MS., written in 1437, in which he describes minutely the technical practices of his time. First the plaster is to be "well washed and kept moist in a tub for at least a month" and is to be stirred up well every day until "it almost rots and is completely slaked and it will become soft as silk." It was then made into cakes, dried and kept for use. By this process it became what was called gesso sottile, though the term is also applied to the similar preparation of whiting, to be mentioned presently. As to its use, it is directed to "Put some cakes of gesso sottile into a pipkin of water and let them absorb as much as they will. Grind it fine, mix it with fine glue in a pipkin, put the pipkin in water so that it becomes hot but does not boil, for if it did it would be spoiled."

A very important point is the thorough slaking and tempering of the plaster, which continues to improve the longer it is kept. The glue that was used was made from hides, size being made from the fine kinds

of skin, vellum and parchment, as the finest kind is made now. Fish glue was also used from very early times.

Very useful gesso is made with whiting (calcined chalk) instead of the plaster. The latter is said to be tougher, but whiting is certainly easier in working. The whiting should be soaked in water for at least twenty-four hours (like the preceding preparation this kind of gesso is all the better the more thoroughly it is prepared), and mixed in a vessel, with the fine thin glue, the whole being placed in a saucepan of water and kept hot. By keeping the pot of gesso in the water while it is being used it will be kept liquid for some time (though the top will skin over rather soon) and it may be remelted by again heating it from time to time. I find ordinary gelatine a good adhesive and melt it into the consistency of a not too strong size before adding it to the whiting, together with a few drops of oil or glycerine as a preventive from cracking. The gesso is best used with a long-haired brush, such as those called riggers, from which it is allowed to flow in a blobby way, the lights being first loaded on and afterwards joined down by subsequent painting. It may at this stage be modelled to some extent, and for this a stiffish brush moistened with warm water is an efficient tool. When it is dry the gesso may be carved and shaped with knives and riffles with the same facility as plaster. It may then have a coat of gelatine (which should be very thin, as otherwise it will form a skin that is likely to blur detail), and the work is ready for painting or other treatment.

In the treatment of wooden shields in this way car ·

should be taken that they are well seasoned, and unless they are sufficiently thick they should have transverse pieces at the back to prevent warping; a coat of gesso on the back is also useful for the same purpose. If the wood is well stopped by being sized several times and is slightly roughened the layers of linen or other keying material may be dispensed with.

Gesso work is well adapted for treatment in colour, and of this the quality may be much improved by the use of underlying metal, gold under red, and silver under blue. These metals are applied by the ordinary gilders' methods and are then painted over. Very beautiful effects may also be obtained in monochrome on modelled gesso, when the gradations of tone may be made to help the relief and vary the colour. .

Pyrography, or burnt word etching, is also employed in heraldic decoration, a notable instance being the series of shields on the fireplace of Lord Leven and Melville at Glenferness. An example of this method of work is shown in Fig. 204, a fanciful composition designed for the door of a cabinet

In arranging a scheme of heraldic decoration, the field of choice is a very large and varied one, from the simplest shield or badge on the frieze of a mantelpiece to the carefully planned series decoration of a whole building.

As an example of one form of genealogical scheme may be instanced the series of arms and devices in painted gesso now in the hall of Alloa House, Alloa, which were done to fill a range of panels in a dado, and beginning with the simplest shield of Henricus de Erskine in 1224 (Fig. 141),

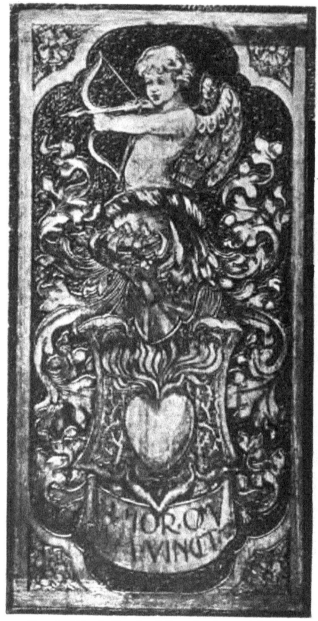

FIG. 204.—Burnt Wood Panel, "Love's Armorials," executed by
Mrs. Geo. W. Eve after design by Geo. W. Eve.

extend round the apartment and end, on the opposite side
of the fireplace, with the quartered and impaled arms of

FIG. 205.—Arms of the Earl and Countess of Mar and Kellie.
Painted Gesso. Geo. W. Eve.

the present Earl and Countess of Mar and Kellie (Fig.
205). Alternating with the arms of each generation are
repetitions of three devices, designed for the purpose and

consisting of the crest and motto of the Earldom of Mar, those of Kellie (Fig. 206) and the monogram and motto with the supporters (Fig. 207) respectively. These devices were of course capable of any necessary amount

FIG. 206.—Device. Crest of the Earldom of Kellie. Gesso, before painting. Geo. W. Eve.

of repetition, and when a knighthood of an order necessitated a group of two or more shields the devices serve to mark the grouping, and as it were to punctuate the whole scheme. The gesso was made of whiting and gelatine as already described, and the surface was varied by the

use of different textures. The colour was applied over
metal which was allowed to show through on the ridges

FIG. 207.—Device. Monogram and Supporters of the Earl of Mar
and Kellie. Gesso, before painting.*.' Geo. W. Eve.

of the diaper that was also introduced to give variety and
interest to the simpler forms. Others of this series are
illustrated in Figs. 141 and 142.

Another method of arranging a scheme of decoration is that which traces the advent of quarterings into the shield of a family, by picking from the pedigree the matches by which the various coats of arms came in, and making them the motives of the work, to the exclusion of intermediate matches, proceeding in regular order from the simple arms to the final shield of complete quarterings.

Many other schemes will readily suggest themselves. The visits of guests of distinction may be marked by panels of their arms in the chambers they occupied, perhaps by an enamel plaque in the centre of a panel.

The arms of Schools, Colleges and Universities, and of other corporations and institutions, motives that are allusive rather than personal, are yet of the keenest interest to those concerned, an interest that is too often tempered by the unworthiness of the heraldic treatment. The practice of hanging on the wall shields of arms of the stationers' shop type may be necessary for commercial reasons, but is much to be deplored. It seems impossible to get them improved, the feeling that they are " good enough " (and perhaps they are !) appears to be sufficient recommendation. Even when the arms are well treated, as is rarely the case, and I am not now referring only to the kind which satisfies the aesthetic perception of the casual schoolboy, the effect of the hanging shield in an ordinary room suggests at best a kind of Strawberry Hill Gothic that is out of keeping with any probable surroundings. When heraldry that can be treated as a movable picture is needed, and something of this kind is made necessary by the want

of permanence in our dwelling-places, a framed panel of arms is probably the most suitable form that modern heraldic wall decoration can take. It may be in wood or metal, in colour or monochrome, of any quality and interest that may be found most pleasing, and being framed, it will take its place in the adornment of an ordinary room in the same way that a picture does.

STAINED GLASS.—Of all methods of heraldic expression stained glass is perhaps the most appropriate as purely decorative treatment of the subject, for not only is the splendour of colour peculiarly fitting, but even the commemorative quality of heraldry assimilates in feeling with the memorial character which is rarely absent from a stained window.

The temptation which it naturally offered to partisan fury has left comparatively little of the early work, but sufficient has remained ·to show how perfectly it could be made to serve its purpose.

In a form of design which is carried out with pieces of coloured glass cut to the necessary shapes and held together by strips of grooved lead, which is soldered into position, this structural lead-work presents considerable difficulty. It follows the lines of the composition wherever possible, but when the shape of the glass makes another course desirable, it does not hesitate to go across a space, and in that case, being frankly used for structural reasons, it must not clash with those lines that help to define form. In short, design in this, perhaps more than in other arts, must conform to the dictation of the material. Thus it is important that the pieces of glass should be designed of cutable shape

without too small re-entering angles, and the limits of bending in the lead must also be recognized. Its passing across objects is vindicated by structural necessity, and by that alone, and narrow places are leaded across, not only because of any difficulty that there may be in the cutting, but because the glass would probably break there when being fired in a kiln, or when under the strains that are set up in a window by wind pressure.

The tendency of outline to lose itself in the darker of the colours that it divides has already been referred to, and is very notable in this connexion. When therefore the objects are light on dark, the leadwork will sink into the background, and although it may leave small space for the glass, it is sometimes surprising how efficiently that little lights up and expresses the colour. If the charges are inconveniently small for the leading, resort is had to what is called flash glass, which consists of two layers, of which one only is coloured, and is made by dipping a piece of molten white into a coloured glass, when the mass is about to be blown into the bulb which, shaped and expanded, ultimately becomes a sheet of glass. The desired shapes are pierced through the coloured layer of the composite sheet by means of grinding, or by etching with hydrofluoric acid, and are left white, or stained yellow with a solution of silver, as the case may be.

In addition to the lead-work, which defines the general forms with more or less accuracy, details are depicted by means of a brown enamel colour, which serves also as a general shadow tint, being painted on the glass, and then fired. The brown enamel

is also used for the diapering which is so especially valuable in glass decoration, and for this purpose it may express the design in lines drawn with the colour or, being applied as a broad wash; the diaper pattern may be scratched out of it with a point. As a general rule over-painting should be used as sparingly as possible for the purpose of defining or emphasizing form.

The silver stain can be similarly put on, either in lines or in washes, these materials, either alone or in combination, serving to express surface decorations of all degrees of elaboration.

In addition to the accurate and expressive drawing which goes to make good heraldry, the principal feature of glass design is obviously its colour effect, the grouping of the colour masses in such a way as will best express the subject in beautiful coloured light. In view of the obligatory nature of heraldic tinctures, though not of their exact quality, the harmony of colour may be helped by suitable treatment of the background (which is susceptible of variation that is only limited by the nature of the materials) in combination with the prescribed colours of the heraldry. And here occurs that temptation to alter the tinctures of mantlings which has proved too much for the correctness of some heraldic compositions.

The design is usually made on a small scale, showing the colour scheme and the general composition, and a full-size drawing in black and white is then prepared, in which the arrangement of the leading and the character of other details are carefully indicated. On this the various coloured glass is laid and cut into the required shapes, which are then arranged in due order with the

Q

lead, and the whole is securely soldered together. The lead having a double groove is in section like the letter H, the inside surfaces being milled, to afford a better key for the glass and for the cement which is added for additional security.

Pugin, whose influence on architecture was so impressive, had no less strong an effect on the heraldry which accompanies it so appropriately, and the beautiful armorial decoration of the Houses of Parliament, for which he is answerable, is a wonderful mass of fine work in glass and stone and other materials. No less remarkable in that it succeeded a long period of such extreme weakness, and was itself but the firstfruits of the revived interest in the subject.

In this work Pugin was fortunate in the efficient assistance that was at his command, and the drawings by his son-in-law and pupil, John Powell, by Burgess and others, show how admirably the master mind was served. The drawings reproduced here were probably designed by Pugin, but the actual work is that of John Powell.

However imbued with the mediaeval spirit Pugin was, the Renaissance feeling unmistakably asserts itself in these designs, and in spite of the Gothic detail of the tracery they seem to associate themselves naturally with the Tudor heraldry rather than with that of an earlier time. Indeed, it is possible that Pugin .was not unmindful of this, for there is little doubt that he had studied the Renaissance work that is to be found, as well as that of the Middle Ages, in the neighbouring Abbey.

Tudor heraldry marked the close of the Middle Ages. In character it was a combination of the mediaeval

FIG. 208.—Cartoon for Stained Glass. (Upper Part) Royal Gallery,
Houses of Parliament.

style with that of the Renaissance; that is to say, it was the expression of what remained of mediaeval regard for its subject, in a form that was strongly influenced by the new feeling in Art.

Besides the technical knowledge and the power of draughtsmanship there is ample evidence of individual design working through various influences, handling and assimilating them, a further proof that no one possessing real ·artistic power, in whatever degree, is content merely to reproduce the dry bones of any period. However that may be, they are very beautiful drawings, serving admirably as models of working drawings, in which is set forth all that is necessary to the carrying out of the work, and I am much indebted to Messrs. Hardman for permission to reproduce them.

The disposition of the lead is very carefully shown throughout, and the smaller details are drawn just so far as is necessary for the direction of the painter. Repetitions of figures being similarly finished only when they differ in some important respect from the initial shape, as in the case of the lion in the base of the shield of the Royal Arms (Fig. 208), when the pose is sufficiently varied from the upper ones, by the field space, as to warrant its separate treatment. These arms occupy the upper part of the light in the Royal Gallery, Fig. 209 being the lower part of the same window. Perhaps the most remarkable for vigour is the little white horse which so admirably occupies its space, a quatrefoil opening (Fig. 210). All the animals are· full of vitality, but none have quite so much as this. In this respect it may well be contrasted with the much inferior Dragon of Cadwallader

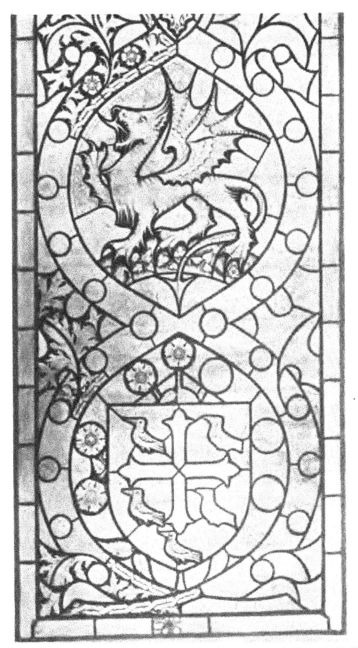

Fig. 209.—Cartoon for Stained Glass. (Lower Part) Royal Gallery, Houses of Parliament.

in Fig. 209. The character of the unicorn (Fig. 211) is altogether unusual in English heraldry, and follows the

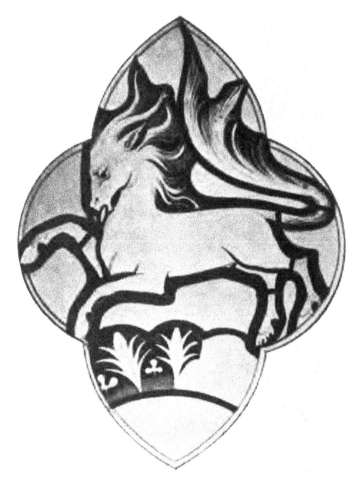

FIG. 210.—Design for Stained Glass in the Houses of Parliament.
Drawn by John Powell.

foreign type which derives its form from that of a goat with one horn, instead of that which is the combination of a horse's body with the legs of a stag and the tail of

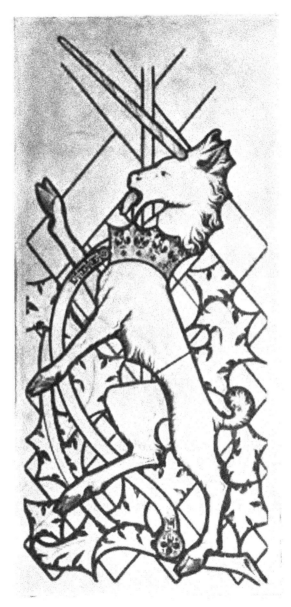

FIG. 211.—Unicorn. Cartoon for Stained Glass, Royal Gallery, Houses
of Parliament.

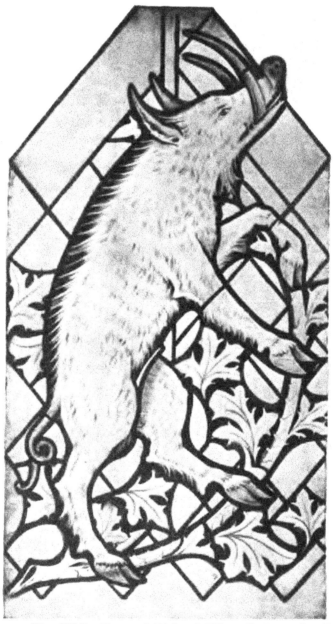

Fig. 212.—The White Boar of Richard III. Cartoon for Stained
Glass. Royal Gallery, Houses of Parliament.

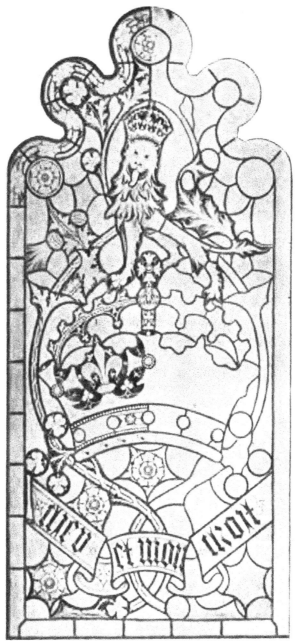

Fig. 213.—The Royal Crest. Cartoon for Stained Glass. Royal Gallery, Houses of Parliament.

a lion, a form with which other examples have made
us familiar. The wild boar of Richard III (Fig. 212),
for all his enormous tusks, seems not unworthy of the
irreverent way in which he is referred to, in a working
note pencilled on the cartoon, as " the pig."

The comparative smallness of the Royal Crest in Fig.
213 is due to the designer's intention to bring the head
into the central line of the composition with a view to
upstanding effect, and in this respect is of course a reason-
able problem to have solved. Whether, however, it was
worth while so to sacrifice the larger proportion which
the lion would have had to the crown in mediaeval
design is another matter.

Nevertheless, the whole series of work is finely designed
and beautifully drawn with clearly thought-out inten-
tions as a whole, and with much delightful fancy in the
variation of the decorated detail, and to conclude this
very interesting series Fig. 214 is from a coloured
drawing of the white swan of the de Bohuns that was
one of the badges of Henry IV.

In domestic stained glass conditions that were differ-
ent from those that were involved in church windows had
to be considered, and especially excessive obscuration of
the light was to be avoided, this being effected by the
use of plain, or slightly decorated, quarries; the stronger
colour being confined to a centre roundel or medallion,
a very suitable space for heraldic treatment, and to
decorated borders. In addition, from the time of the
Middle Ages such stained windows had been made mov-
able by being enclosed in frames which could be tem-
porarily fastened into window spaces, as is still done, and

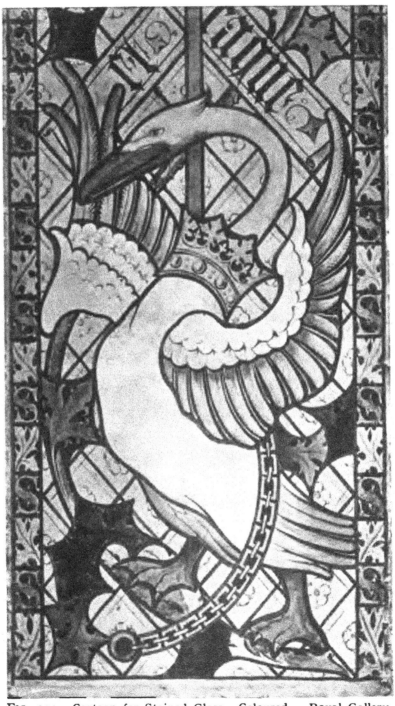

FIG. 214.—Cartoon for Stained Glass. Coloured. Royal Gallery,
Houses of Parliament.

for a similar reason armorial roundels may remain detached from the window and be suspended by wires (see Fig. 168). Of such roundels there are many excellent examples, that were originally in Netley Abbey, in the Hartley Museum at Southampton.

From the second half of the fifteenth century onwards armorial stained glass increased greatly in extent and freedom. The shields became square and in many instances have the form (derived from the tournament shield à bouche) which became associated later with the name of the Tudors. Probably the finest examples of domestic stained glass that we have are the splendid heraldic windows at Ockwells Manor, Berks. In these the shields are much curved, the helmets and mantlings are very elaborate, and the figures are drawn with great vitality and beauty. Each light has an achievement, consisting of arms with mantled helm and crest, in the middle, upon a background of quarries placed diamondwise and bearing the Norreys Badge, three distaffs, in yellow stain. In diagonal lines, the motto in text letters, " Feyth=fully serve," is several times repeated in all but two of the lights, the exceptions being the Royal ones, where "Dieu et mon droit" accompanies the Arms of Henry VI (Fig. 215) and " Humble et Loiall," the motto of his Queen, Margaret of Anjou, is with her armorials. In both these lights the Norreys Badge appears as in the others. Below the King's Arms are his two supporters, heraldic antelopes Argent, which are spotted, as well as armed, crined and unguled (i.e. horned, haired and hoofed) Or. The series, which included twelve lights that are now vacant, was erected by Sir John Norreys, the builder of Ockwells

FIG. 215.—Arms of Henry VI, Ockwells Manor, Berks.

FIG. 216.—Arms of the Earl of Warwick, K.G. Ockwells Manor.

237

Manor House, and consists of his arms and those, to
quote Mr. Everard Green, "of his sovereign, patrons and
kinsfolk. In short a liber amicorum in glass, a not
unpleasant way for light to come to us." The arms
here illustrated are those of Sir Edmund Beaumont,
K.G., and Sir James Butler, K.G. (Figs. 217 and 218),
of Sir Henry Beauchamp, Earl of Warwick (Fig. 216),
and the Royal Arms, to which reference has already
been made. The heraldic particulars of those and others
that remain will be found amply set forth in *Archae-
ologia*, vol. lvi., 1899. It will be observed that the
arms of such as were K.G. are not encircled with the
Garter, that practice not having as yet come into full
general use. Some attention should be given to the
badges on these windows as being good examples of the
practice in domestic glass of decorating transparent
quarries with devices, badges and monograms, floral and
other running patterns, in stain and grisaille, as ad-
mirably serving its purpose without too much sacrifice
of light, and therefore as affording suggestions for modern
work which has to comply with similar conditions. The
lights herein illustrated are from the excellent drawings
by Mr. W. T. Cleobury, in the Victoria and Albert
Museum.

The glass that has been hitherto mentioned is that
which, like the true enamels, is coloured in the making
with metallic oxides, the painting on it being confined to
the use of the brown shadow colour, and the yellow silver
stain. Windows made wholly in that way can be de-
scribed as painted glass because though the silver is a
true stain, it is used as paint and fired, instead of being

Fig. 217.—Arms of Sir Edmund
Beaumont, K.G., Ockwells Manor.

Fig. 218.—Arms of Sir James
Butler, K.G., Ockwells Manor.

incorporated with the glass in the pot. About the middle of the sixteenth century, the practice came into vogue of using panes of transparent glass as surfaces for decorative design in painted colours or in grisaille, and large windows of square panes of white glass with elaborate designs of arabesque ornament were done in vitrifiable enamel colours and with a minimum of leading, such as those in the Laurentian Library, Florence (Fig. 219). The medallion in the centre contains the arms of the Medici, the family of Pope Clement VII, whose tiara and keys accompany the arms in another of the same series of windows that has been reproduced in Mr. Lewis Day's admirable book, *Windows*.

A very remarkable school of enamelled glass painting that largely concerned itself with heraldry existed in Switzerland, encouraged by the custom which had grown up of persons and guilds presenting painted windows to each other. These largely consisted of portrait subjects accompanied by armorial bearings.

Into this work the use of the point entered to a surprising extent, the washes of colour being frequently covered with the scratched lines with which details were drawn or textures indicated with the minuteness of fine engraving. Indeed the process of obtaining effects by drawing with a needle in lines of light through a dark medium inevitably suggests the art of etching on metal.

Marvellous as were the effects produced by the needle in the hands of a master the method was a dangerous one under less capable control, and in any case the effect is altogether different and less glass-like than that

FIG. 219.—Painted Window in the Laurentian Library, Florence.
Sixteenth Century.

of the earlier method, being characterized by a sharp glittering brilliancy in place of the deep effulgence of pot metal.

This painted glass of the sixteenth century contains much fine vigorous heraldic drawing, as may be seen in the working drawings that are extant, as well as in the windows themselves, Burgmair and many others, whose

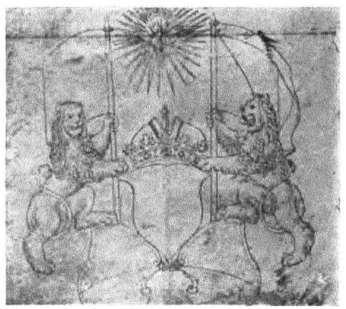

FIG. 220.—Drawing for Stained Glass, Victoria and Albert Museum.

power in heraldic art is well known in other directions, having also made designs for the glass painters.

Fig. 215 is a characteristic sketch of lions supporting banners and shields, a favourite method of grouping in compositions of this kind. The vigour and "go" of these animals is very remarkable, and it is unfortunate that the artist's name is not on the drawing.

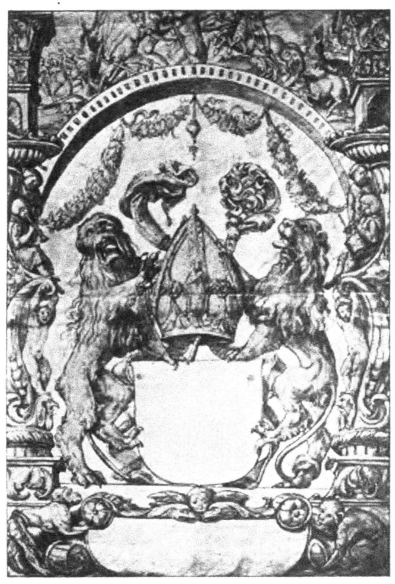

FIG. 221.—Drawing by Holbein, Victoria and Albert Museum.

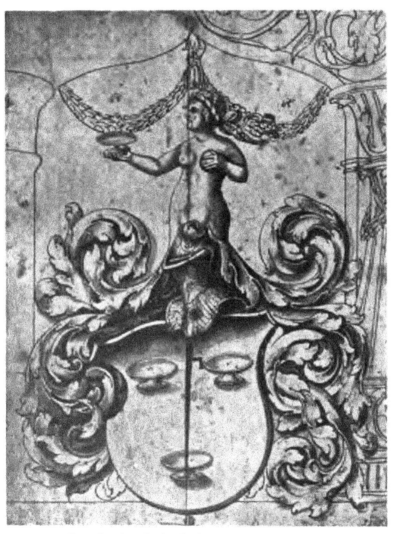

Fig. 222.—Drawing for Stained Glass, Victoria and Albert Museum.
A. Renten. Sixteenth Century.

The drawing by Holbein, Fig. 221, is very characteristic of his work, and of the style of continental heraldry in the sixteenth century when the early simplicity was giving way to great elaboration of design. The helmets in the glass work of this period are useful indications of how structural facts, re-inforcing pieces for example, and surface ornament may be made available as decorative detail, and Fig. 222, by A. Renten, is one of many good examples that are found among drawings of this kind. The mantlings by this artist are particularly well drawn, as is evident in the illustration.

CHAPTER X

Embroidered Heraldry

THE romantic associations that embroidered heraldry
call to mind, of fair fingers working the devices on battle
flags and on knightly surcoats, render it a subject of
the utmost fascination, and although its adequate treat-
ment would demand more space than can be devoted
to it here, it will still be possible to refer in some measure
to an art that, like the heraldry it embodied, touched
in one way or another all the life of the Middle Ages
and has transmitted no little of its beauty and charm
to the work of our own time.

Long before heraldry was formulated noble ladies
practised the art and found in it a delightful occupa-
tion. Embroidered heraldry is even alluded to in that
dim time where myth and history meet, as when the
Raven banner of the Vikings, the dread Landeyda,
desolation of the land, was woven and embroidered in
one noontide by the daughters of Reyner Lodbrock, son
of Sigurd.

In England in the sixth century Aldelswitha, a noble
Saxon lady, taught the art to some young girls and so
formed the first school of art needlework of which we

have any record. The four daughters of Edward the Elder were celebrated embroiderers, and there was a constant succession of skilled needleworkers whose names and even many of their notable works were handed down as worthy of remembrance; the altar cloths and vestments, covered with golden eagles, that had been worked by Queen Aelgitha the wife of Canute among many others. And the reputation was not merely a local one, but throughout Europe the praises are recorded of the Opus Anglicum, whose name, from being at first a general one, afterwards acquired a particular technical meaning. The excellence that called forth such universal appreciation continued throughout the mediaeval period, as when in the thirteenth century Pope Innocent III was enthusiastic in its praise. In the development of heraldry embroidery found a congenial subject, and ladies busied themselves in depicting with the needle their husbands' armorials, as their predecessors had pictured the incidents of their own times, on hallings and banners and emblazoned garments, such employment being a frequent subject of the beautiful illuminations of the painted MSS. which had so much affinity with fine needlework, from which it copied and was itself copied in return.

Ecclesiastical vestments and altar frontals contain much heraldry, and the Syon Cope, that most interesting work of the thirteenth century, contains on its orphreys and borders some sixty coats of arms on round or diamond shaped shields. One of those on the orphreys is shown at Fig. 223, although it is perhaps more curious than beautiful.

Among the earliest examples of heraldic embroidery
that survive is the surcoat of Edward the Black Prince,
no less admirable in its way than the already mentioned
shield, and on account of its unique character it is necessarily

FIG. 223.—Arms of Geneville from the Syon Cope.

reproduced again and again. It consists of the arms of
the shield translated into terms of embroidery, and if it
were but in better preservation a finer model for heraldic
work it would be hardly possible to conceive. This is
but one of the many splendid heraldic garments of which

so little remains, but which are depicted on the monumental effigies with absolute fidelity. Of the latter fact this surcoat is one of the proofs, for its copy on the effigies was made with such accuracy that even the faults of

Fig. 224.—Embroidered Cap with badges, Victoria and Albert Museum. Sixteenth Century.

the needlework are there.[1] The embroidery of badges on garments instead of the regular arms was also common, as witness the effigies of Richard II and his Queen, Anne of Bohemia, in Westminster Abbey.

[1] *Needlework as Art*, Lady Marion Alford.

A sixteenth-century example of embroidered badges, a cap of fine linen beautifully worked with fleurs-de-lis and roses as the principal motives, is in the Victoria and Albert Museum, and is reproduced in Fig. 224. Another example of embroidered linen (Fig. 225)

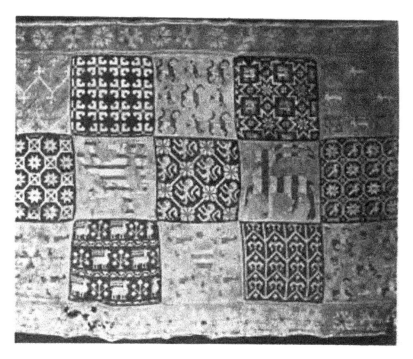

Fig. 225.—Altar Frontal in Embroidered Linen, Victoria and Albert Museum.

in the Victoria and Albert Museum, is an altar frontal which is decorated with heraldic motives in appliqué work.

Some interesting and instructive fragments of embroidery exist in the Museum at Berne, part of the spoil taken from the tent of Charles the Bold, Duke

of Burgundy, after the disastrous Battle of Grandson
in 1476. Fig. 226 is the badge, the flint and steel, of

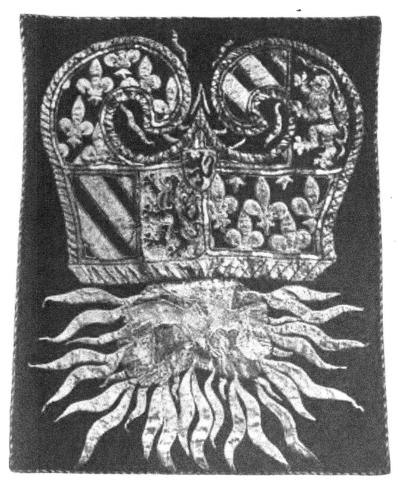

FIG. 226.—Embroidered Badge. Part of the Insignia of Charles
the Bold, Duke of Burgundy. Fifteenth Century.

the Great Burgundian Order of the Golden Fleece,
whose insignia are conspicuous in the decoration of
the next century in association with the Emperors

Maximilian and Charles V. In this instance the stee
striker serves as a space for the quartered arms o
Burgundy, Limbourg and Flanders. Fig. 227 shows th₁
same arms on what was perhaps part of the bardings, th₁
tournament or other ceremonial drapery of a charger.

Both show admirably how heraldic embroidery shoul₁
be done, namely, in flat applique strongly designed an₁

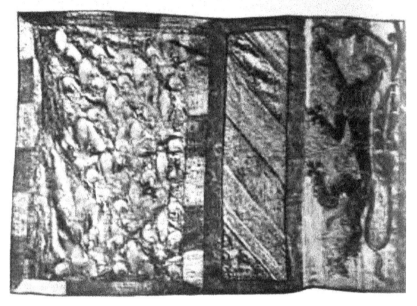

FIG. 227.—Heraldic Embroidery. Part of the Insignia of Charles
the Bold, Duke of Burgundy. Fifteenth Century.

simply executed. The sable lions of Flanders are con
clusive proofs of how heraldic vigour and decorative
distribution may be attained in embroidery.

Towards the end of the sixteenth century embroidery
began to be padded into relief, a practice which afterwards
developed to a remarkable extent in spite of its inartistic
unsuitability to the material and work. It was naturally

least offensive in its beginnings, and the shield of Eric XIV, King of Sweden (Fig. 228), is a somewhat exceptionally good example of the heraldry of its time (about 1560). The arms are well designed, the lions of the fourth

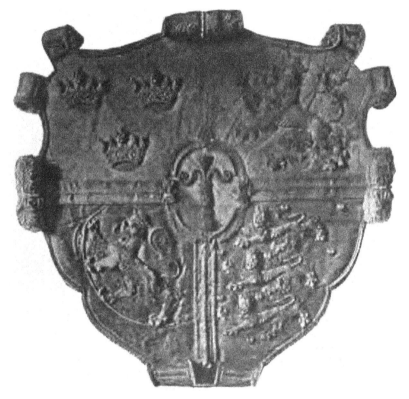

FIG. 228.—Arms of Eric XIV, King of Sweden. Berne Museum.
About 1560.

quarter, Denmark, being particularly spirited, while the execution is very excellent of its kind.

An instance of domestic embroidery occurs in Fig. 229, where the arms of James I are used as a centre to a design that is, in the main, floral.

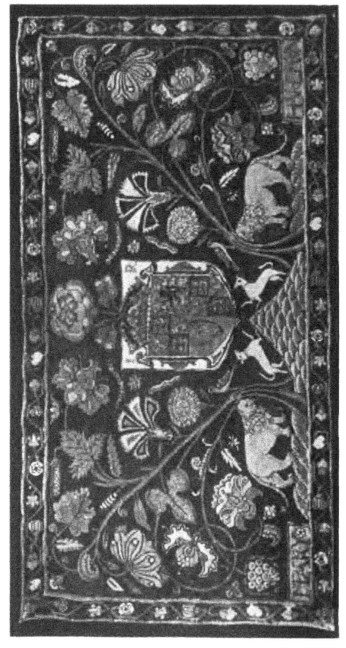

FIG. 229.—Arms of James I. Victoria and Albert Museum. Early Seventeenth Century.

Work of the highest heraldic importance must always have been that of the banners, as the very concentration of battle heraldry, but of these, alas! there are no very early examples.

The banners of the Knights of the Garter in St. George's Chapel were doubtless all embroidered formerly, as that of the Sovereign still is, but they have for long been done in an inferior way, even as the painted stall plates superseded their enamelled predecessors.

Of the various forms of flag that were in use in the day of the tournament and even survived, at funeral ceremonies, until comparatively modern times, the principal were the Banner, the Pennon and the Standard. The Banner, sometimes called the Great Banner, was square in shape and bore the arms of its lord exactly as they were borne on his shield, i.e., occupying the whole surface. Its use was confined to such knights as were especially privileged, and who were therefore called Knights Bannerets, and to nobles of higher rank. Although the banner as such bore the whole arms of the shield, other large and square flags, even when charged with badges, were sometimes called by the same name when employed for a special purpose, as, for instance, the banner of the Red Dragon of Cadwallader that was borne at Bosworth Field.

The Pennon was a long pointed flag, which was borne by a knight and was charged with his arms or device. The cutting off of the tail of the pennon, leaving the flag square, conferred on its owner the right to have a banner thenceforward, which ceremony of creating a Banneret always took place on the field of battle and

under the royal banner displayed. The Standard. properly so called, was also a pointed flag, though banners were sometimes called standards when they were flown from a mast that was either fixed in the ground or was supported on a solid platform or wagon. From this comes the inaccurate custom of describing the Royal Banner as the Royal Standard. The Standard always. in England, had the national emblem, the Cross of St. George, next the staff, and the remainder of the flag

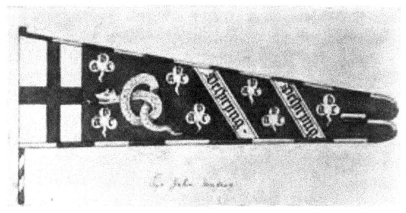

FIG. 230.—A Standard. Sixteenth Century.

was of the owner's colours, and was charged with his badges and motto (Fig. 230).

The early form of the banner was higher than it was long, that is to say, the hoist, that part of a flag that is next the staff, was greater than the fly or the length from the staff to the further edge of the flag, and that shape continued throughout the Tudor period ; later, however, the form became more square and finally extended in the other direction until at the present time the

Admiralty pattern is greater in length than in height in the proportion of two to one. This has, no doubt, been arranged as the best suited to naval use, and for the Union Flag and for the Ensigns it appears satisfactory, but when a more armorial sort of flag is in question the naval proportion becomes more or less objectionable according to the nature of the bearings. In the Royal Banner, as so proportioned, the difficulty of designing the rampant lion of the Scottish quarter, so that it may be well distributed in its space and still vigorous, or of the Irish harp so that it may properly balance with the other quarterings, is nearly insuperable.

When we remember that the whole plan on which armorial bearings are devised is based on filling an upright space, the shield shape, it is not difficult to understand how it is that the attempt to adapt such emblems to a horizontal space so frequently suggests the ludicrous effect of a distorting mirror. There is of course no reason why the proportion of flags should be the same whether they are flown on land or sea, and this is very properly recognized in regimental colours and in the banners of the Knights of the Garter at Windsor, all of which are more nearly square.

Animals on flags, and also on the bardings of horses, always faced towards the staff in the one case and towards the head of the horse in the other, and this for a very natural reason. The flag flowing backward would cause the figure that turned towards its staff to face in the direction of advance and the figures on the bardings would, of course, have the same direction under the similar circumstances, while it is evident that if they

s

faced in the opposite direction they would inevitably have given rise to the offensive gibe that they were running away.

The banner that concerns us more especially, the Union Jack, may have its essential construction explained by reference to the diagrams in Fig. 231. First we have two of the three national emblems (1) and (2), the cross of St. George and the saltire of St. Andrew, as they had long been used by England and Scotland respectively. Soon after King James succeeded to the English Crown a banner was made (3) which combined the two by placing the red cross of St. George (with a narrow line, taken from its white field, left round it) over that of St. Andrew, and thence was formed the first Union Jack, under which the great naval actions of the eighteenth century were fought.

At the Union with Ireland, in 1801, a fresh element, a red saltire on a white field for St. Patrick (4), was introduced, and the red of St. Patrick and the white of St. Andrew were united in equal proportions in this manner —(5), the red being made to retain a little of its white field as St. George had done formerly, and the result so far appears in—(6). The cross of St. George, with its white edge, was then placed over all, to complete the Union Jack as we know it. This will be found quite easy to follow if care is taken to remember the construction, and that the lines from corner to corner of the flag divide equally the broad white and the red of the saltires. Also that in the upper quarter, next the staff, the broad white must be uppermost, and for this reason : it is heraldically usual to begin a counterchange of two

tinctures, a metal (silver or white) and a colour (red),
by naming the metal first. Further, the tincture that
is mentioned first is always placed next above the line

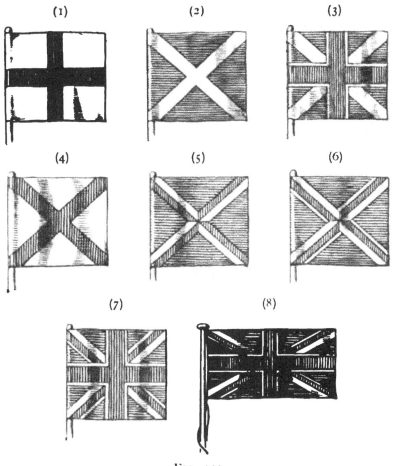

FIG. 231.

of diagonal division. Therefore, as the blazon in the
warrant is a " saltire per saltire quarterly argent and
gules," the white must be where it is. And so any
possible question of precedence was automatically avoided.

The form of the flag as shown on the Royal Warrant of 1801 is seen in (7), and is that which has been followed in regimental colours. In this it will be observed that in consequence of the narrow white of the saltire being a fimbriation that is added to the red the outline of the saltire does not register across. The Admiralty pattern, however, in what one cannot but feel was an unnecessary effort to avoid this, seems to place narrow red strips on top of the white saltire, so that the outside diagonal lines manage to register, but the result is to reduce St. Patrick's half of the joint saltire by the width of the narrow white.

Now, the evident intention in devising the flag was to effect equal representation of Scotland and Ireland in order to lessen the probability of quarrels such as had occurred between the Scotch and English seamen before the first Union Jack was made in the early seventeenth century ; and this is perfectly effected by the pattern of the Royal Warrant.

The intention of equality is also evidenced in the warrant by similar care in designing the Union badge of Rose, Thistle, and Shamrock, for after the badge has been described as a rose with a thistle on one side and a trefoil on the other, the description is carefully repeated, but with the positions of the shamrock and thistle reversed, the obvious intention being to remove any ground for a claim to priority that might have arisen by assigning the dexter side to one emblem in preference to the other. Indeed I have known exception to be taken to a perfectly correct rendering of this Union Badge, under the impression that such precedence did in fact exist.

Another form of banner which survives is that which was, from a very early period, used to decorate trumpets and is still so employed by the trumpeters of the Household Cavalry and by those of the Sheriffs of counties for use on occasions of ceremony. Such decorations usually contain the arms alone, as a great banner does, but there are also instances of badges being borne on them and also complete armorial insignia. They are tied to the instruments by ribbons or laces, and hang squarely down. The bearings, whether simple or complex, are made to read upright, when the trumpet is held horizontally, as though they were on a hanging shield. This is, of course, the natural way, though there are instances to the contrary.

As we have seen, flags were generally embroidered and with more or less elaboration according to the circumstances which influenced other heraldic treatment. Frequently they were done in cutwork, sewn down and done over with beautiful needlework and even adorned with gems. The greatest artists were employed to design them, Sandro Botticelli among many others.

The methods of the missal painter in his use of gold lines for lights and other definitions and decorations were employed in the needlework, indeed all the arts of illuminated decoration, taking the term in its widest sense, copied from each other, but each adapted the method to its own needs and materials; and that is the gist of the whole matter. At the beginning, in the seventeenth century, of the period that was so fatal to all decorative art, when embroidery took what was probably thought to be a wonderful new departure, its subjects

were raised to an increasing height from the ground where before it had been flatly treated. Thenceforward the embroidery became lumpy as the heraldry became weak, and both were alike inartistic until comparatively recently, until in fact it began to be again recognized that the mediaeval artists were right, that the right way to use a material was the natural way and not in attempting to make it resemble something else. At the time referred to it seems to have been thought that the more embroidery was made to look like a coloured relief and the less like embroidery the better embroidery it was, and therefore the lions, for example, were stuffed up and raised as high as possible and the whole effect became coarse and clumsy, an effect that was largely contributed to by the inferior design.

The costliness of embroidery helped the introduction of painted banners, which in time, assisted by the decay of embroidered as of other decorative arts, superseded the needlework. However, the inferiority of the painted banner was always recognized, and although even the banners of the Knights of the Garter had come to be done in the cheaper method, that which hung over the stall of the Sovereign continued to be embroidered, as it is to this day. The present banner is beautifully worked, and is on the correct lines of flat design.

In painted banners, usually of silk, the material is strained in a frame, by means of laces passed through tapes sewn to the edges, and the design being drawn or pounced on it, is carefully gone over with size, which fills the interstices of the silk, and when dry forms an

excellent surface for the subsequent gilding and painting in oils.

There can be no doubt, however, that embroidery, now that it has so brilliantly revived, is the method of all others in which modern banners should be executed, and if this were recognized there need be no lack of opportunity. Among others the trumpet banners of the Sheriffs who every year are appointed to the respective counties, are used to display their arms during the year of office, and afterwards, their official life being ended, are frequently made into screens for domestic use. It is in this connexion that their method of production becomes of especial importance. Their somewhat tawdry and incongruous appearance is quickly felt, and they soon disappear into the retirement that they merit.

The banners of the City Companies would better decorate their venerable halls if fashioned in beautiful needlework, and when they were carried in the procession on Lord Mayor's Day would impart a gleam of real splendour into that properties-in-daylight pageant. The painted banners could still serve for bad weather flags.

In modern heraldic embroidery the design is the weak point, but improvement would certainly follow the study of good early work and also of good examples of other decorative methods if they were intelligently adapted to the materials employed. The purpose and character of the object must influence the work, and considerations of weight and substance affect the making of a banner, which is to wave and flow, at least to some extent that would not need to be insisted on in a framed panel. Not that the treatment need be wholly flat, like

FIG. 232 Bed Cover. Flemish Work. Victoria and Albert Museum.

the diagrammatic shield of an early roll of arms, for it
may well have such definition of the charges as are seen
on the Black Prince's surcoat ; also the complete form of
an object may be sufficiently suggested without the em-

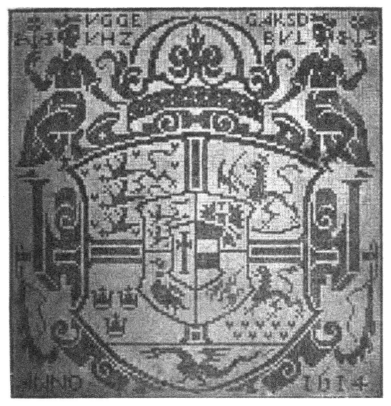

Fig. 233.—Design for Lace. Arms of Frederick II, King of Denmark.
From the pattern-book of the Duchess of Brunswick.

ployment of methods more suitable to another material.
Thus, it is not particularly difficult to indicate that a
thing is round without making it as round as possible.

LACE.—Although heraldry does not appear to have

been so extensively practised in lace as in other forms of needlework, it is still used to a considerable extent, and generally as a device that is introduced as a personal detail in a large pattern.

Among the few examples of heraldic lace at South Kensington are a piece of English needlepoint and the bedcover of Flemish work in which the double-headed eagle is well done (Fig. 232), which will repay study, and serve to explain the method of this kind of work.

The method of making the preliminary designs for lace is set forth in the pattern-books which began to be produced in the sixteenth century, and of which very interesting examples are extant. The lace design, Fig. 233, is from a book of patterns which belonged to the Duchess of Brunswick and is now in the National Art Library of the Victoria and Albert Museum, and represents the arms of Frederick II, King of Denmark. It has the usual characteristics of the German heraldry of its time.

CHAPTER XI

Some Miscellaneous Charges

ANNULET.—A simple ring, as in the mark of cadency of a fifth son, Fig. 295, p. 288. A ring in which a precious stone is mounted is called a gem-ring, and an interesting example occurs in one of the badges of the Medici, Fig 234; another Medici badge has three gem-rings interlaced.

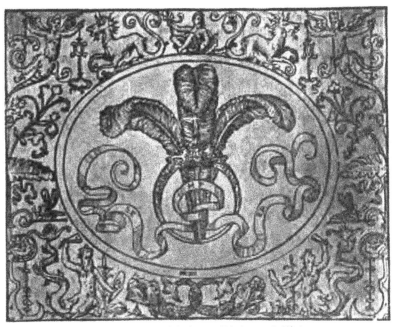

FIG. 234.—Badge of Medici from Dialogo dell' imprese, 1559.

BARNACLES OR BREYS.—An instrument that was used to control a restive horse by exerting pressure on his nostrils. They are represented as in Fig. 235, or open as in Fig. 236. (*See also* Geneville, Fig. 223, p. 248.)

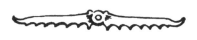

FIG. 235. FIG. 236.

BATTERING RAM.—A siege weapon consisting of a heavy ·beam headed like a ram and having hooks or other means of fastening the chains by which it was supported and swung. Figs. 237 to 239 are some of its forms. When difference of tincture requires it is said to be headed, or armed, and garnished of these appliances. Sometimes the term purfled is used for garnished. One of the best known examples is the coat of Bertie : Az. three battering rams barways in pale ppr. headed and garnished, az.

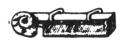 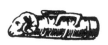 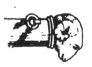

FIG. 237. FIG. 238. FIG. 239.

BUCKLES.—Being important part of military equipment were frequently employed as charges or as badges in allusion to battle occurrences or other notable events. Thus the Badge of the Pelhams commemorates the capture of King John of France at the Battle of Poictiers. Buckles afford some scope

for decoration, as in Fig. 240, a fifteenth-century example from Westminster Abbey.

FIG. 240. FIG. 241.

BUGLE HORN.—This, the most frequent of the charges derived from the Chase, forms an interesting subject for decorative treatment, in its possible grace of line and in the ornamental character of its details. It is usually shown as if suspended from a knotted or twisted cord, of which it is *stringed*, though it is occasionally hung from a flatter form of baldric. Its garnishings, mouth-piece, rim rings, etc., are usually gold (Fig. 241).

CHAPLET.—A wreath of leaves or of flowers and leaves. In the latter the flowers are usually four in number

FIG. 242. FIG. 243. FIG. 244.

(Fig. 242). When a " chaplet " without further qualification is mentioned, a severely convention-alized form is sometimes employed, consisting of

a ring with four flower bosses, as Fig. 243. *See*
Garland. A chaplet of oak is called a civic crown
(Fig. 244), and one of laurel a triumphal crown.
CHESS ROOK (Fig. 245).—This is probably the result of
a misreading of roc, the coronal of a tilting spear.
It is always represented with the cleft shape of the
latter and never as a castle, the usual form of chess-
rook.
CINQUE-FOIL (Fig. 246).—A five membered leaf, or con-
ventional flower of five petals.

FIG. 245. FIG. 246 FIG. 247.

CLARION.—A combination of musical pipes in a hand
case, the Syrinx or Pan-pipe. It is of frequent
occurrence in the heraldry of the Middle Ages and
in a large variety of more or less elaborate forms,
one of which is here represented (Fig. 247). It is
sometimes called a rest, with the suggestion that
it represents the piece fixed on a breast-plate as a
support for the tilting spear, but this appears to be
extremely improbable.
CLOUDS occur as bordures and other ordinaries in
various interesting conventional forms and also as
points from which emerge arms and other objects.
Ordinaries composed of clouds in this way are

blazoned nebuly equally with the more simplified nebuly line. There are many examples of this treatment of which Fig. 72, p. 57, will give an idea of a bordure nebuly, as it appears in one of the representations at the Heralds College of the arms of the Mercers Company.

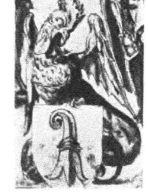

COCKATRICE.—A wyvern-like mon-ster with a cock's head, as in the many sixteenth-century drawings of the arms of the City of Basle, to which it was a supporter under its other name of Basilisk, as in Fig. 248, part of a drawing by Holbein.

<div align="center">FIG. 248.</div>

CORONETS.—Crown and coronets other than those of rank, al-ready described, may be considered as of two kinds, and are of purely symbolic import.

Crowns (including coronets) used as charges, are generally those that are more accurately de-scribed as heraldic crowns, that is, those which have no allusion to specific rank, but are emblematic in various other ways. The coronet of decorative leaves set on a rim and sometimes called a crest-coronet (Fig. 249) is thus borne as

<div align="center">FIG. 249.</div>

a charge in the arms of some of the Companies of London in allusion to events in which kings have been concerned. When, however, a specifically Royal Crown appears it is usually as an Augmen-

tation by special grant from the Sovereign. A fine
example of crowns and their distribution as charges

Fig. 250.—Shield from the tomb of Prince Edmund of Langley.
Early Fifteenth Century.

on a shield is Fig. 250, from the tomb of Prince
Edmund of Langley, at Kings Langley, Herts.
The arms are those ascribed to St. Edmund.

Other heraldic crowns are the mural crown, representing a fortified wall (Fig. 251), and the naval crown, composed of sails and sterns of ships (Fig. 252), and both are at the present time restricted

FIG. 251. FIG. 252. FIG. 253.

with care, in the cases of new grants or augmentations, to circumstances in which their obvious symbolism applies.

The mural crown is usually composed in our heraldry of the simple crenellations shown in the example. Abroad, however, a more elaborate and picturesque form occurs in the form of a castellated wall showing three towers at intervals.

The crown vallery is intended to represent palisades, as in Fig. 253, and when the palisades are more definite and are fastened to the rim instead

FIG. 254. FIG. 255.

of rising out of it, the crown is palisado instead of vallery (Fig. 254).

The Eastern crown, sometimes called an antique crown, is formed of five straight rays (Fig. 255),

and when in addition there is a star on each point it becomes a celestial crown.

CRESCENT.—This charge, beautiful as it appears in the badges connected with Henry II of France and Diana of Poitiers, has come to be drawn clumsily as to look more like a biscuit with a bite out of it than a graceful shape derived from the crescent moon. When it is simply described as a crescent it always has its points upwards, and it becomes a decrescent if they point to the sinister, and an increscent when they are pointed to the dexter. Still rarer as a charge than these latter is the full moon, and when she thus occurs she is blazoned a Moon in her Plenitude. It is understood that the proportionate thickness of a crescent may be any that is felt to be in harmony with the general character of the design that accompanies it.

ESCALLOP SHELL.—This beautiful charge, with its radiating lines within its outline, appears to have been specially connected with the Crusades as the pilgrim's badge, as such being sewn on to the cloak or hat. Later the shells so worn were sometimes elaborately painted in the manner of the illuminators, in memory of the pilgrimage. The escallop is especially associated with St. James, and so frequently occurs in Spanish decoration such as that of the House of the Shells, Saragossa, the whole front of which is semée of escallops in high relief.

Also, an old writer says: " The shell thereof is the fairest instrument that can be, being of nature's

making, which for the beauties sake is put in the collars of Saint Michael's Order."

ESTOILE.—A star of six wavy points.

ESCARBUNCLE (Fig. 256).—Is derived from the strengthening bands of the shield which the mediaeval metal worker's decorative instinct made into beautiful ornament even as it did the hinges of a door. The metal plates radiating from the central boss of the shield terminated in foliated forms of great beauty, the fleurs-de-lis of the present charge, while the hollow ring in the centre enabled it to fit over the boss. Many beautiful examples exist of this piece of armour become the Badge of Anjou, worn by Henry II.

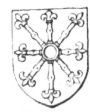

FIG. 256.

FOUNTAIN (Fig. 257).—The symbol of a spring of water, is a roundle barry, wavy argent and azure, wavy lines having been emblematic of water from time immemorial. Its occurrence in the arms of Lord Stourton (Sable a bend or between six fountains) is very interesting as an example of heraldry of which the meaning is well understood. In the admirable account given by Mr.

FIG. 257.

Fox Davies in *The Art of Heraldry* he points out that the manor of Stourton on the borders of Wilts and Somerset obtained its name from the river Stour which rises within the manor. The sources of that river are six wells which exist in a tiny valley in Stourton Park, which is still called Six Wells Bottom. When Leland wrote in 1540 to 1542 the

whole six were in existence (some have since dis-
appeared), for he wrote : " The ryver of Stoure risith
ther of six fountaynes or springes, whereof 3 be
on the northe side of the Parke, harde withyn the
Pale, and other 3 be northe also but withoute the
Parke. The Lorde Stourton giveth these 6 foun-
taynes yn his Armes." In addition, not only were
three springs inside the park and three outside, but
also three were in Wiltshire and three in Somerset.
The appropriateness of three fountains on either
side of the ordinary is therefore manifest. Would
that all heraldic origins were equally clear !

FYLFOT (Fig. 258).—A symbolic figure which appears
to have been used from the remotest antiquity and
round which much literature has been written in
common with its Indian form, the Swastica.

Its presence in heraldry is probably to be
ascribed to mere copying from some eastern
example, though even thus a symbolic meaning
may have been ascribed to its cross-like form,

FIG. 258.
or perhaps some one of the transmitted mean-
ings may even have been known.

It occurs in the arms of Sir Wm. Kellaway in a
" Copy of an antient roll of Arms," in the Heralds'
College.

In Japan it is well known as the Mon or badge
of the Matsudaira family.

HAMMER.—In heraldry both the workman's hammer,
emblematic of industry, if it have no more definite
symbolism, occurs as well as the military *martel-
de-fer*. Examples of both are given in Figs. 259

and 260. Another instance of the first is in the Arms of the Blacksmiths Company of London, Sa a chev. Or between three hammers Arg. handled

FIG. 259. FIG. 260.

and ensigned with crowns gold ; and with this is their swinging motto, " By hammer and hand all arts do stand."

HAWK'S BELLS AND JESSES.—The bells are of the globular kind (Fig. 261), and jesses are the leather straps by which they were secured to the falcons' legs. Also attached to the jesses were pieces of metal, called vervels, that were stamped with the owner's monogram or badge.

HAWK'S LURE.—A bird's wing that was attached to a cord by means of which it was thrown in the air in order to attract the falcons to hand. Its usual shape as a charge is as in Fig. 262.

HEMP-BRAKE OR HACKLE.—An instrument for bruising hemp. Its best known heraldic example is as the badge of Sir Reginald Bray (Fig. 263), the architect

to Henry VII, for whom he built the magnificent Chapel in Westminster Abbey and completed St. George's Chapel at Windsor. The badge is now

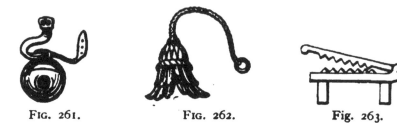

FIG. 261.　　　　FIG. 262.　　　　Fig. 263.

used by Lord Bray, who is descended from Sir Reginald's brother.

KNOTS.—A form of badge that is composed of one or more cords or straps twisted into open knots and used to symbolize the bond of a vow. The best known, perhaps, is the Stafford knot (Fig. 264), which from being the badge of the Earls of Stafford has been appropriated by many institutions connected with that county. The Heneage knot, also on a

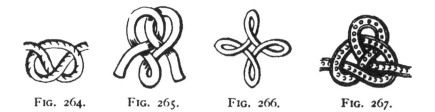

FIG. 264.　　　FIG. 265.　　　FIG. 266.　　　FIG. 267.

single line, is Fig. 265, and is sometimes accompanied by the motto, " Fast though untied," and Fig. 266 is the Bowen knot of four bows. Fig. 267 is

from among the devices on the robe of the effigy
of Anne of Bohemia on her tomb at Westminster
Abbey, and is thought by Boutell to convey the
idea of a monogram. He also sees in the Wake
and Ormond knot (Fig. 268) the initials W and O
entwined. A modern attempt was made to form a
monogram of the silken tags represented as depend-
ing from the seal shape of the bookplate (by C. W.
Sherborn, R.E.) of the celebrated J. Robinson
Planche, Dramatist and Somerset Herald.

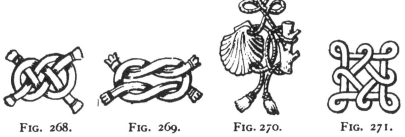

FIG. 268. FIG. 269. FIG. 270. FIG. 271.

The Bouchier knot is Fig. 269, and Boutell men-
tions a Bouchier badge formed of the knot tied to
a coudiere or elbow piece, as from a monument in
Westminster Abbey.

The Dacre knot is less a knot than a badge, consist-
ing of an escallop shell linked by a cord with a
ragged staff or a billet (Fig. 270). In the same
way a sickle and a garb are tied together in the badge
of Lord Hastings, and are suggestive of the way in
which initial letters of names were linked with each
other and with badges in the splendid pageants
of the sixteenth century.

The Lacey knot is shown at Fig. 271.

LOZENGE.—Fig. 272.

MANCHE OR MAUNCHE.—A severely conventionalized
form of a sleeve, derived from the actual sleeve
which was worn at a tournament, as a ladies' favour,
floating from the shoulder of a favoured knight.

FIG. 272. FIG. 273. FIG. 274.

The illustrations are from the fifteenth-century
seal of Lord Hastings (Fig. 273), and from a MS.
of the following century relating to the same family
(Fig. 274).

MULLET.—A five-pointed star-like figure whose name
is derived from Mollette, the rowel of a spur (Fig.
293).

PALL.—An heraldic figure which occurs in the arms of
certain Archbishoprics, being indeed a representation
of the Pallium, which is an especial vestment of an
Archbishop. Mr. Everard Green, Rouge Dragon
Pursuivant, has fully dealt with this in an admirable
monograph which is among the Archaeologia of
the Society of Antiquaries, from which it appears
certain that the pall is not the arms of a particular
see, but is an ensign of the ecclesiastical rank of
an archbishop.

PHEON.—The head of a dart, the so-called broad arrow
of Government stores. It usually has its inner

edges engrailed, but this is not essential any more
than are the rigidly straight lines with which it is
generally drawn. There are many other
forms in early use that are much more
satisfactory, such as Fig. 275, which is
from an early sixteenth-century MS.
The pheon is understood to be point
downwards as in the example, unless it
is otherwise described.

FIG. 275.

ROUNDELS.—Circular charges whose names differ accord-
ing to their tincture. Thus a roundel or is supposed
to be a flat piece of gold and is called a Bezant
after Byzantium. A roundel arg. is a Plate; a
roundel gules is a Torteau ; the Hurt is azure ; the
Pellet or Ogress is sable ; the Pomme is vert. Ancient
armorists also mention Golpes, which are purpure ;
Guzes, sanguine ; and Oranges, tenné ; but these
are not actually used in English heraldry. Another
roundel, called a Fountain, is barry-wavey arg.
and az., and is further alluded to under its
name (Fig. 250). The use of the heraldic names
of the various roundels is not obligatory, however,
their description by tinctures, like other charges,
being equally correct. They are frequently them-
selves charged and may be of ermine or other fur,
and be treated in every way as other flat spaces.
Their treatment in relief or otherwise is largely a
matter of taste, and whether a roundel be treated
as flat or globular must depend on the character
of the surrounding work. The frequently made
suggestion that bezants and plates, being derived

from flat objects, should always be flat, while others should always be globular, would often be awkward if carried out in practice, especially in sculpture ; and even if the derivations be correct, a roundel as a circular object without other qualification is just as conceivable as a roundel derived from a coin. Suitability to the general design seems to be the governing factor here as elsewhere.

PORTCULLIS.—A strong grille for the protection of a fortified gateway. It was made of heavy beams securely clamped together and shod with iron, and

FIG. 276.

FIG. 277.

is represented with the chains on either side by which it was suspended. The example (Fig. 276) is from the Chartulary of Westminster Abbey, where it forms part of the painted decoration of the MS. as one of the favourite badges of Henry VII. It has given a name to one of the pursuivants of arms, and as part of the armorials of the city of Westminster is one of the most familiar charges.

QUATREFOIL (Fig. 277).—A four-leaved charge, derived from clover or from a four-petalled flower.

SHAKEFORK (Fig. 278).—An unusual charge which occurs in the Arms of Cunningham.

SPADE.—Emblematic of agriculture and industry. It is of great variety of form. Figs. 279 and 280 are fifteenth. and sixteenth century forms of these implements, which were usually of wood shod with iron, as in the examples.

SPEAR.—Is usually described as a tilting spear, and when

FIG. 278. FIG. 279. FIG. 280.

its shaft is without swell as a javelin. It is regarded as the emblem of manhood, as the distaff is the symbol of womanhood. As usually depicted, without the vamplate, it appears as in Fig. 281 ; but there is no reason against representing the plate in addition if it is thought desirable. Although

FIG. 281. FIG. 282.

the tilting spear was most frequently used with the blunted head, the coronel or roc, it is almost always represented heraldically with a sharp spear point. The shaft is sometimes parti-coloured, or else grooved into flutings as it was in actual use. In some cases these grooves were so large and deep

as to result in a form of the girder principle by which great lightness and strength were obtained. The Arms of Shakespeare, granted in 1546, are: Or on a bend Sable a spear Gold.

SPURS.—As the peculiar symbol of knighthood are naturally of frequent occurrence as charges. They are given star-shaped rowels unless the more ancient form with a single point is intended, and it is then blazoned a Prick Spur.

" The Spurs ben given to a knight to signify diligence and swiftness."

SRUTTLE.—Another name for winnowing fan (Fig. 282).

FIG. 283.

FIG. 284.

FIG. 285.

SWORD.—Is sometimes borne in allusion to St. Paul, as it is in the Arms of the City of London. Unless otherwise described, a straight sword with a cross hilt, an arming sword as it was sometimes called, is understood. Its position—that is to say, the direction of the blade—whether pale, wise or fess-wise, and where there are more swords than one, their relative positions and the direction of their points are duly stated.

TREFOIL (Fig. 283).—Is always represented with a stalk, as in the example, but the term slipped is always

included in the blazon nevertheless. The form of the charge is usually as given, but in rare instances it appears as in Fig. 284, which is from a fifteenth-century MS. in the Heralds' College.

WATER BOUGET.—This, like the maunche, is an instance of the conventionalization of an actual thing into a shape that bears but remote likeness to the original form. Although there are instances in which its derivation from water carriers, its undoubted origin, is more nearly suggested, its heraldic form was clearly established in the fourteenth century, chiefly in connexion with the family of Bourchier, which furnished so many persons of note to mediaeval history.

CHAPTER XII

Marks of Cadency

IN order to distinguish the various members of a
family among themselves certain additions to the shield
called marks of cadency are employed; and in the
earliest days of the heraldic system a son charged
the arms that he derived from his father with such a
mark of difference as he thought fit and effectual, but
by the middle of the fourteenth century some amount of
regularity was arrived at, and by the end of the sixteenth
century the present method had become usual. In
this system the eldest son is distinguished by a file or

FIG. 286. FIG. 287.

label of three points, which consists of a horizontal part
from which depend the lambeaux (Fig. 286 *et scq.*). Its
origin is extremely obscure, and whether it represents
the points of garments, or tongues or labels threaded
on a cord, no one can say with certainty. It seems
probable that it may have originally been a favour or
distinction whose history and original significance have

been lost. The effigy at Artois of Charles Count d'Eu has a label which passes round the shoulders, exactly as other collars did, and consists of large labels charged with castles and suspended from what appears to be a narrow cord (Fig. 288). On a shield the label is borne in chief and passes over any charges that may be in that part of the arms. In early examples the pendant parts are wider than the

FIG. 288.

rest, in some cases much wider, as in the Garter Plate of Gaston de Foix, Comte de Longueville and Captal de Buch, whose label is charged with a complete coat of arms repeated on each point, a cross charged with five escallop shells, which are the arms of John de Grielly, a previous Captal de Buch who married Blanche de Foix. In later times the points of labels were widened at the ends as in Fig. 289, a form which in the eigh-

FIG. 289. FIG. 290.

teenth and nineteenth centuries had become as squat and ugly as the still common type (Fig. 290). In ordinary cadency the label which extends from side to side of the shield is no longer used, being reserved for members of the Blood Royal, and a shortened form takes its place

in ordinary coats of arms. Distinctions of cadency are
provided to the number of nine, and no regular provision
is made beyond the ninth son ; not because others are
to go undifferenced, but because in old heraldic treatises
great importance is ascribed to that mystic figure 9.
There were nine tinctures (including the rare colours
tenné and sanguine), nine ordinaries, nine partitions,
or methods of displaying charges with ordinaries, and
so forth. The differences are as follows :—

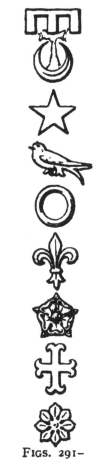

The eldest son a label.

 second ,, a crescent.

 third ,, a mullet.

 fourth ,, a martlet.

 fifth ,, an amulet.

 sixth ,, a fleur-de-lis.

 seventh ,, a rose.

 eighth ,, a cross moline.

 ninth ,, a double quatrefoil.

FIGS. 291–
299.

A mark of cadency is borne on any part of a coat that may be found most suitable for its conspicuous display, but always in such a manner that it may not be mistaken for a charge. It is generally placed somewhere in chief or sometimes in the centre of the shield, and its colour may be any that is well seen. Bossewell says (1572): " Every difference ought to be placed in the moste evidente part of the coat armour, videlicit, in the place where the same maie soonest be scene or perceived." And another early writer indicates the distance at which a difference should be easily perceived on a banner or other flag as eighteen yards.

The sons of the eldest son bear each his own difference charged upon the label of his father, and in similar manner the sons of the second son of the head of the family charge their differences on their father's crescent, and so forth. As marking the degree of nearness to the headship of the family such distinctions are disused or changed as circumstances dictate, but in some cases a second or other junior son continues to use his difference after his father's death in order to prevent confusion with his elder brother who has in due course succeeded to the undifferenced coat, and in spite of the inevitable clashing with the second son of that elder brother, who would also bear a crescent for difference. Such a method of distinguishing " Houses " as well as sons would, of course, become impossible in a very few generations, and this points to the superiority of the mediaeval method of differencing as well as to what is the principal weakness of modern heraldry in England as a system, namely, the want of distinction between the branches

of a family. That, however, is more a matter for the scientific herald. The mark of cadency may be placed on the crest as well as on the arms, but it is not commonly done, except when the crest is used alone.

It should be noted here that though daughters (other than Princesses of the Blood) do not difference their arms personally, for they rank equally among themselves, they do bear their father's difference so long as he bears it.

When by impalement or other means the individuality of the bearer is sufficiently pointed out, marks of cadency are frequently considered to be redundant, and are therefore omitted; but their inclusion is preferable.

Royal cadency follows a method apart, and when arms are assigned by the Sovereign to the various members of the Royal Family, as is done by warrant on their arrival at full age, the proper individual mark of cadency is assigned at the same time. At the present day it always takes the form of a label; which is plain for the Prince of Wales, and charged in some distinctive manner for other members of the Blood Royal.

The labels of the other living Princes and Princesses to whom arms have been assigned are as follows : and it should be noted that all these various labels are Argent. The Princess Royal (Duchess of Fife) bears over the Royal Arms a label of five points charged with three crosses gules alternating with two thistles ppr.

The Princess Victoria differences her arms with a label of five points charged with three roses alternately with two crosses gules.

The Princess Maud (Queen of Norway) bears a label

of five points charged with three hearts and two crosses gules.

The Duke of Connaught has a label of three points, charged on the centre point with St. George's Cross and on each of the others with a fleur-de-lis Azure.

The Princess Christian, of Schleswig-Holstein, bears a label of three points, the centre of which is charged with St. George's Cross and each of the others with a rose gules.

The Princess Louise (Duchess of Argyll) bears a label of three points, the centre point charged with a rose, each of the others with a canton gules.

The Princess Beatrice (Princess Henry of Battenberg) bears a label of three points, the centre one charged with a heart and each of the others with a rose.

In Royal Achievements the labels are charged on the crest and supporters as well as the arms, and in these positions are usually couped at the ends, though there is no reason why they should be so ; on the contrary, remembering that these figures are " in the round)" it would be preferable to follow the ancient usage.

A further distinction from the arms of the Sovereign is made by substituting for the Imperial Crown, which is borne on the heads of the lion crest and supporter and also encircles the throat of the unicorn, the coronet which is proper to the personage concerned.

INDEX

Butler & Tanner, The Selwood Printing Works, Frome, and London.

INDEX TO ILLUSTRATIONS

X